GENESIS

IDEAS OF ORIGIN IN AFRICAN SCULPTURE

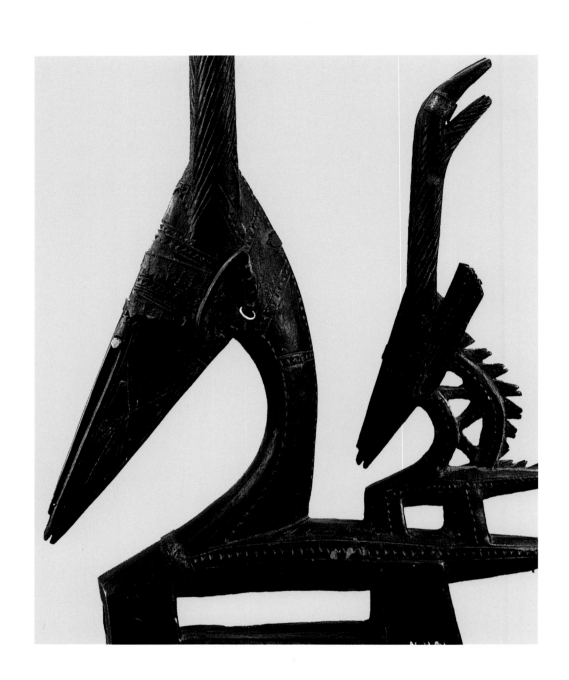

GENESIS

IDEAS OF ORIGIN IN AFRICAN SCULPTURE

Alisa LaGamma

THE METROPOLITAN MUSEUM OF ART, NEW YORK

YALE UNIVERSITY PRESS, NEW HAVEN AND LONDON

This volume is published in conjunction with the exhibition "Genesis: Ideas of Origin in African Sculpture," held at The Metropolitan Museum of Art, New York, from November 19, 2002, to April 13, 2003.

Published by The Metropolitan Museum of Art
John P. O'Neill, Editor in Chief
Dale Tucker, Editor
Robert Weisberg, Designer and Typesetter
Sally VanDevanter, Production

Separations by Professional Graphics, Inc., Rockford, Illinois
Printed by Brizzolis Arte en Gráficas, Madrid
Bound by Encuadernación Ramos, S.A., Madrid
Printing and binding coordinated by Ediciones El Viso, S.A., Madrid

Cover: Harp-Lute Player, Dogon peoples, Mali, 16th–19th century (cat. no. 3)
Frontispiece: Detail, Female *Ci Wara* Headdress, Bamana peoples, Mali, 19th–20th century (cat. no. 40)
Page 25: Detail, Head, Yoruba peoples, Ile-Ife, Nigeria, 12th–14th century (cat. no. 1)
Page 79: Detail, Male *Ci Wara* Headdress, Bamana peoples, Mali, 19th–20th century (cat. no. 35)
New color photography by Paul Lachenauer and Eileen Travell, The Photograph Studio, The Metropolitan Museum of Art: fig. 11; cat. nos. 3–6, 7, 10, 11, 13, 14, 18, 21–33, 42–45, 48–51, 54, 56, 59–63, 68, 73, 75

Library of Congress Cataloging-in-Publication Data
LaGamma, Alisa.
 Genesis : ideas of origin in African sculpture /Alisa LaGamma.
 p. cm.
 Catalog of an exhibition held at the Metropolitan Museum of Art,
Nov. 19, 2002–April 13, 2003.
 Includes bibliographical references.
 ISBN 1-58839-074-8 (pbk.)—ISBN 0-300-09687-9 (Yale University Press)
 1. Sculpture, African—Themes, motives—Exhibitions. 2. Creation in art—Exhibitions. I. Metropolitan Museum of Art (New York, N.Y.). II. Title.

NB1080.5 .L34 2002
730'.966'0747471—dc21 2002032554

CONTENTS

DIRECTOR'S FOREWORD

Contemplation of the works assembled in "Genesis: Ideas of Origin in African Sculpture" takes us on a journey of discovery not unlike that traveled a century ago by Picasso and Matisse, whose confrontations with African art works abetted the invention of new forms of expression in Western art. This exhibition illuminates some of the powerful themes in African sculpture that have had such a potent impact on the world's imagination. In particular, it explores how the creative minds and hands of Africans have conceived and depicted the very origins of life, society, governance, and other elemental forces that are both common to cultures worldwide and vital to the human condition. Simply put, "Genesis" bears witness to the artist grappling with the very idea of creation.

The act of human creation is a broad and recurrent theme of African art. The seventy-five works in this exhibition, drawn from some of the finest American collections, are notable for their aesthetic refinement as well as for the astonishing diversity of tradition and expression they represent. They give materiality to the abstract thoughts and concepts that have shaped human experience. The artists who executed them have, in doing so, fulfilled one of the exalted roles for the visual arts: expressing in tangible form a society's beliefs about the most profound of human questions.

As we reflect on the concepts embodied in these works, we would be remiss not to remember the beginnings of the collection of African art within our own institution. It was the vision of Nelson A. Rockefeller that helped to make The Metropolitan Museum of Art one of the world's premier venues for the study and appreciation of Africa's outstanding contributions to the history of art. We are proud to advance that distinguished tradition through exhibitions such as "Genesis," which was organized by Alisa LaGamma, Associate Curator, Department of the Arts of Africa, Oceania, and the Americas, who also wrote the accompanying catalogue. The Museum thanks her for bringing themes of such universal social and cultural significance to life. Finally, the Metropolitan's ability to pay tribute to Africa's outstanding artistic heritage has been made possible by the unfailing support and generosity of the lenders to this exhibition, to whom we are sincerely grateful.

Philippe de Montebello
Director
The Metropolitan Museum of Art

ACKNOWLEDGMENTS

"Genesis" has benefited immeasurably from the enthusiastic and much appreciated contributions of many esteemed colleagues, valued friends, and generous lenders. From the outset and throughout the gestation of this project, I have greatly enjoyed the extensive interactions with the collectors whose works serve as the foundation of the exhibition. I thank them all for their support and for affording us access to their masterworks: Roslyn Adele Walker, National Museum of African Art, Smithsonian Institution, Washington, D.C.; William Siegmann, Brooklyn Museum of Art; Christa Clarke, Neuberger Museum of Art, Purchase College, State University of New York; Kathleen Bickford-Berzock, The Art Institute of Chicago; Pam McClusky, Seattle Art Museum; Armand and Corice Canton Arman; Saretta Barnet; Edward and Marianne Burak; Sidney and Bernice Clyman; Shelly Mehlman Dinhofer; Mr. and Mrs. Harold S. Gray; Udo and Wally Horstmann; Dr. and Mrs. Pascal James Imperato; Eliot and Amy Lawrence; Drs. Daniel and Marian Malcolm; Herbert and Paula Molner; Karel Nel; Frieda and Milton F. Rosenthal; Laura and James J. Ross; Herbert and Lenore Schorr; Ed and Sheri Silver; Sheldon Solow; Jeff Soref; Thomas G. B. Wheelock; Maureen and Harold Zarember; and the Ziff Collection. I am also grateful to Holly Ross and Susan Kloman, who were especially helpful during the search for many of the pieces that were ultimately included in the exhibition.

The research behind "Genesis" was enhanced immeasurably by the scholarship of many distinguished colleagues. I want to express my gratitude to Pascal James Imperato for his invaluable contributions. He served as a mentor and principal advisor, contributed much of his vast knowledge and documentation of Bamana *ci wara*, and called on long-standing friendships in Mali to facilitate my witnessing this performance tradition firsthand. Stephen Wooten also provided exceptional insights and greatly appreciated commentary on the essay as well as primary research documents

that have enriched this presentation. Valued expertise on Bamana culture was also generously provided by Kate Ezra, Mary Jo Arnoldi, James Brink, Jerry Vogel, Samuel Sidibé, and other friends made during my July 2002 visit to Mali. Dialogue with other colleagues about their own research and about various aspects of the ideas reflected in this text contributed significantly to the content of the exhibition and catalogue. I am particularly appreciative of Chris Geary and her staff at the National Museum of African Art's Eliot Elisofon Photographic Archives, Judith Ostrowitz, Christopher Roy, Zoe Strother, Enid Schildkrout, Mary Nooter Roberts, Louis de Strycker, and Christopher Henshilwood.

The successful execution of both the exhibition and publication derives from the contributions of many talented professionals at The Metropolitan Museum of Art. I would like to acknowledge the crucial role of colleagues in the Department of the Arts of Africa, Oceania, and the Americas: Virginia Lee Webb, Leslie Preston, Ross Day, and Victoria Southwell. I would like especially to acknowledge Hillit Zwick for her help and support in myriad ways throughout the project. As always, Julie Jones was unwavering in her helpful direction, encouragement, and friendship. I also worked with a series of gifted and dynamic interns who conducted valuable research, and I would like to acknowledge the contributions of Nichole Bridges, Paul Hempel, and Justin Marquis, as well as Exie Huntington and Alexa Rose, who cheerfully volunteered their summers to assist me.

The evolution of this publication began with a conversation with John P. O'Neill, Editor in Chief and General Manager of Publications. I want to express my appreciation to him and to the staff of the Editorial Department, particularly Sally VanDevanter, Peter Antony, and Robert Weisberg for the production and design of the catalogue. I am especially grateful for the patient efforts of Dale Tucker, who edited the

manuscript carefully and thoughtfully and in doing so elucidated its content. Susan Bresnan also played an invaluable role in coordinating outside photography.

Colleagues in the Photograph Studio here at the Metropolitan undertook the challenge of photographing most of the works featured in this publication. I want to thank Barbara Bridgers for the outstanding efforts of her staff, especially Paul Lachenauer and Eileen Travell, who captured the sculptural forms so eloquently with invaluable installation assistance from Sandy Wolcott and Nancy Reynolds. Conservators Ellen Howe and Christine Giuntini also played crucial roles in that process. The coordination of loans was facilitated by the efforts of Herb Moskowitz, Blanche Kahn, and Nina Maruca in the Registrar's office. As this publication was going to press, the work of designing the installation had just begun, and I want to acknowledge the creative talent of the outstanding team of designers, Dan Kershaw and Barbara Weiss, whom it has been my pleasure to work with on this and other projects. Dimensions of the installation that cannot be captured in this volume but that nevertheless enriched its content are reflected in the efforts of Christopher Noey and Jessica Glass, who produced the performance footage, and Christine Giuntini, who created a masquerade ensemble for the exhibition space.

Finally, no one has shared in the discussion of the ideas developed in this exhibition and inspired my imagination more than my own family, and for that and for their unfailing encouragement I want to thank Robert, Anita, and Ard.

AL

GENESIS

IDEAS OF ORIGIN IN
AFRICAN SCULPTURE

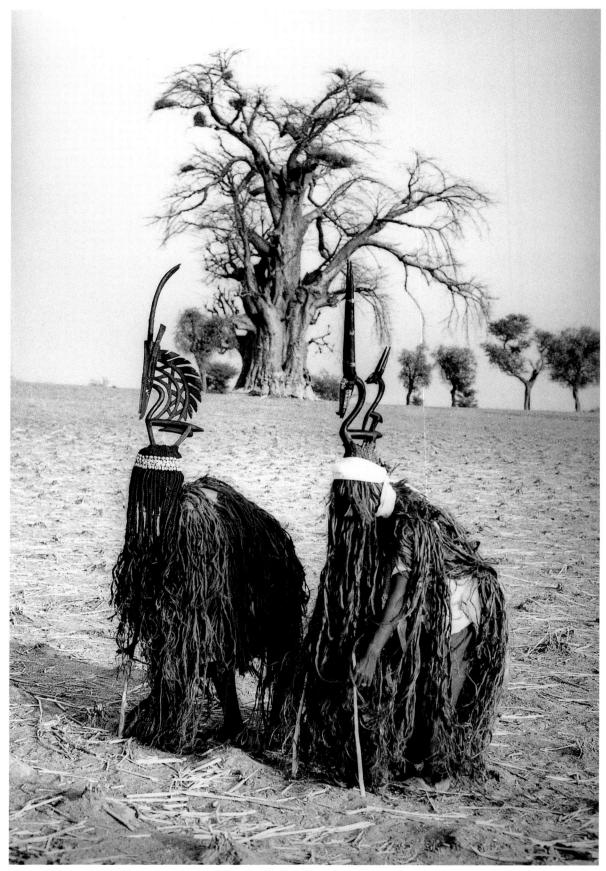

Fig. 1. *Ci wara* dancers from the village of Boussin, Ségou region, Mali, 1970. Photograph by Pascal James Imperato

GENESIS: IDEAS OF ORIGIN IN AFRICAN SCULPTURE

A fortunate blend of myth and history penetrates even deeper into that area of man's cosmogonic hunger, one which leads him to the profounder forms of art as retrieval vehicles for, or assertive links with, a lost sense of origin.
— Wole Soyinka, *Myth, Literature and the African World*

Introduction

In the beginning there was Africa, a land where the drama of human evolution unfolded: a land of origins. There our distant ancestors emerged some five to seven million years ago, and *Homo sapiens* evolved more than one hundred thousand years ago. Now it seems that creative expression, the act that essentially defines "modern" humans, is also inextricably linked to the African continent. Until recently, it was widely believed that a "creative explosion" occurred following the migration of *Homo sapiens* to Europe about forty thousand years ago, and that this development marked the beginning of modern human behavior.[1] That assumption has been cast into doubt by recent discoveries in South Africa, where researchers at the site of Blombos Cave, two hundred miles east of Cape Town, have unearthed ocher engravings, finely made bone tools, and symmetrical stone spear points created more than seventy thousand years ago.

Christopher Henshilwood, director of the Blombos Cave Project, emphasizes that "the authors of these artifacts created them to have aesthetic qualities that probably added to their value and significance." This aesthetic refinement served no utilitarian purpose, however, and at present appears to be the earliest evidence of human creativity and the earliest known visual manifestations of abstract thought. "They were making their tools with great care and deliberation," Henshilwood continues, "because, I believe, it appealed to their sense of beauty. Surely this is a key indicator of modern humans—people who think like us."[2] Africa, so it seems, is not only where our common ancestors developed, it is also possibly the font from which all human artistic traditions flowed. It is significant, then, that the African continent, which spawned modern

1. John Noble Wilford, "Artifacts Suggest an Earlier Modern Human," *New York Times*, December 2, 2001, pp. 1, A16.
2. Christopher Henshilwood, personal communication with the author, April 2, 2002.

3

humans as well as their unique, defining trait—creative expression—is also a land where ideas of origin are articulated in a staggeringly varied array of artistic and cultural traditions.

Since earliest human history, peoples around the globe have pondered their origins: Who are we? How did the world begin? Their answers to these questions formed the cores of their communal identities. As human societies sought to ground contemporary experience in the past and explain the familiar through myth, they came to define their places in the cosmos through narratives interweaving spiritual belief, lore, and historical fact. These narratives generally fall into two broad but distinct categories: creation myths or cosmogonies, which tell how the cosmos was created from a primal state; and myths of origin, which explain how extended families, social institutions, communities, cultures, and humanity itself came into being.

Historian Jan Vansina observes that "every community in the world has a representation of the origin of the world, the creation of mankind, and the appearance of its own particular society and community."[3] Stories of creation, he explains, are by nature "reflexive, the product of thought about existing situations—they represent a stage in the elaboration of historical consciousness and are among the main wellsprings of what we often call culture." Peoples' aspirations concerning their place in the world—their worldview—developed out of these conceptions of the past. A worldview, Vansina comments, "is a representation of ultimate reality in all its aspects, visible and invisible."[4] As such it is often intuitive to its proponents but difficult for outsiders to comprehend. Vansina suggests that one key to understanding a worldview is to study a culture's religious system and its traditions of origin: "how the world began, how people were created, and how they became as they are now."[5] These "mythical charters" complement, and often justify, existing social structures, but they are subject to continual revision over time. Most notable for our purposes, they have been translated into visual forms of expression that rank among the most celebrated monuments in the history of art.

When we think of the origins of Western civilization, we think of Greece and Rome. In the fifth century B.C., the desire to glorify Athenian power and influence, and to celebrate the Greek victory in the Persian War, prompted the creation of one of the wonders of the ancient world: the Parthenon. The first and most impressive in a series of new structures built on the Acropolis, the Parthenon was a temple dedicated to the goddess Athena, the patron deity of the city. The great sculptor Phidias designed the colossal chryselephantine statue of her within (destroyed in antiquity) and the exterior sculptural program, whose east pediment depicts Athena's birth in the presence of all the gods and the west pediment her struggle with Poseidon for possession of Attica. As a monument, the Parthenon visually affirmed the goddess's centrality to the city's

3. Vansina 1985, p. 21.
4. Ibid., p. 133.
5. Ibid.

identity as it also conflated the heroic present with the mythic past. The Ara Pacis in Rome—the "altar of peace" consecrated in the Campus Martius after Augustus's triumphs in Spain and Gaul—is a similar type of sculptural statement. The scenes depicted on either side of its two entrances, including Romulus and Remus being suckled by the she-wolf and Aeneas's sacrifice at Lavinium, metaphorically linked Augustus to Rome's mythical founders while crediting him with laying the foundation for a new age of peace and prosperity.

The Greeks gave Western civilization the word most closely associated with Judeo-Christian concepts of the origins of the world: genesis, derived from *genesis kosmou,* or "origins of the cosmos." As the first book of the Jewish Pentateuch and the Christian Old Testament, Genesis articulates not only the narrative of the beginning of the world and of humankind but also some of the moral charters and concepts that govern human behavior. There exists perhaps no greater pictorial interpretation of the biblical account of Creation than Michelangelo's frescoes on the ceiling of the Sistine Chapel (1508–12). Michelangelo infused the series of nine narratives within the ceiling's vault, from Creation to the Fall to the New Covenant after the Flood, with the vitality and immediacy of human drama, epitomized by God separating light from dark and touching Adam to imbue him with life. As a result, the Sistine ceiling is a uniquely powerful and comprehensible illustration of one conception of human origins.

In the latter half of the eighteenth century, the inception of an American republic and its democratic model of governance inspired artists to celebrate the origins of America by immortalizing its founding fathers through portraiture and history painting. The universal resonance of the American moral and political charter instilled in the German-born painter Emanuel Leutze the ambition to paint "a long cycle from the first dawnings of free institutions in the middle ages to the Revolution and Declaration of Independence."[6] Leutze's project culminated in 1851 with one of the most celebrated icons in American art, *Washington Crossing the Delaware,* an artistic tribute that transfigures the quest for America's independence as a heroic deed of its great revolutionary leader.

The ideas of Native Americans about their origins have also been translated into visual form. The Iroquois myth known as the "Woman Who Fell from the Sky," or "Earth-grasper,"[7] informs a rich artistic repertory that includes abstract decorative designs, sacred ritual artifacts, and contemporary paintings. Before there was Earth, the myth relates, humans dwelt in a realm on the other side of the sky. Their leader, who was jealous of his wife because of her pregnancy, gouged a hole in the sky by uprooting a tree and pushed her into the void. Her fall was broken by a flock of birds and a turtle, which provided its shell as a foundation that living beings could cover with earth. The woman's establishment on this "turtle island" caused it to expand and flourish with abundant plant life.

6. Barbara Groseclose, "Leutze, Emanuel (Gottlieb)," in *Grove Dictionary of American Art Online,* updated and revised September 27, 1999, from the *Dictionary of Art,* printed 1996.
7. Hewitt 1903; Fenton 1962; Lafitau 1974.

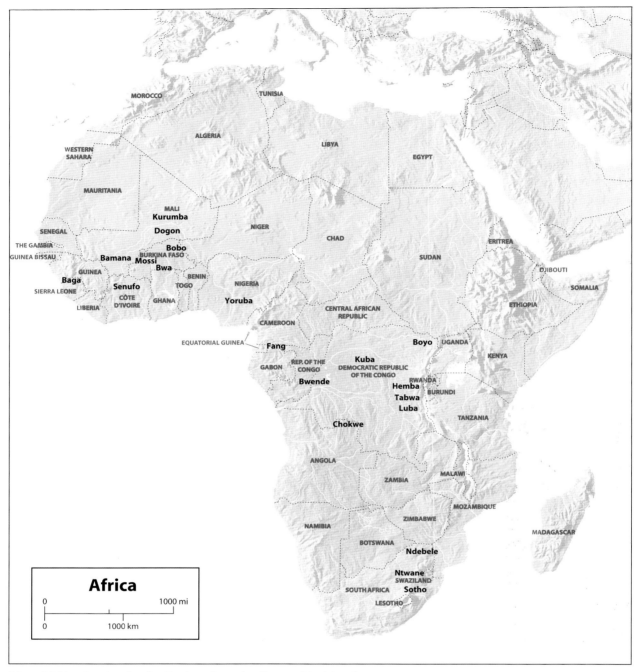

Map of Africa showing the distribution of peoples discussed in this volume

Iroquois artists have drawn upon various aspects of this account in their work. Some, such as Arnold Jacobs, Jesse Cornplanter, Ernest Smith, and Tom Dorsey, evoked the spectacle of the falling woman being assisted onto the turtle's back by waterfowl. Other artists, using more understated, graphic imagery, referenced the cosmological idea of the uprooted celestial tree unifying two superimposed realms: a sky-dome above and vegetal life springing from the terrestrial turtle below. Generations of Iroquois women working in moosehair, porcupine-quill embroidery, and beadwork have developed a series of linear motifs relating to these intertwined realms, including an abbreviated plant tendril that continues to be drawn upon by contemporary Iroquois graphic artists and sculptors.[8]

<p style="text-align:center">∗ ∗ ∗</p>

Although tens of thousands of years separate the Blombos Cave artifacts from the Egyptian pyramids, and some five thousand more follow from dynastic Egypt to our contemporary world, except for relatively recent works, little record remains of the art forms that Africa produced in those long intervening spans of time. We are obliged to deal with the tip of the proverbial iceberg, as it were, as our knowledge of the African continent is limited to several centuries of historical contact with the Western and Islamic worlds and some archaeological sites. This exhibition presents a selection of seventy-five sculptures, drawn from American collections and representing seventeen distinct African cultures, as examples of African art that make manifest the conceptions of origin, both human and cosmological, of the societies in which they were created. These sculptures—which, along with oral history, poetry, and other art forms, constitute elaborate, interwoven expressive traditions—provide insight into how Africans answered fundamental questions of origin: What is our ancestry? What is the source of agriculture, or kingship, or other social institutions?

There is, of course, the danger of oversimplifying seventy thousand years of African art history and its thousands of distinctive cultures. Therefore, this exhibition includes an analysis of how artists in a broad spectrum of African cultures have interpreted ideas of origin and sought answers to questions central to their identities. The works discussed in Part I represent a range of cultural perspectives and related local traditions. Each is an outstanding example of artistic achievement that serves as a visual document for the consideration of several aspects of the idea of "genesis": theories about the creation of humankind; the source of precepts and social values; the origins of a collective heritage and common identity; genealogies that situate individuals within an extended history of descent; and the origins of a political system. Against this backdrop, Part II considers a single, iconic genre of African

8. Parker 1912; *Iroquois Art* 1998; Phillips 1998.

sculpture—the *ci wara* headdress of the Bamana peoples of Mali—in all its nuanced complexity, particularly the diverse regional and individual interpretations that have come to characterize *ci wara* over the course of the last century.

Part I: *Icons of Origin*

In *The Religion, Spirituality, and Thought of Traditional Africa,* anthropologist Dominique Zahan suggests that the quest for an explanation of the creation of man "constitutes the supreme effort of the mind desirous of situating humankind in terms of certain coordinates—inorganic world, vegetable world, animal world, spiritual universe—and affirming thereby both his attachment to all these domains and his transcendent position relative to them."[9] Zahan observes that "the accounts transmitted by oral traditions always give a privileged position to man and, at least in part, to his destiny, both of which are never-ending sources of interest. At times he is 'made' directly by divinity, at others he 'emerges' from a reed or a tree. At still other times he rises out of the earth, or descends from the sky."[10] Jan Vansina proposes that all these types of accounts evolve through the same process of reflection, and that as a consequence a people's common understanding of "genesis" is often defined by more recent events. The level of specificity in these narratives tapers off as one moves back through time, and earlier periods become explained by authoritative tales of origin. Those responsible for preserving these accounts—in African cultures, those who retell oral histories or create works of poetry and art—thus give individual expression to their culture's most profound collective ideas about its origins and identity.

In the 1940s, the French ethnologist Marcel Griaule pioneered research on the Dogon peoples of Mali. Beginning with his landmark *Conversations with Ogotemmêli* (1948), Griaule published the most extensive existing literature on an African belief system, analyzing the worldview, cosmology, and philosophical system of the Dogon with an unprecedented sophistication and complexity. In his later works he presented additional versions of the intricate Dogon creation myth, which other scholars drew upon to interpret the imagery of Dogon sculpture.

Griaule's project—to demonstrate that African belief systems and theories of human experience parallel those of other civilizations—triggered major scholarly debate.[11] Walter van Beek contends that Griaule attributed to the Dogon a cosmology and theory of "genesis" that are unrecognizable to contemporary Dogon society and that resemble nothing else in African religions. Van Beek is also critical of the alacrity with which Griaule's interpretations have been grafted onto an understanding of Dogon material culture. In his recent monograph on contemporary Dogon society, Van Beek summarizes his assessment of Griaule's legacy: "The

9. Zahan 1970, p. 7.
10. Ibid., pp. 6–7.
11. Bedaux et al. 1991.

8

Dogon have no creation myth, no deep story relating how the world came into being. (An anthropologist some decades ago probed his informants for creation myths so insistently that the Dogon, polite as ever, obligingly produced them.)"[12] The debate rages on, but certainly other African peoples do retain a strong sense of their origin myths. Nonetheless, there is some ambivalence at this juncture in our understanding of Africa's heritage, given its fragile roots in oral tradition.

Clearly the cosmogony that Griaule developed in his writings has little relevance to the lives of contemporary Dogon in Mali. But did such a cosmology ever exist, perhaps as knowledge that was preserved orally by cultural elites and was thus vulnerable to loss? One is reminded of a saying attributed to Amadou Hampate Ba, a diplomat, historian, and writer who spent much of his life translating and transcribing African oral traditions, which laments, "When an old man dies, it's as if a library burns." Indeed, as the analysis of Bamana *ci wara* traditions reveals in Part II, even the core of a people's culture may be profoundly altered or transformed within the space of a few generations in response to rapid social change or development. Similarly, many of the works discussed in Part I are the products of belief systems and societal traditions that may either no longer exist or that have undergone fundamental changes during the colonial and postcolonial eras. For the purposes of this discussion, they are divided into three categories that broadly designate the type of "origin" narrative they exemplify: the genesis of humanity; foundations of kingdoms, and family origins.

Genesis of Humanity

The Senufo of Côte d'Ivoire and Mali commemorate divine creation with large-scale sculpted figural pairs that depict the primordial couple, the first man and woman (see cat. no. 4). Such representations give material form to an ideally balanced Senufo archetype of humanity and emphasize the important roles women play as matrices of life, as intermediaries with the supernatural world, and as founding members of extended family lineages. This concrete, somewhat literal portrayal of genesis contrasts with the more abstract modes employed by other African societies. In some cultures, for example, the artistic transformation of inert matter—clay, reeds, or grass—is a metaphor for divine creation. This conception underlies the humanism of the terracottas unearthed at the ancient Yoruba center of Ile-Ife (cat. no. 1) as well as the schematic reed, grass, and bead fertility figures from southern Africa (cat. nos. 7–9). Ephemeral physical gestures are also used to evoke the divine. Performances of Bobo sacred masks (cat. nos. 5–6), for instance, use powerful kinetic movements to make tangible the ultimate force of creation. The abstract masks themselves are exalted products of their authors' imaginations, unrelated to anything known to them through their senses.

12. Van Beek 2001, p. 103.

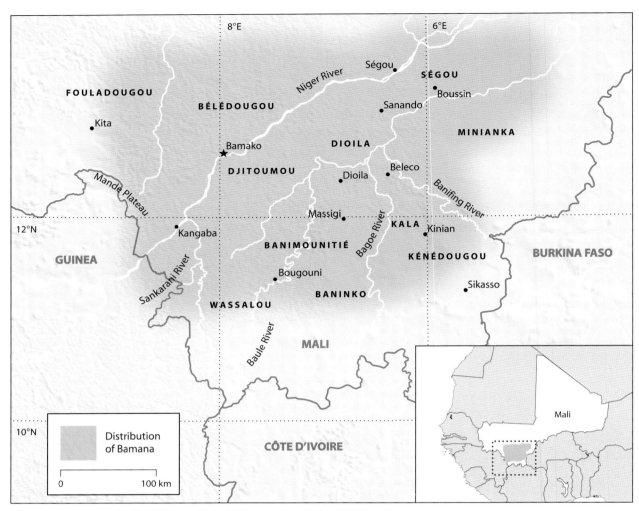

Map of southwestern Mali showing principal Bamana cities and regions

Foundations of Kingdoms

Oral narratives recalling the foundations upon which precolonial African states were built have been retold countless times and are often complemented by visual forms of expression, including sculpture. Such works help to articulate a polity's ideology and play an important role in legitimizing authority by aligning leaders metaphorically with the sources of their office, lineage, or other base of power. At the Kuba court, the king may participate in a royal masquerade performance in which a triptych of masks (see cat. nos. 10–12) acts out the Kuba myth of royal power and original sin.[13] The drama, which unfolded at the beginning of time, set Kuba history in motion and informed all subsequent political dynamics.

In Luba society, investiture rites transform a leader into a reincarnation of the first Luba king, Kalala Ilunga, who reigned during the

13. Vansina 1984, p. 113.

sixteenth and seventeenth centuries and whose enlightened political order differed radically from the primitive, despotic regime it replaced. The instigator of this cultural revolution was Kalala Ilunga's father, a hunter-hero prince from the east named Mbidi Kiluwe, who introduced sacral kingship to the Luba peoples. When power is transferred to a new Luba ruler, he receives a treasury of artifacts emblematic of this divine royal lineage. The treasury ensembles of later generations of Luba leaders, although original creations of great aesthetic power and beauty, are conceived as reproductions of Kalala Ilunga's prototypes (see cat. nos. 13–19).

Chokwe leaders, who accrued regional power and influence during the nineteenth century, adopted the Lunda hunter-prince Chibinda Ilunga, the son of Kalala Ilunga, as their role model and as a legitimizing symbol of their authority. In a remarkable tradition of royal portraiture, Chokwe leaders commissioned sculptures that conflated their identities with this larger-than-life mythical figure. These depictions (see cat. nos. 20–22) were intended to reinforce the chiefs' prestige both as temporal masters and as spiritual intermediaries.

Family Origins

Throughout Africa, extended families derive a sense of cohesion from accounts that commemorate and honor their founding ancestors. The oral histories that help preserve this precious knowledge are often accompanied by sculptural representations designed to impress both the ancestors and competing clans. Such works are the focal point of a community's spiritual life, prayers, and invocations for ancestral intervention in daily affairs. In some cultures, the origin and continued well-being of a family are linked to a nature spirit represented by a carved mask. This type of relationship accounts for a rich corpus of masquerades sponsored by Bwa, Mossi, and Kurumba families in Burkina Faso, as well as the awesome, monolithic serpent headdresses of the Baga peoples, who live in Guinea along the Atlantic coast (see cat. nos. 23–29).

In Central Africa, the importance of preserving family genealogies is reflected in a range of figurative traditions that idealize the human form according to local aesthetic conventions. Represented in this exhibition by works from the Fang, Bwende, Tabwa, Hemba, and Boyo peoples, these diverse sculptures (see cat. nos. 30–34) straddle the boundary between history and myth and serve as documents of their owners' idealized connections to the past. At one end of the spectrum are the intense miniature depictions of Bwende founding ancestors; at the other are the series of monumental Boyo ancestral figures that honor a chief's collective forebears. The core of each Boyo ensemble, usually its largest and most dominant representation, is a depiction of the founding ancestor that served as the prototype for likenesses of his successors.

The world began and so it will end with farming.

—Bamana proverb

Part II: *The Invention of Agriculture: Ci Wara's Divine Gift*

The dynamism inherent to African systems of thought, and reflected in African art, is rarely appreciated by outsiders. In fact, African art is sometimes seen as formulaic by Western observers, who have tended to privilege the static form while largely ignoring the mutability of the underlying tradition. This bias overlooks the evolutions of opinion and practice that distinguish one generation's artistic response to ideas of origin from another's. It is a tendency that is exemplified by Western perceptions of the classic Bamana antelope headdresses that are generically referred to as "*ci wara*."[14]

Ci wara headdresses are among the most widely known and admired of all African art forms. The genre originated in Mali, a region that for a millennium has been the wellspring of some of Africa's most outstanding artistic traditions. The elegant abstraction characteristic of *ci wara* is valued both in Bamana society and in the West, where it has inspired such modern artists as Constantin Brancusi, Marius de Zayas, and Fernand Léger. In this exhibition, a careful analysis of forty well-known and especially

14. There are multiple accepted spellings of this term. Pascal James Imperato, for example, uses Tyi Wara. The orthography of Bamana words in this volume generally follows current standard practice, although traditional spellings, particularly of place-names, have been retained in some instances.

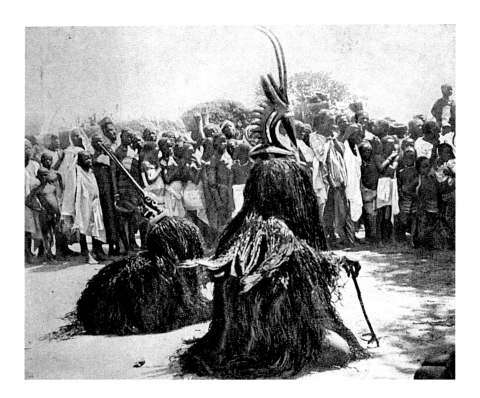

Fig. 2. *La danse sacre en l'honneur du fétiche Tji wara ou génie du travail* [The sacred dance of the *ci wara* fetish or spirit of work]. Photograph by the Reverend Père Dubernet, taken in eastern Bamana country before 1910. Published in Henry 1910, p. 144.

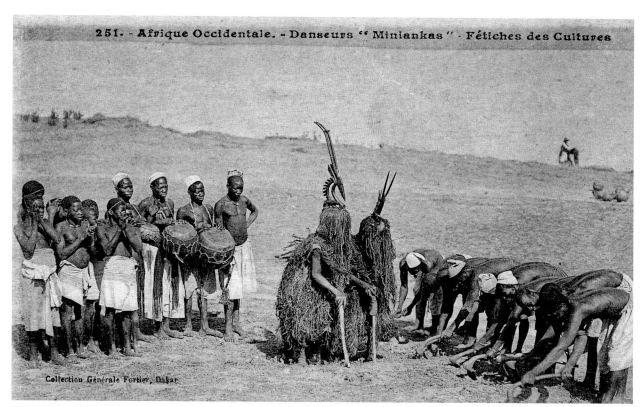

Fig. 3. Postcard of a photograph by Edmond Fortier showing Minianka *ci wara* masquerades in southern Bamana country, ca. 1905–6. The Photograph Study Collection, Department of the Arts of Africa, Oceania, and the Americas, The Metropolitan Museum of Art, New York

accomplished examples of the genre makes apparent that what in scholarly literature is generally conceived to be a monolithic tradition is in fact a heterogeneous set of regional traditions and individual interpretations that respond to an overarching cultural ideal. Moreover, the analysis demonstrates how the term *ci wara* encompasses several distinct but related performative genres that developed in response to significant changes in Bamana cultural and spiritual experience.

Among the Bamana, the invention of agriculture and the understanding of earth, animals, and plants were at one time attributed to a mythical culture hero named Ci Wara. In the nineteenth and early twentieth centuries, this knowledge was shared exclusively among members of a men's agricultural association, also called *ci wara,* that performed ceremonial dances to celebrate the skills of successful farmers as well as the benevolence of Ci Wara as the giver of agriculture. The outstanding feature of *ci wara* dances was the performance of a pair of gracefully designed, sculpted headdresses in the form of antelopes.

The Bamana belong to the Mande family of peoples, which includes the Malinke and Dyula, and are Mali's largest ethnic group, concentrated in the west central part of the country.[15] Patrick McNaughton

15. Imperato 2001, p. 1.

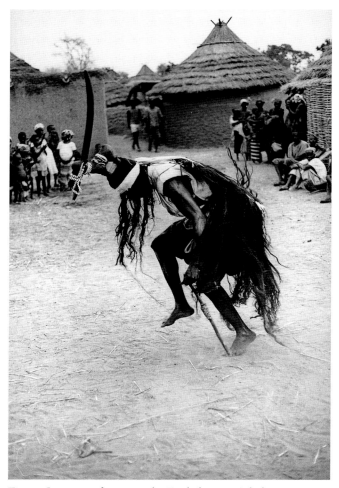

Fig. 4. *Ci wara* performer in the Fouladougou-Arbala region, Kita district, Mali, 1970. Photograph by Pascal James Imperato

notes that "until the advent of colonialism in the nineteenth century, the Mande were divided into three main social groupings: the farmers and 'nobles,' specialized professionals, and slaves."[16] He suggests that this structure was probably put in place at the time of the founding of the Mali Empire in the thirteenth century. Despite the social divisions within this tripartite social system, most of the Mande are full-time subsistence farmers.[17]

Pascal James Imperato relates that farming is not only an activity essential to Bamana survival, it is considered the noblest of vocations.[18] A Bamana proverb proclaims, "The first work of mankind is farming." Historically, the dominant farming clans forged alliances with great warriors and military strategists, resulting in dynastic regional leadership such as that of the Diarraso clan, which ruled the Bamana states of Ségou and Kaarta from the seventeenth through the nineteenth century and whose achievements are chronicled in epic poems recounting Mande history.[19] The intensity with which the Bamana identify with the farming profession is reflected in the arrangement of their communities. A traditional Bamana village is situated as the core of a series of areas designated for cultivation by extended families. During the planting and harvest seasons, the Bamana spend most of their time in these outlying "family" fields. This agricultural lifestyle inspired the development of religious beliefs and rituals celebrating the centrality of agriculture to Bamana experience.[20]

Several Bamana accounts of creation have been recorded. In one version, documented by Dominique Zahan in northern Bamana country, the Earth was initially devoid of living things. God, referred to variously as N'gala or Pemba,[21] manifested himself as a grain, also known as Pemba. This seed grew into a *balanza* tree (*Acacia albida*) that eventually withered and fell to the ground, becoming a wood beam known as Pembélé. Pambélé secreted mildew that he mixed with his saliva to create a new female being, Mouso Koroni Koundyé, who is conceived as one of a series of divine manifestations that set about creating all matter of life, from plants and animals to human beings. Her creative endeavors extend to every aspect of existence, including the fostering of ideas that develop along with human consciousness. The union of Mouso Koroni

16. McNaughton 1988, p. 1.
17. Ibid., p. 2.
18. Imperato 1970, p. 8.
19. McNaughton 1988, p. 2.
20. Imperato 1970, p. 8.
21. Zahan cited in Imperato 2001, p. 14.

with a cobra yields Ci Wara—a divine being, half mortal and half animal—who introduces agriculture to humanity by teaching the Bamana how to cultivate the land. According to myth, Ci Wara tilled the earth with his claws and a stick of the *sunsun* tree (*Diospyros mespiliformis*), transforming weeds into corn and millet.[22] Under his tutelage mortals developed into able and prosperous farmers. But humans gradually became careless and wasteful, and Ci Wara, disappointed, is said to have buried himself in the earth. To honor his memory and lament his departure, men created a power object, *boli,* in which his spirit could reside, and carved headdresses to represent him.

The earliest Western reference to Ci Wara, translated literally as "farming animal," is in the book *Haut-Sénégal-Niger* (1912) by Maurice Delafosse, who defines "Tyi Ouara" as the Bamana god of agriculture and the focus of an eponymous, nonsecret association.[23] The name was also assigned to outstanding farmers as a token of praise.[24] The *ci wara* association was one of a series of religious, political, judicial, and philosophical fraternities, known collectively as *dyow,*[25] that in the last century constituted one of the cornerstones of Bamana society. *Dyow* (singular *dyo*) were concerned with the maintenance of social, spiritual, and economic harmony and provided the structure within which individuals could seek to attain knowledge about the world as imparted by elders in religious and secular leadership positions.[26] Six successive *dyo* levels—*n'domo, komo, nama, kono, ci wara,* and *kore*—afforded a progressively more complex understanding of the Bamana worldview and of humankind's position within the universe. Entry into each level was governed by an established set of prerequisites and rules and required mastery of a discrete body of information not accessible to outsiders.

As an agrarian society, the Bamana were keen observers of the elements of the cosmos, such as Earth, the sky, the Sun, stars, the Moon, fauna, flora, and seasons.[27] The tenets of the *ci wara dyo* emphasized connections with nature and inculcated agriculture as men's primary role in life. At the time of Zahan's fieldwork, between 1948 and 1958, the established *dyo* initiation sequence was no longer being followed,

22. Imperato 1970, p. 8.
23. Ibid.
24. McNaughton 1988, p. 39; Imperato 1970, p. 8.
25. Imperato 2001, p. 10.
26. Zahan 1970, p. 134.
27. Ibid., p. 71.

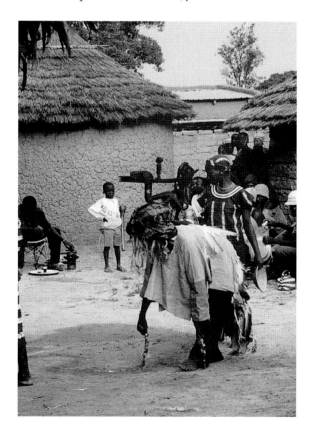

Fig. 5. Male *ci wara* performer followed by a young girl attendant (*ci wara musoni*), Mande Plateau, Mali, October 1993. Photograph by Stephen Wooten. The dancer, holding his *sunsun* sticks to the ground, adopts the characteristic "four-legged" posture as he makes his way around the performance space.

and men were progressing directly into *ci wara* soon after entry into *komo*.[28] Imperato points out that in recent times the *ci wara dyo* has not existed in every Bamana village. He adds that where it did exist *ci wara* was the least secretive of all the *dyow* and its dances were performed in the presence of noninitiates, including women and children.[29] By 1970, Imperato observed, *dyow* were slowly disintegrating and in most villages no longer existed as described by Zahan.[30] As a result, the metaphysical and religious ideas they once promulgated were fading. Their decline has been attributed to a number of factors, including the spread of Islam,[31] the shift to a cash economy, and the many significant social developments that followed colonial rule, such as migrant labor and urbanization.

In contrast to the *dyow*, which imparted esoteric and ritual knowledge to its adult initiates, a community's circumcised youth were grouped together in secular associations known as *ton*.[32] The *ton* were a collective source of labor and entertainment. Male members farmed the fields of families who lacked the necessary manpower to do so or who had insufficient resources. The *ton* was compensated for its efforts through payments of cash, food, or livestock, which were used to sponsor communal celebrations. In some communities, charitable work was also performed by men's voluntary associations known as *gonzon*.[33] Because of their involvement with agricultural projects, *ton* and *gonzon*, taking their inspiration from the *ci wara* association, commissioned headdresses that they performed in their theatrical dances. Without contextual documentation, it is often difficult to distinguish which of these three entities—*ci wara, ton,* or *gonzon*—originally performed a particular headdress.

28. Imperato 1970, p. 11.
29. Ibid., p. 13.
30. Ibid.
31. Imperato emphasizes that as a result of the Muslim Tukulor Empire's domination of the Kingdom of Ségou during the second half of the nineteenth century, the region affected by change the earliest and most profoundly was Ségou. Ibid., pp. 72–73.
32. Ibid., pp. 8–11.
33. Ibid., p. 72.

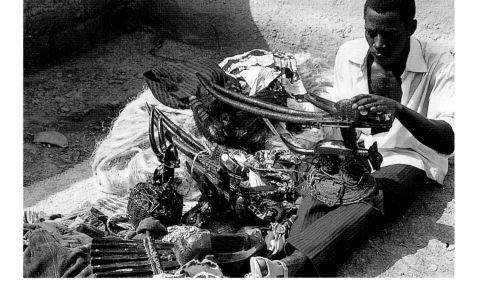

Fig. 6. *N'gonzon koun* headdress being rubbed with shea butter prior to a *ton* performance, Djitoumou region, Bamako district, Mali, 1969. Photograph by Pascal James Imperato

Bamana headdresses are zoomorphic in form and are carved in wood in male and female pairs, each attached to a basketry cap that is worn on a dancer's head. The fine linear designs of the sculptural elements are silhouette-like, with positive and negative spaces juxtaposed so that they resemble intricate cutouts. The headdress is inspired mostly by the roan antelope, but distinctive features of other creatures symbolic to the Bamana, including the aardvark and pangolin, are sometimes fused together in one piece. While drawing upon established regional formal conventions, the Bamana sculptor also deploys his own imagination to endow each headdress with unique qualities. There are two widely recognized approaches to the overall structure of these works, one from the eastern Bamana territory and one from the west. The eastern variety is relatively long and attenuated, with vertically oriented horns that are said to be inspired by those of the roan antelope, known as *dage*. This type also has a tapered face derived from that of the anteater, or *n'gonzonkassan*. The western format displays the body and horns of the roan antelope but is more horizontal, with a head and mouth reminiscent of the hornbill (*dyougo*).

The poetic eloquence and seemingly infinite variety of the *ci wara* headdress is described by Dominique Zahan in *Antilopes du soleil* (1980), his celebrated monograph that includes more than five hundred examples of the genre. Zahan discusses the iconography of *ci wara* as well as its significance in Bamana myth and spirituality, relation to agricultural practices, and role in the initiation association. Zahan's exhaustive study has several limitations, however: he does not address regional stylistic differences among headdresses or the fact that over time distinct but related sculptural genres came either to coexist with or replace *ci wara*.

Pascal James Imperato's empirical documentation explores a tradition that he sees as continually evolving in response to changes in Bamana society. Imperato observes that "like all other dances of the Bamana, that of [*ci wara*] was never static . . . the development and change took place somewhat independently in each region and indeed in each village, finally leading to local differences which . . . one finds considerable."[34] By the time of the earliest documented *ci wara* performances, the dance, although it still had a ritual dimension, was no longer exclusively performed in the company of *dyo* members. As the influence of the *dyow* waned and that of Islam increased, some of the ritual dances and masks once associated with the initiation societies, including *ci wara,* gradually passed over to the secular *ton.* In that context their religious

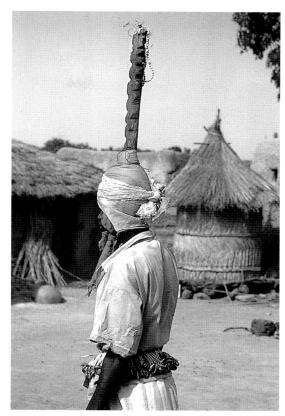

Fig. 7. *Nama tyétyé* performer in the Djitoumou region, Bamako district, Mali, 1970. Photograph by Pascal James Imperato

34. Ibid., p. 13.

17

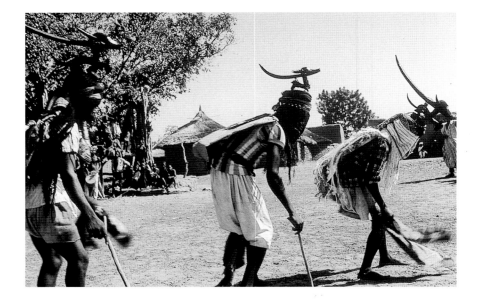

Fig. 8. *Ci wara* performers with horizontal headdresses, Sirakoro, Mali, June 1970. Photograph by Eliot Elisofon. Courtesy Eliot Elisofon Photographic Archives, National Museum of African Art, Smithsonian Institution, Washington, D.C.

content was deemphasized, and their performances instead encouraged the *ton*'s younger members to be good farmers and to serve as popular entertainers.

A *ton* collectively owned a diverse series of zoomorphic masks whose performances were vehicles for social criticism, often parodying human behavior and imparting moral lessons.[35] Different age groups within the *ton* danced particular mask forms; as members advanced to more senior levels, they danced masks with increasingly elaborate costumes and more demanding choreography.[36] The *kono* mask, for example, represents the hornbill, a bird whose shrewdness and intelligence are hidden beneath a clumsy exterior, and it was generally performed by older *ton* members. Occasionally, when its members were engaged in communal farming, *ton* would also sponsor *ci wara* performances in the fields.[37] These versions of *ci wara* sometimes featured an interlude in which a hyena masquerade, referred to as *nama tyétyé,* entered the arena, diverting the audience with its speed and acrobatic movements. All the masks belonging to a *ton* were danced at its annual weeklong festival held just before seasonal rains.[38] The timing of these festivals changed, however, as the relevance of the *ton,* like *ci wara,* diminished in certain regions, and as young men migrated to cash labor markets. In some communities the *ton* festivals were abandoned entirely.

The *ton*'s appropriation of the *ci wara* headdress is one example of how *ci wara* came to be integrated into other distinct performative traditions. Part II of this exhibition examines several of the individual, regional, and historical influences that informed the different contexts in which "*ci wara*" headdresses appeared. Works that have previously been identified as

35. Imperato 1980, p. 47.
36. Imperato 1975, p. 47.
37. Imperato 1980, p. 52.
38. Imperato 1970, p. 76.

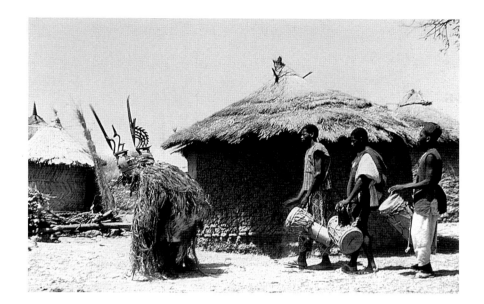

Fig. 9. *Ci wara* performers with vertical headdresses, near Bamako, Mali, April 1971. Photograph by Eliot Elisofon. Courtesy Eliot Elisofon Photographic Archives, National Museum of African Art, Smithsonian Institution, Washington, D.C.

examples of the *ci wara* genre are identified and discussed as representatives of discrete subgenres, including *sogoni koun* (cat. nos. 49–63), *n'gonzon koun* (cat. nos. 64–73), and *nama tyétyé* (cat. nos. 74–75).

Because every *ci wara* performance is essentially a unique event, no single description of a particular dance can provide a comprehensive understanding of an entire tradition. Our knowledge of Bamana headdress performances is further limited by the small number of published accounts and the relatively brief descriptions therein. Of these, one of the most informative is Imperato's overview, based on the recollections of regional elders, of an unfolding *dyo ci wara* performance.[39] The *ci wara* headdresses, he relates, were kept in the same enclosure that held the *boli* (the power object in which the spirit of the deity Ci Wara resided). The spiritual power of the *boli* differed from village to village; those with the most powerful and prestigious reputations were usually associated with communities that had reaped the greatest agricultural success and sponsored the most skillful performances.[40] Dances were generally organized during the latter part of April or May, before the beginning of the rains, as well as during the rainy season and into October, before the harvest.[41] Each spring, sacrificial libations were applied to the *boli* when the headdresses were removed from the enclosure for performances.

On the day of the dance, the *dyo*'s leaders carried the *ci wara* headdresses out to the field that was to be tilled. The head of the *dyo* buried a fragment of the *boli* along the path of the procession. The *dyo* members, including two individuals who had been selected to dance, then concealed themselves at the edge of the field. The *dyo* leader oversaw the dressing of the dancers. Before the tilling began, women arrived and men

39. Ibid., pp. 75–76.
40. Ibid., p. 13.
41. Ibid., p. 74.

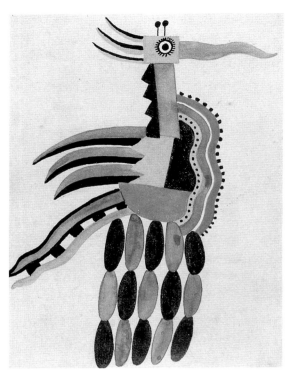

Fig. 10. Fernand Léger (French, 1881–1955). *Bird,* 1923. Costume design for the ballet *La Création du Monde.* Watercolor, 13⅜ x 9 in. (34 x 22.9 cm). Dansmuseet, Stockholm

emerged from the village with an ensemble of drums and bells. Songs were intoned to encourage those toiling in the fields under the unrelenting Sahelian heat. The lyrics of the performances celebrated farming as man's most important achievement and as the activity that allies him with the forces of the cosmos.[42] In the midst of the tilling and singing, the performer wearing the male headdress emerged from the bush, followed by his female companion. They leaned forward on *sunsun* sticks—like those used by Ci Wara in the Bamana creation myth—and slowly approached the farmers. A piece of the *boli* was attached to the male's right *sunsun* stick. Their arrival was acknowledged with songs addressed to Ci Wara, personified by the male dancer, whom the women lyrically praised as the most powerful being on Earth. The songs also celebrated the farming skills he had imparted to their ancestors. To this accompaniment the male dancer enacted extraordinary physical feats, such as thrusting a knife into his thigh without its penetrating the skin and placing a piece of hot metal in his mouth without being burned.

The oldest known visual documentation of *ci wara* performances date from the first quarter of the twentieth century.[43] The Reverend Père Dubernet took what Christraud Geary believes are the two earliest photographs of an authentic performance, published as sequential images in Joseph Henry's 1910 monograph on the Bamana (fig. 2).[44] They show male and female *ci wara* performers from eastern Bamana territory as they leave the fields, surrounded by men, women, and children, and enter a village, where they dance. Also from this period is a widely disseminated postcard made from a photograph taken by Edmond Fortier in the southern Bamana country (fig. 3). Fortier, a photographer and postcard publisher based in Dakar between 1900 and 1928, staged this scene, in which a pair of Minianka dancers wearing vertical *ci wara* headdresses are positioned in a field. The dancers are bent slightly forward over their *sunsun* sticks; musicians and a female chorus appear at left, while at right a row of men till the soil with hoes.

Eliot Elisofon, a celebrated American photographer and African art enthusiast, took tens of thousands of images of African art and culture from the late 1940s to the early 1970s. Drawn to *ci wara* because of its celebrity as African art's most familiar visual icon, he captured several *ci wara* performances on film (figs. 8–9).[45] Elisofon's photographs, as Geary points out, profoundly informed twentieth-century Western attitudes and perceptions of Africa.[46] In his quest for pictorial drama, however,

42. Ibid., p. 72.
43. Geary 1995, pp. 116–17.
44. Henry 1910, pp. 143–44.
45. Geary 1995, pp. 104–13.
46. Ibid., p. 104.
47. Ibid., p. 116.
48. Rosenstock 1984.
49. Ibid., pp. 480–82.

Elisofon manipulated or subverted reality. To capture the elegant forms of the vertical-style headdresses associated with the eastern Bamana country, which by that time were performed infrequently in only a few villages, Elisofon staged reenactments. On one occasion, as described by Imperato and Geary, he removed any trappings of modernity before taking his photographs, and on another he ignored significant local differences in interpretations of the form by insisting on photographing vertical headdresses in a western Bamana village, where they had never been performed.[47]

Elisofon's preconceptions of Africa's "exoticism" were shaped by long-standing Western attitudes. African art was a source of fascination to artists in Paris as early as 1906. After World War I, the appeal of what was then generically referred to as *art nègre* extended to a broader cultural milieu.[48] This enthusiasm has been attributed in part to a desire to revitalize Western society and to reinvigorate its artistic traditions by drawing on fresh sources of inspiration. Among the many works that gave expression to those ideals was the ballet *La Création du Monde,* an innovative, collaborative venture by several avant-garde European artists that was performed by the Ballets Suédois in 1923.[49] The ballet, whose scenario of primeval creation was the conception of the Swiss writer Blaise Cendrars, was inspired by traditional African mythologies and ideas of cosmological origins. In 1921 Cendrars had published *Anthologie nègre,* a celebration of the rich humanism and poetry of African creation myths and oral literature, which he mined for subject matter. The ballet includes three great creation deities who oversee the emergence of living beings from an undefined mass, beginning with animals, insects, birds, and, finally, humankind. Jean Börlin, the Ballet Suédois's lead dancer and choreographer, researched African dance as source material for his choreography, and Fernand Léger, one of the most prominent artists in Paris during the first half of the twentieth century, designed the elaborate sets and costumes. Léger prepared his visual accents and backdrop by carefully studying and copying reproductions of African sculpture, including a Bamana *ci wara* headdress. His pencil study of the headdress became

Fig. 11. Paul Ahyi (Togolese, b. 1930). *Adoratrice,* 1981. Monotype, 66½ x 17½ in. (168.9 x 44.5 cm). Collection of A. Vitacolonna

Fig. 12. Blacksmith (*nyamakala*) carving a *ci wara* headdress, Mande Plateau, Mali, June 1998. Photograph by Stephen Wooten

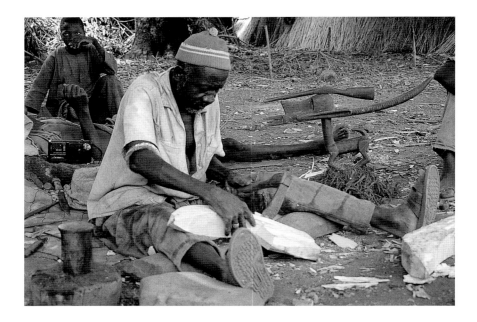

the point of departure for one of the ballet's protagonists, whom Léger transformed into a vibrant, birdlike creature (fig. 10).[50]

In the second half of the twentieth century, a generation of African artists was for the first time exposed to formal Western training in European art schools. There they mastered technical processes that afforded them new means of expression for both their personal experiences as well as the traditions associated with their African heritage. Paul Ahyi is a Togolese artist who received his degree from the École Nationale Supérieure des Beaux-Arts, Paris, in 1959. His distinguished career as an artist and teacher working in a variety of media, including sculpture, painting, ceramics, and tapestry design, has garnered him numerous awards in France and in Africa. In his monotype *Adoratrice,* or "worshiper," of 1981 (fig. 11), Ahyi pays tribute to the powerful and monumental idea of the *ci wara* by conflating the notion of it as a venerable sculptural tradition with his response to it as a contemporary African artist. Ahyi, like a Bamana viewer, is moved by the spiritual essence of the *ci wara* and a sense of the creative force behind the sculpture. In his interpretation, he translates the sculpted object into a two-dimensional medium and thus plays on its flatness and abstraction by designing a work in which the iconic configuration has been impressed onto a fiber surface. Ahyi emphasizes the antelope's verticality by fitting it into an especially narrow, elongated format. His block strokes, rolled onto the surface to re-create the *ci wara*'s architectural structure, are at once concrete and impressionistic. The image evokes the essence of the *ci wara,* while Ahyi's artistic approach—to create a work of elegance, strength, and beauty through an assemblage

50. Ibid., p. 480.

of features—harmonizes conceptually with the artistic process used by Bamana sculptors.

Ahyi is one of many contemporary African artists who have drawn upon seminal forms like the Bamana *ci wara* that evoke the Western ideal of African culture and that transcend ethnic boundaries because of their iconic stature. In doing so, these artists make reference, in ways not dissimilar to their Western counterparts, to a collective African past. As artists at a crossroads between two artistic traditions, however, their point of reference is unique. Some see themselves as responsible for imbuing traditional forms of African expression with new life. Ahyi speaks to this point: "The modern Africa should be the continuation of the ancient Africa without there being a disjunction, rupture, or relinquishing of values that belong to us. It is according to this concept that I embark upon my artistic research and hope that the aesthetic or the message that follows can contribute in some way to the development of modern African culture."[51]

The continuity that Ahyi speaks of is also evident in contemporary Mali, where spiritual and secular genres of *ci wara* continue to coexist. A series of recent performances documented by Stephen Wooten in agrarian communities in the Mande Plateau, about thirty kilometers from Bamako, supports this contention (fig. 12).[52] In his account of these performances, which he witnessed in 1993 and 1994, Wooten observes three distinct contextual variations: performances that the Bamana considered to have "underlying force," or references to religious practices; performances known as *cekorobawfenw,* or "old men's things"; and performances referred to as *tulonkefenw,* or "playthings," which were theatrical pieces used to amuse children.[53] Wooten concludes that the *ci wara* tradition remains vital and evolving, with ongoing relevance to contemporary Bamana experience: "Whether or not the actors or observers involved in the cases I have presented know the agricultural origin myth, make explicit connections to the mythic inventor of this way of life when they perform, or participate in a *ciwarajo,* their links to an agricultural way of life are affirmed and strengthened in the activities involving [*ci wara*]. Farming is at the core of their identity."[54]

On the broader stage of contemporary Malian society, the *ci wara* headdress has become a powerful symbol not only of Bamana cultural identity but also of the nation as a whole. This was made apparent most recently by the adoption of the profile of a *ci wara* headdress as the logo for Mali's official airline. Among urban intellectuals in Bamako, the image is no longer associated with mythic origins of agriculture; rather, it is emblematic of the achievement of excellence in any given domain. One proposal for an essential meaning of the term *ci wara,* as it is generally understood today, is *lion de travail,* suggesting a powerful and insatiable motivation to work extraordinarily hard and a formidable ambition to succeed.

"Genesis: Ideas of Origin in African Sculpture" seeks to shed light on the act of human creation as a broad and recurrent theme of African art.

51. "Paul Ahyi ou un artiste africain entre tradition et modernité," afrocom.org/ahyi/ ahyil.htm and ahyi2.htm [website], January 2002.
52. Wooten 2000.
53. Ibid., p. 21.
54. Ibid., p. 31.

Within this context, the Bamana *ci wara* headdress, along with the other examples of similarly inspired works from sub-Saharan cultures discussed here, become metaphors for explaining how the concept of "origins"— where humanity comes from, how kingdoms arose, where societal patterns or families began—has been articulated in African sculpture. Although the works examined relate to a panoply of social perspectives and traditions, they all reflect a desire to give tangible form to the abstract forces that shaped the course of human experience. They are also points of reference that allow individuals to conceive of their place within an expansive history. The artists who created these works, each responding to their society's most exalted challenge, thus provide us with unique insights into their distinctive worldviews.

CATALOGUE

PART I
ICONS OF ORIGIN

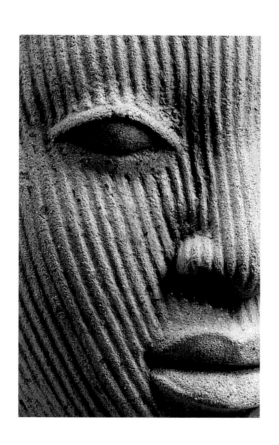

GENESIS OF HUMANITY

YORUBA

1. Head

Yoruba peoples; Ile-Ife, Nigeria
12th–14th century
Terracotta, mica, quartz, and pigment; H. 8¾ in. (22.2 cm)
Private collection

According to Yoruba conceptions, the city of Ile-Ife in present-day Nigeria is the cradle of all human existence and social institutions. This sacred center, which figures so prominently in the Yoruba's oral histories and spiritual imagination, is also the focus of one of Africa's most distinguished artistic traditions, one that flourishes to this day. The Reverend Samuel Johnson, a twentieth-century chronicler of Yoruba history, notes, "[A]ll the various tribes of the Yoruba nation trace their origin from Oduduwa and the city Ile-Ife. In fact Ile-Ife is fabled as the spot where God created man, white and black, from whence they dispersed all over the earth."[1]

The various versions of Yoruba origins recounted by priests, family heads, and literate elders all begin with Olodumare, the creator of existence, instructing another deity that life and civilization be established at Ile-Ife. Some accounts identify this deity as Obatala, the divine artist who modeled humans from clay, but other versions emphasize the fact that Obatala, who began to create deformed humans after he drank palm wine, was replaced by Oduduwa. Oduduwa then descended on an iron chain to a world covered with water, carrying with him a gourd or snail shell containing earth, a cockerel, and a chameleon. He dispersed the earth onto the surface of this watery realm, and the cockerel distributed it to create land. Other deities eventually arrived at this site, which became Ile-Ife, where they established society and whence they spread out to found many other kingdoms.[2] Among the enduring legacies of these origin myths is the fact that most contemporary Yoruba leaders trace their descent from Oduduwa and consider him to be the founder of sacred kingship. Others give preeminence to Obatala as the original creator and the ultimate divine authority.[3]

Archaeological evidence suggests that Ile-Ife was occupied as early as 350 B.C. and that it became a major urban center—with walls, a network of shrines, building complexes, streets, courtyards, and domestic and communal altars—between A.D. 500 and 900.[4] Among the tangible traces of the Yoruba past uncovered at Ile-Ife are works in terracotta, stone, and copper, as well as brass works produced through lost-wax casting. Such artifacts were found at sites throughout Ile-Ife, many concentrated near walls delimiting the ancient city, gateways, and forest sanctuaries.[5] The terracottas are by far the most numerous and diverse corpus of these objects,[6] ranging from almost lifesize figures to very small figurines, freestanding heads, animals, and figurated vessels. Many reflect an idealized, naturalistic humanism, but there are also examples of fantastical beings and severely abstracted forms.

It has been suggested that the high level of artistic talent and the rich range of imagery evidenced in the terracottas reflect a well-established sculptural tradition that might have begun about A.D. 800. These skillfully made, creatively diverse works in fired clay are also seen as potential sources or prototypes for creations in other media.[7] The use of clay to give shape to the human form resonates profoundly with Obatala's role as the divine artist in the Yoruba account of human origins. Interestingly, in contemporary Yoruba society women, not men, work clay for both sacred and secular purposes. It is possible, then, that women were the authors of these early creations.[8]

This work, like many other comparable examples, was designed as a freestanding head. Ife terracottas in this idealized style have been dated to between the eleventh and twelfth century. Here the neck is strong and broad with bold horizontal creases. The surface of the face below the hairline is covered with dense incised striations against which the fine facial features project dramatically. The head reflects a classic treatment of Ife sculpture in which stylized features— eyes, hairline, lips, and neck creases—complement the heightened realism of the carefully modeled flesh and cartilage of the facial structure.[9]

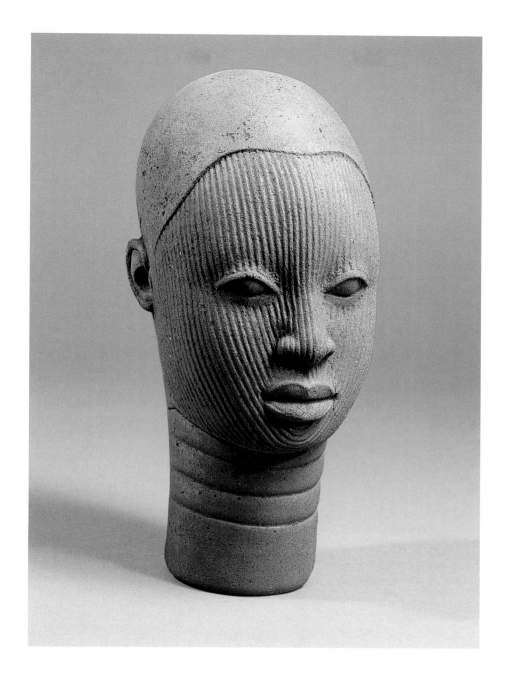

The profoundly sensitive humanism of this representation suggests a tradition of portraiture. Isolation of the head as the focus of artistic exploration also relates to Yoruba cultural ideas concerning individual being, in which the head is conceived as both the locus and wellspring of a person's essential nature and life force. Ideally, an individual's physical appearance is informed by a self-control and patience that emanate from within. The tranquil dignity portrayed in ancient Ife terracottas gives expression to those noble qualities of character.[10]

Notes

1. Johnson 1921, p. 15.
2. Drewal and Pemberton 1989, p. 45.
3. Ibid.
4. Ibid., p. 47.
5. Ibid., p. 49.
6. Willett 1967, p. 57.
7. Drewal and Pemberton 1989, p. 49.
8. Ibid., p. 63.
9. Ibid.
10. Ibid., p. 26.

2. Granary Door Lock

Dogon peoples; Mali
19th century
Wood, organic matter, and resin; H. 8 in. (20.3 cm)
Private collection

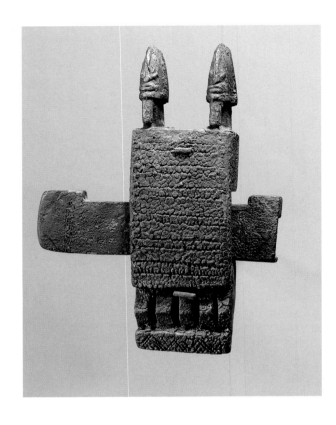

In 1931 a team of French researchers led by Marcel Griaule arrived in the village of Sanga, in present-day Mali, to undertake a study of Dogon culture. Griaule's investigations sought to expose the inner workings of Dogon thought and religious belief about the world and its origins. In the process he became aware of a vast corpus of myths that described "a complex cosmogony, an epic struggle between order and disorder, and the place of humanity within the universe."[1]

According to the Dogon mythological system described by Griaule and other members of his team, the divine power of Amma created the first living being, called Nommo, who multiplied to become four pairs of twins. One of these Nommo twins rebelled against the order set in place by Amma. In response, Amma, seeking to purify the universe and restore order, sacrificed one of the other Nommos. This Nommo's body was cut up and scattered throughout the universe, and from these parts Amma created eight ancestors of humanity: four males—Amma Serou, Lebou Serou, Binou Serou, Dyongou Serou—and their four female twins. In the final phase of genesis, these eight ancestors, together with another Nommo and everything needed for human life, were placed in an ark and sent to Earth.[2] Griaule and his colleagues based their investigations on the premise that "the everyday object may reveal in its form or decoration a conscious reflection of this complex cosmogony."[3] In their writings, they applied the Dogon ontological framework to all manner of artifacts, from household objects, such as this granary lock, to figurative sculptures placed on altars.

The Dogon are remarkably resourceful farmers who cultivate a harsh and demanding rocky landscape. They store and preserve the fruits of their labors—crops of millet, sorghum, corn, fonio, beans, and rice—in narrow, rectangular mud granaries with thatched dome roofs. Every family has several of these structures, one for each wife and the rest for the family head. As a repository for essential sustenance, the granary has been associated with the celestial ark sent to Earth by Amma;[4] the small wood bolt and key that opens the granary has been described as a metaphor for the work of Amma in opening the celestial realm and allowing his creations to reach Earth. The realistic representations of human, animal, and vegetal forms that surmount Dogon granary locks have also been correlated with protagonists from the creation myth. These forms, often paired figures, have variously been identified as Nommo pairs, lineage ancestors, or the twin children revered and desired by all Dogon women.[5]

In this example, two parallel human heads extend from the top of the rectangular lock; their narrow rectilinear legs hang down from the base. The entire surface of the lock is obscured by a thick layer of encrusted sacrificial matter: ritual libations—such as millet porridge, the blood of sacrificed chickens, sheep, and goats, or mixtures of various fruits and plant juices with millet flour—that are applied as vehicles for *nyama,* the vital force found in all living things. When an offering is made, the libation strengthens the *nyama* of both the spiritual entity to whom the offering is directed and the person who performs the sacrifice. The layer of

matter that remains on the surface is intended to vitalize the lock and is associated with a state of purification.[6]

Notes

1. Ezra 1988, pp. 15–16.
2. Ibid., p. 20.
3. Griaule 1965, p. xiv.
4. Dieterlen 1970.
5. Ibid.
6. Ezra 1988, p. 48.

Ex coll.

Max Granick, New York

3. Harp-Lute Player

Dogon peoples; Mali
16th–19th century
Wood; approx. H. 28 in. (71.1 cm)
Collection of Drs. Daniel and
Marian Malcolm

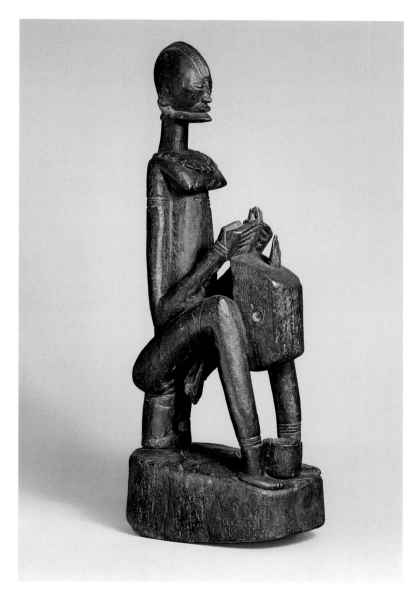

Dogon myths concerning the origins of human mortality recount how Lebe, the first ancestor to die, was exhumed by his descendants, who had decided to move and who wanted to take his remains with them. When they dug him up, however, they found in his place a living snake. The earth from this first burial site was then carried away and added to a sacred altar that they established in Lebe's memory in each new place they settled.[1] The high priests of Lebe, known as Hogon, are the supreme religious and political leaders in every region in Dogon country.[2] The cult of Lebe is responsible primarily for the renewal of the earth and agricultural concerns.

In Dogon spiritual life, ancestors serve as intermediaries between the living and the ultimate forces of the universe. Figurative sculptures portraying a range of male and female subjects are placed on many types of Dogon ancestral altars. According to Marcel Griaule, a myth about the origins of this practice relates how at the time of Lebe's death a wood figure depicting him was created to provide a support for his soul and vital force.[3] Few such altars have been documented in detail, however, and there is little information with which to identify the subjects of surviving sculptures that were torn from those contexts.

This imposing seated figure, who may be a Hogon, is playing a musical instrument known as a *koro* or *gigru,* a form of four-string harp-lute.[4] He holds the oblong cylindrical resonator in his lap, with the bridge

facing out toward the audience. The figure supports the instrument with both hands and plays it with his thumbs. The harp-lute is the preferred instrument of Dogon diviners and healers. A diviner's harp-lute is his own creation and a sacred object to which his powers of perception are ascribed.[5] It is played during divination sessions to determine the cause of a disruption and to restore order, and it accompanies rites of fertility, purification, and quests to recover stolen or missing objects. According to Dominique Zahan, whatever the context for the harp-lute's intervention, the diviner must from the outset conceptually situate himself and the instrument at the center of the universe. Through this positioning, the diviner indicates that all individual or social disruptions of order reverberate in creation and that a restoration must be effected at a cosmic level.[6]

Marcel Griaule and Germaine Dieterlen trace the harp-lute back to the Dogon creation myth, in which it is one of the scattered bits of the sacrificed Nommo.[7] According to their writings and those of Zahan, the Dogon may conceive of the harp-lute as a microcosm of the world and its component parts as metaphorical elements (i.e., the hide that covers the resonator as the surface of the world, and the zigzag arrangement of the strings as the helical path of the Sun around Earth).[8] At this metaphysical level, the harp-lute player is thus described as the embodiment of the spirit of intelligence and as a divine being who creates the world in subordination to Amma, the supreme being.[9]

Zahan suggests that the playing of the harp-lute is a sort of "sonorous synthesis of all the elements of creation dispersed in time and space."[10] Its music is said to have the power to move the human spirit on a creative and divine level. Throughout the Western Sudan, music is an essential part of devotion and prayer as well as the predominant means to recount and preserve a peoples' history and origins. The individual immortalized through this sculpture may thus be seen as a bard who sang the tale of his peoples' origins.

Notes

1. Ezra 1988, p. 18.
2. Ibid., p. 19.
3. Ibid., p. 21.
4. Zahan 1950, p. 193.
5. Ibid., pp. 4, 195.
6. Ibid., p. 197.
7. Griaule and Dieterlen 1950.
8. Zahan 1950, p. 198.
9. Ibid., p. 203.
10. Ibid., p. 205.

Ex coll.

Jay C. Leff, Uniontown, Pennsylvania

Published

Leff 1960, p. 9, fig. 19; Leff 1964, fig. 8; Leff 1970, fig. 16; Klobe 1977, p. 35, fig. 3.

SENUFO

4. Primordial Couple

Senufo peoples; Côte d'Ivoire or Mali
19th–20th century
Wood and pigment; male H. 45⅝ in. (115.9 cm),
female H. 38⅛ in. (96.8 cm)
Collection of Frieda and Milton F. Rosenthal

According to the Senufo account of genesis, Kolotyolo, the creator, gave life to the first man and woman, who became the first human couple.[1] The woman conceived and gave birth to twins, a girl and a boy. In Senufo society twins are thus thought to have supernatural power that they may exert to positive or negative effect. In order for them to fulfill their potential

to be a force for good, twins must be male and female, the ideal gender balance of the creation myth.[2] Senufo large-scale sculptural pairs commemorate the primordial couple of the myth and celebrate their enduring beauty and idealized complementariness.

Both figures in this pair have rectilinear contours with broad vertical torsos framed by strong, straight shoulders. The female's torso, with the exception of the conical breasts, is almost identical to that of her male companion. Negative space separates each torso from the arms, which extend fluidly from the shoulders, narrow in the area of the upper arm, broaden at the forearm, and terminate in blocky hands resting on the stomach. The strong slender legs are apart, bent slightly at the knee, and the calves are embedded in a truncated base. The

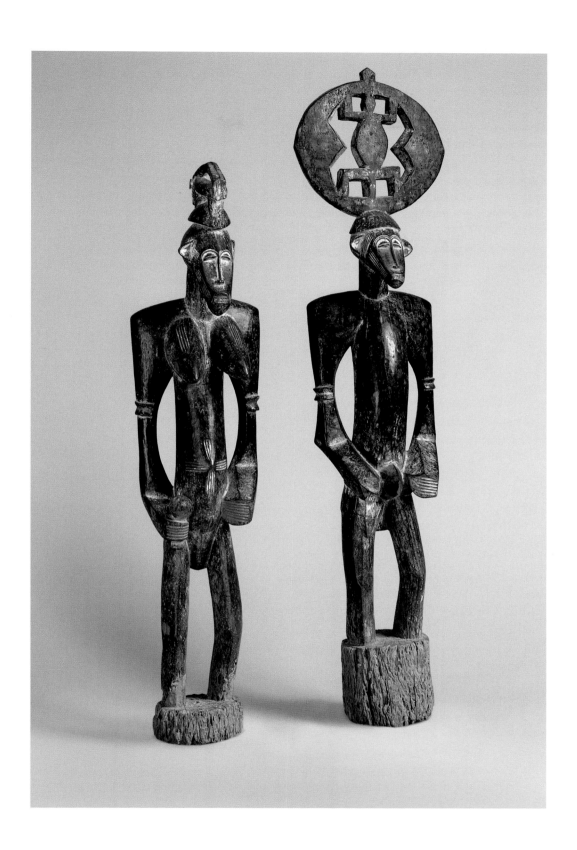

faces of the figures are only slightly differentiated; both feature a nose with a long narrow ridge and delicate nostrils, and both have their eyes closed in meditative expressions. At the crown of the male figure's head is a circular element with a lizard design carved out and accented by negative space. The female figure's neck has more of a forward thrust, and her head is surmounted by a sagittally oriented crest with a double-headed animal. There are traces of pigment across the surfaces of both figures, including a reddish patination and white kaolin.

The ideal of human male-female duality represented in this work also informs Senufo conceptions of the divine, especially the bipartite deity that is central to Senufo religious belief. Kolotyolo, the male aspect of divinity responsible for creation and "bringing us forth," is a benevolent but relatively remote presence who is balanced by a more accessible female dimension known as Katyeleeo, or Ancient Mother.[3] She is a divine protectress responsive to the needs of the community. Within Senufo society, an optimal relationship with this divinity and the ancestors is assured through Poro, an initiation-based organization whose teachings also prepare members for responsible and enlightened leadership.[4] Participation in Poro is universal among Senufo males, who safeguard their community's social and political welfare by making frequent sacrifices to the ancestors—conceived as past children of Ancient Mother—so that they may intercede on behalf of her current, living children.

A Senufo village is composed of a series of residential settlements known as *katiolo*.[5] In a large village, each *katiolo* has its own Poro society, set of initiates, and sacred sanctuary,[6] or *sinzanga,* situated in a dense grove of trees beside the village. A site of instruction, political dialogue, and reverent worship, the *sinzanga* is conceived as the *katiolo* of Ancient Mother,[7] where her children (Poro graduates) come under her protection and direction.

Although Poro is essentially a male institution, the most important ancestor invoked is the woman who was the head of the *sinzanga*'s founding matrilineage.[8] Anita Glaze suggests that this emphasis on female ancestral origins is reflected in Poro sculptural couples, the majority of which interpret the female as the dominant of the

two figures. Such "ancestral couples" are the primary sculptural form used by Poro and are displayed on the occasion of a distinguished member's funeral.[9] Both figures in this example hold attributes of Poro in their right hands: the male grasps a fly whisk, the female raises a rattle.

A preoccupation with ancestral origins is articulated visually in this pair through the treatment of the navels. The male figure has a protruding, herniated navel that evokes the remnant of the umbilical cord. Glaze notes that this feature serves as a reminder of the matrilineage that reaches back to Ancient Mother. A variation on this idea is expressed through the highly abstract motif that accents the female figure's navel. It consists of four sets of three or four parallel lines that radiate horizontally and vertically out from the navel to form a crosslike configuration, with the navel at its center. Known as *kunoodyaadye,* which translates as "navel of mother" or "mother of twins," this design is used to ornament the body of Senufo women at puberty.[10] *Kunoodyaadye* synthesizes references to the Senufo creation myth and to the role of women as the matrices of life and the guarantors of social continuity.[11]

Notes

1. Glaze 1981, p. 72.
2. Ibid.
3. Ibid., p. 53.
4. Ibid., p. 51.
5. Ibid., p. 7.
6. Ibid., p. 11.
7. Ibid., p. 53.
8. Ibid., p. 51.
9. Ibid., p. 16.
10. Ibid., p. 73.
11. Ibid., p. 74.

Ex coll.

Nelson A. Rockefeller, New York; Museum of Primitive Art, New York

Published

New York 1961, pls. 26, 27; Goldwater 1964, pl. 93; Parke-Bernet 1967, lot 25; Sieber and Walker 1987, p. 33, no. 2.

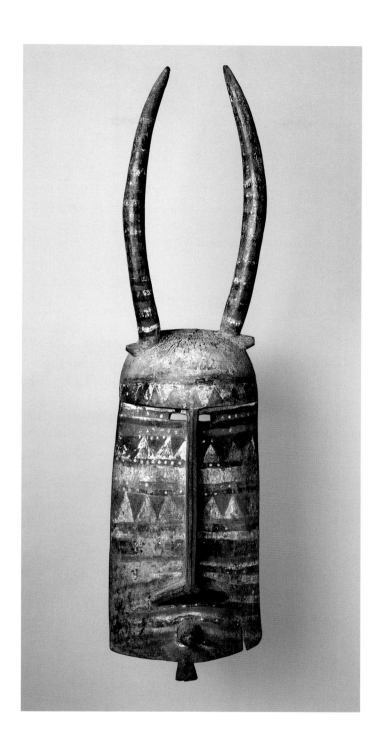

BOBO

5. Sacred Mask (*molo*)

Bobo peoples; Burkina Faso
19th–20th century
Wood and pigment; H. 58½ in. (148.6 cm)
Collection of Thomas G. B. Wheelock

Bobo accounts of genesis credit the divinity Wuro with the creation of a perfect but precariously equilibrated world that is easily disrupted and damaged by change. Wuro began by molding the Earth from moist clay. He then populated it with pairs of living beings and elements: chameleon and ant; water and

fish; cat and dog; toad and mud dauber wasp; and the first human, a smith, whose companion was a Bobo farmer.[1] This conception of genesis profoundly informs the Bobo experience of history, dividing it into two distinct epochs. The first, described above, is the creation of the universe by Wuro; the second is historical time following Wuro's departure from his creation, when he determined that he could not improve upon it and retreated. He ensured continued assistance to humankind, however, by leaving behind a manifestation of himself: Dwo, his son, who serves as the representative of humanity to its creator. Through Dwo, mortals are linked to the forces that control life, and communication with the divine is facilitated through Dwo shrines that are erected in every Bobo community. A Dwo shrine is controlled by a priest who is often a smith and who is considered to be a descendant of the first man.[2]

During the epoch of creation, Wuro gave the first human (the smith) masks made of different kinds of matter through which Dwo was revealed to humankind.[3] The first of these manifestations of Dwo are the most respected and sacred, especially those made of the freshly gathered leaves of various sacred trees. Among masks made of wood, the most important genres are the sacred *molo* and *nwenke*, which incarnate the spirit of Dwo in nonrepresentational forms. Their designs reflect a fundamental challenge to human artistic ingenuity: to express the idea of divine power through a creation that resembles nothing known in nature.

Monumental *molo* masks are carved from the wood of the sacred *lingue* tree (*Afzelia africana*). The overall form is a long rectangular or trapezoidal face surmounted by a spherical helmet from which a pair of menacing horns projects dramatically upward. They are created in two regional centers of Bobo country: in the north, around Tanguna, and in the center at Kurumani. This work is a classic example of the style associated with the latter region. The rounded forehead extends beyond a planklike face, which is bisected by the long, narrow nose, accented with red pigment. The mouth is small and conical. Red, black, and white pigments are integrated into alternating broad and narrow horizontal bands of design, some punctuated by triangles, that extend across the rest of the mask's surface.

When *molo* masks are worn in performance, they are secured to the dancer's head by a small handle of plaited fiber beneath the chin, which permits the mask to be held in place during acrobatic presentations. In addition to the mask, the dancer wears a costume of *tabe* leaves (*Isoberlina doka*) that covers the rest of his body. As Bobo masks are conceived of as incarnations of Dwo's spirit, they often serve as a sort of portable Dwo altar, and offerings may be applied directly to a mask's head. *Molo* masks can also serve as sites for prayer and sacrifices during funerals.[4]

Notes
1. Le Moal 1980, pp. 97, 102; Roy 1987, p. 318.
2. Roy 1987, p. 320.
3. Ibid., p. 321.
4. Ibid., p. 345.

Published
Skougstad 1978, p. 24, fig. 19; Robbins and Joseph 1979, p. 12, no. 25.

6. Sacred Mask (*nwenka*)

Bobo peoples; Burkina Faso
19th–20th century
Wood and pigment; H. 68 in. (172.7 cm)
Collection of Thomas G. B. Wheelock

Christopher Roy describes Bobo dance performances in which certain masks, despite their often considerable size, are spun wildly from one side of the dance arena to the other. Such dances culminate in an impressive explosion of kinetic movement in which the mask leaves the performer's head as he plants his feet firmly, tightly grasps the small handle that protrudes from the mask's chin, and spins the mask around two or three revolutions.[1] This rapid rotation celebrates the creative powers of Wuro, maker of the universe.[2] The masks themselves, made of fiber, wood, and cloth, are manifestations of Dwo, Wuro's son and representative on Earth. Their most important public appearances relate to male initiation, but they also play a role in annual harvest rituals as well as in burial and funeral rites of elder Dwo priests.[3]

In contrast to *molo* masks, which as a genre were given to Bobo smiths but appropriated over time by

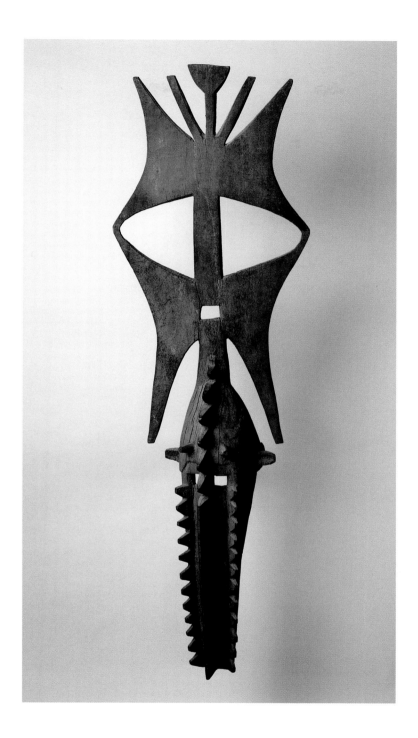

farmers, *nwenke* (singular *nwenka*) have remained the exclusive prerogative of smiths. They typically consist of an elongated trapezoidal face with a narrow chin surmounted by a frontal plank. The nose and protuberant brow intersect to form a "T," and the small eyes are set high in the resulting angles. The nose is long and bisects the face vertically; the mouth is small and always very low on the face. The characteristic frontal plank is the visual focus of the composition, providing an opportunity for complex and dramatic arrangements of negative and positive space.[4]

In this dynamic interpretation of the genre, the surface of the lower half of the mask bristles with projections. Two serrated ridges carved in relief extend from the corner of the eyes to the tip of the nose. They frame the smooth ridge of the long, narrow nose and are

echoed by a column of less severe raised knobs from the bridge of the nose to the crown of the head. In contrast to the intensity and menace of the lower portion, the plank, balanced above, is a smooth flattened expanse of forms that suggests a playful spontaneity. A central vertical column serves as the axis of a starfish-like configuration. Two symmetrical open triangular spaces at the summit form an abstract passage reminiscent of a butterfly.

Bobo *molo* and *nwenke* masks are traditionally painted red, black, and white in abstract patterns that enliven the surface and appear spontaneously applied.[5] (Bwa masks, in contrast, are painted and carved in low relief; see cat. nos. 24–27.) They are repainted at the beginning of each performance season. Old masks that have been weathered or cleaned by private collectors in the West may no longer show traces of the original brilliant surface patterns.[6]

Notes

1. Roy 1987, pp. 338–39.
2. Ibid., p. 322.
3. Ibid., p. 345.
4. Ibid., p. 333.
5. Passages of triangular units have been described as magical amulets (*sebe*).
6. Roy 1987, p. 337.

Ex coll.

Patricia Withofs, London

Published

Robbins and Nooter 1989, p. 92, fig. 105.

SOUTH AFRICA

7. Fertility Figure (*gimwane*)

Ntwane peoples; South Africa
20th century
Wood, beads, grass, textile, thread, hide, buttons, and metal beads; H. 10¼ in. (26 cm)
Collection of K. Nel

8. Fertility Figure (*nguano seho*)

South Sotho peoples; South Africa
20th century
Wood, beads, buttons, metal, leather, fabric, plant fiber, and string; H. 11 in. (28 cm)
Collection of W. and U. Horstmann

9. Fertility Figure (*umndwana*)

Ndebele peoples; South Africa
20th century
Wood and beads; H. 7⅝ in. (19.5 cm)
Collection of W. and U. Horstmann

7.

M any southern African peoples share a common origin myth in which earth, water, and reeds are catalysts for the creation of human life.[1] In one South Sotho account of genesis, man springs up in a marshy place where reeds are growing.[2] It has been suggested that the confluence of these elements serves as a metaphor for the act of human procreation (i.e., the reed is rooted in the riverbed and transfers life-giving fluid). Indeed, in South Sotho tradition the birth of a child is announced by fastening a reed over the doorway to the home.[3] Women throughout southern Africa often use reeds to construct a range of objects imbued with potent, fertility-enhancing powers. Sometimes referred to as "child figures," these intimate creations encompass a multiplicity of parallel traditions in which abstract human forms are created using grass and reeds as well as clay, gourds, cloth, and beads. They are invested with their owners' desires to become vessels for new life and as such are ascribed talismanic properties.[4] The skills necessary to fabricate these fertility figures are passed down from mother to daughter in order to nurture the next generation's potential to marry and bear children.[5]

The figures designed by South Sotho women for their marriage ceremonies, called *nguano seho,* reflect wishes to bring children into a union or to counter infertility.[6] They are not representations of infants, however, but rather conceptual models of a woman's body.[7] They consist of a conical core that is covered with cloth and an outer layer of woven beadwork. The core was originally made of materials related to beliefs about human origins, such as a calabash, reeds, or clay, but in the early part of the twentieth century wood became the standard medium.[8] The beadwork sheath is embellished with elaborate designs that typically consist of rows of triangles, parallelograms, or diamonds. In this example (cat. no. 8), rivulets of beaded bands cascade the length of the conical form, framing lozenges that are subdivided into triangles of black paired with alternating green, yellow, and red triangles. At the cone's narrow top, a series of horizontal bead bands is surmounted by a rounded tuft of fiber strands, each terminating in a single bead.

Ntwane and Ndebele women, who share close cultural ties, give expression to their roles as wives and mothers through comparable fertility figures. At the core of Ntwane figures is a perfect cylinder of bundled and tied grass over which layers of delicate grass rings are slipped. In this example (cat. no. 7), strands of beads and buttons have been interspersed between the horizontal coils of woven grass. The summit is crowned

8.

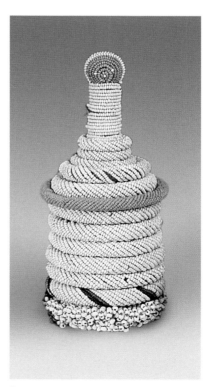

9.

37

by a wiglike shock of black fibers to which a button has been attached. Ndebele figures feature a conical core engulfed by beaded hoops (cat. no. 9). Here white seed beads have been used throughout, with pink and black accents in the round head. At the base of the long, narrow neck is a series of six progressively wider bead rings, with the widest in bright blue. These rings sit atop a columnar, uniformly wide stack of rings. The overall shape of the figure refers to the traditional dress, made of grass hoops covered with beadwork, that is worn on the bodies and legs of initiated and married women to enhance their fertility.

It has been suggested that underlying the construction of all of these forms is the principle of an inner core wrapped in an outer layer, possibly a reference to the sexual union of man and woman.[9] The preciousness of these abstract vessels and, by extension, of human conception is reflected in the costly and skillfully woven beads used to enhance them.[10] Although each expresses a distinct cultural aesthetic through its formal design and color scheme, the figures are united by their makers' shared desire to replicate the divine act of human conception.

Notes

1. Johannesburg 1998, p. 151.
2. Ibid., p. 41.
3. Ibid., p. 57.
4. Ibid., p. 219.
5. Ibid., p. 131.
6. Ibid., pp. 35, 49.
7. Ibid., p. 57.
8. Ibid., p. 223.
9. Ibid., p. 151.
10. Ibid., p. 227.

7.

Ex coll.

J. R. Ivy

Published

Johannesburg 1998, pp. 14 (colorpl.), 15, 132 (colorpl.).

8.

Published

Berg en Dal 1995, p. 32; Cameron 1996, p. 105, no. 139; Johannesburg 1998, p. 16 (colorpl.); Bassani, Bockemühl, and McNaughton 2002, p. 231, no. 99.

9.

Published

Cameron 1996, p. 110, no. 146; Johannesburg 1998, pp. 30 (colorpl.), 31; Bassani, Bockemühl, and McNaughton 2002, p. 233, no. 100.

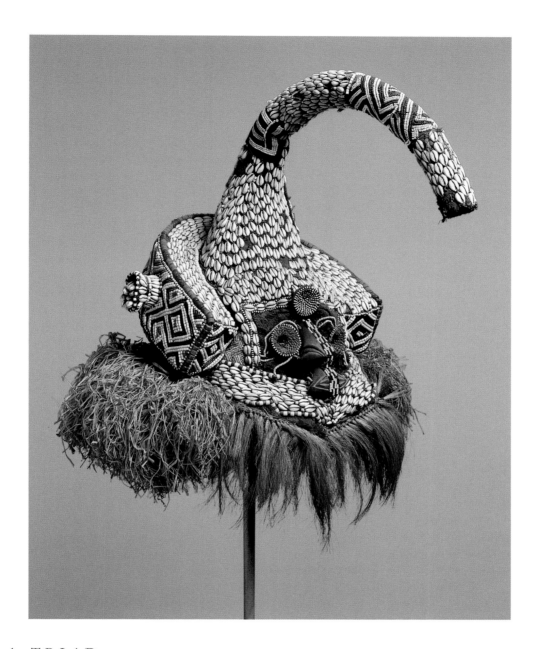

KUBA TRIAD

10. Mask (*mukyeem*)

Kuba peoples; Democratic Republic of the Congo
19th–20th century
Wood, beads, fiber, hair, cowrie shells, and cloth;
H. 18 in. (45.7 cm)
Collection of Frieda and Milton F. Rosenthal

The many peoples of Kuba heritage keep alive several different versions of the story of their origins. Historian Jan Vansina distinguishes three categories among these accounts: stories that describe the creation of the world and humankind; mythological genealogies that recount how today's ethnic groups are related to one another; and legends that identify the

place of origin whence a people migrated to the country they currently inhabit.[1] According to most of these narratives, the first man, who is also the personification of civilization, is identified as Woot, although his role varies from account to account. In one example, Ncyeem apoong, the creator, takes a rolled-up mat and flings it into the void so that it unrolls and floats at an angle, differentiating upstream from downstream and defining Earth. He subsequently creates Woot by "speaking" him into being.[2] In another version, Mboom is the creator and he has nine children, all called Woot, who shape the world: Woot the ocean; Woot the digger of riverbeds and trenches and the carver of hills; Woot who made rivers flow; Woot creator of woods and savannas; Woot creator of leaves; Woot maker of stones; Woot the sculptor of humans out of wood; Woot the inventor; and Woot the sharpener, who gave an edge to pointed things.[3]

Related to these creation narratives are myths concerning the movements of the human family. The central Kuba describe Woot's incestuous relationship with his sister, Mweel, as the catalyst for a migration. According to them, Woot was quarantined in the forest because he had contracted leprosy and was cared for by Mweel. After he recovered, they returned to the village together with their children. When their incestuous affair was exposed by Pygmies, however, Woot fled upstream in shame. The Bushong peoples—one of the principal chiefdoms within Kuba society—followed Woot because of his powers, and Woot in turn gave them magical protection and fertility.[4]

As the original ancestor, Woot is memorialized in a lavishly appointed masquerade that is the prerogative of kings. His persona is invoked to emphasize the continuous lineage that descends from him to the founder of royal lines to contemporary leaders. This particular mask, known as *mukyeem* or *mukyeeng*, is unique to the southern Kuba area but closely resembles a related Bushong version known as *mwaash aMbooy*. Both genres represent Woot; the *mukyeem* is distinguishable by the elephant trunk form on the top.[5] Vansina notes that the *mukyeem* masquerade was invented by the wife of the seventeenth-century Kuba king Shyaam, founder of the Kuba-Bushong kingdom, for use in funeral dances for the aristocracy.[6]

In this example, the fiber understructure is completely covered with an ornate application of cowrie shells and beadwork, an ostentatious display of wealth that underscores the mask's royal status. The surface of the trunk features two passages of beadwork in which dark blue, black, and white beads are arranged in linear, interlaced motifs. Around the back of the head is a broad horizontal band covered with turquoise, white, dark blue, royal blue, and red tube beads arranged in patterns of interlaced lozenges. Three clusters of cowrie arrangements project from around the perimeter at either side and in the back. The vibrant colors are all significant: red is said to suggest suffering and abundance; white refers to mourning and religious purity; and blue to high rank.

The carved wood facial features jut out from the surface of the face. At the base is a ruff of fur, and the perimeter is lined with a raffia fringe collar. Although the features are human—dislike eyes, a nose and mouth unit, and ears attached to either side of the head at the back—the overall form takes on a fantastical quality through the projection of a trunk from the crown of the head, which narrows from the conical summit into a long extension that arcs forward beyond the face.

The imagery of *mukyeem* and *mwaash aMbooy* royal masks are said to represent simultaneously Woot, the king, and nature spirits, underscoring the relationship between these forces and Kuba leadership.[7] *Mukyeem* depict the ruler with the attributes of an elephant because it is an animal of great size and strength, highly prized for its valuable ivory. Such masks were often strongly identified with a specific leader, given personalized names, and guarded at the palace as property of the king. When a mask was new, it was performed first by the king himself; afterward it could be lent to others. Sometimes, at the end of a leader's life, the mask was buried with him.[8]

Notes

1. Vansina 1978, pp. 29–46.
2. Ibid., p. 30.
3. Ibid., pp. 30–31.
4. Ibid., pp. 34–35; Vansina 1955, p. 144.
5. Cornet 1982, p. 256.
6. Vansina 1978, p. 216.
7. Blier 1998, p. 237.
8. Ibid., p. 236.

Ex coll.

Eliot Elisofon, New York

Published

Preston 1985, p. 64, no. 63; Robbins and Nooter 1989, pp. 422–23.

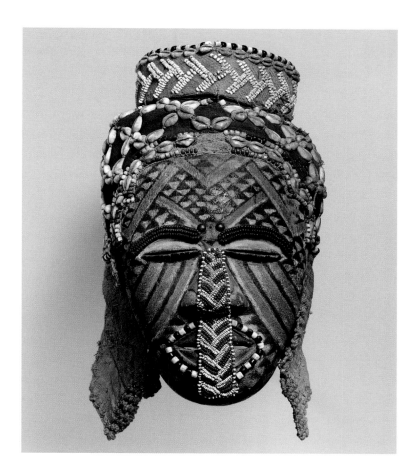

11. Mask (*Ngaady aMwash*)

Kuba peoples; Democratic Republic of the Congo
19th–20th century
Wood, beads, pigment, cowrie shells, raffia, and trade cloth;
H. 13½ in. (34.3 cm)
Collection of Laura and James J. Ross

The mythical drama of Kuba origins involves a triad of protagonists: Woot, the larger-than-life culture hero (see cat. no. 10); Ngaady aMwash (discussed below); and Bwoom (see cat. no. 12). It is often reenacted in performances at public ceremonies, initiations, and funerals. Ngaady aMwash, an idealized female figure, assumes a number of roles in these performances, including that of Woot's consort, the king's sister and wife, and women in general.[1] Joseph Cornet cites oral histories that describe how this masquerade genre was established during the reign of Queen Ngokady, who wanted to validate the condition of women through dance and a mask.[2] According to tradition, the queen

did not dance herself but rather found a man who could dance like a woman by imitating her movements.

This classic depiction of Ngaady aMwash consists of a carved wood face mask with a fiber hood—made of green trade cloth, raffia fiber, and applied cowrie shells—attached to the perimeter. The surface of the wood is covered with densely painted passages of red, white, and black configurations complemented by beads that highlight facial features and embellish the textile superstructure. A band of cowrie shells framed by white and turquoise beads has been stitched to the raffia at the intersection of the mask and the hood.

The forehead is covered by arrangements of alternating black and white triangles known as *lakyeeng lanyeny*. Directly below, three contiguous rows of blue beads highlight the horizontal slit eyes, which are closed. The upper lid is accented in white, the lower in black. A beaded band—a herringbone pattern of white and turquoise beads framed by alternating white and red beads—runs from the bridge of the broad nose down the center of the mouth to the chin. The contour of the mouth is outlined by a band of alternating white and black tubular beads. A series of parallel black, white, red, and yellow lines extends from the underside of the eyes along the cheekbone to the side of the face. Known as *byoosh'dy,* these tearlike marks may refer to the funerary context in which these masquerades were sometimes performed as well as to the hardships of a woman's life.[3]

Notes

1. Blier 1998, p. 240.
2. Cornet 1982, pp. 270–71.
3. Blier 1998, p. 238.

Ex coll.

Gaston de Havenon, New York

Published

Preston 1985, p. 65, no. 64.

12. Mask (*Bwoom*)

Kuba peoples; Democratic Republic of the Congo
19th–20th century
Wood, copper, hide, cowrie shells, and beads; H. 11½ in.
(29.2 cm)
Brooklyn Museum of Art, New York

The third member of the Kuba royal masquerade triad, Bwoom, is perhaps the oldest. Oral traditions suggest that the genre may date to about the middle of the eighteenth century.[1] As a character, Bwoom has been interpreted variously as a prince (the king's younger brother), a commoner, a Pygmy, even a subversive element at the royal court. There are many differences among regional stylistic interpretations of the Bwoom mask, but the form's most pronounced features invariably are a bulging forehead and broad nose.

In this example, the carved wood understructure is covered with copper sheeting that is extended by a beard made of hide and accented throughout by beadwork. The contours of both the eyes and the mouth are also embellished by beads. A series of bead bands crosses the surface of the face, one from the crown of the head to the tip of the nose and another from one side of the head to the other, bisecting the eyes. Oral traditions indicate that the earliest Bwoom masks were less lavishly ornamented. A song for the son of King Kot aNce, which Jan Vansina dates to the eighteenth century, makes reference to the first instance of adorning Bwoom masks with cowries and beads. It is unclear how the many variations of the mask evolved, or if they did so from a single prototype.[2]

Bwoom is usually performed during initiation rites for Kuba men. In the Kuba genesis myth, Woot, the first ancestor, is the inventor of men's initiation, or *nkaan*. According to oral tradition, one day Woot, drunk with palm wine, lay on the ground naked. His sons mocked him, but his daughter showed him respect and covered him. When he awoke, he rewarded his daughter by promising that her children would be his heirs, thus introducing matrilineal succession. His sons were punished by having to undergo initiation, and it is this punishment that is reenacted in the initiation rites undergone by all men in Kuba society.[3] In *nkaan*, initiates are taught the Kuba worldview and are instilled with an appreciation for Woot's role as creator, originator of fertility, and founder of the ruling dynasty. Vansina notes that as mythic creator, Woot is the ultimate reference point for all Kuba social institutions as well as for the natural realm in which they operate.[4]

Kuba rulers underwent an additional level of initiation whereby knowledge related to the environment, religion, and history was revealed to them. After his own initiation, the king, appearing in the mask known as *mwaash aMbooy,* supervised the initiation of the youth of the capital.[5] In one of these performances, Bwoom engages the king in mock combat to win the affections of the king's sister.[6] It has been suggested that in this dramaturgical conflict, Bwoom and the *mwash aMbooy* mask represent the commoner and the king, respectively.[7]

Notes

1. Vansina 1978, p. 216.
2. Ibid.
3. Vansina 1955, p. 144.
4. Ibid., p. 151.
5. Blier 1998, p. 236.
6. Ibid., p. 240.
7. Vansina 1955, p. 150.

Published

Blier 1998, p. 238, fig. 190.

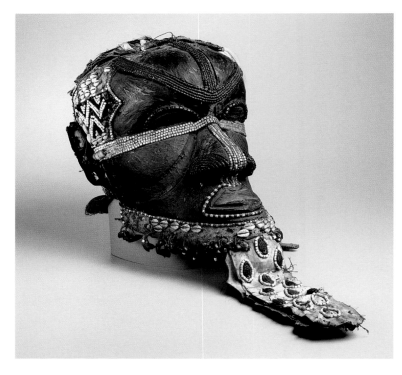

13. Bow Stand

Warua Master
Luba-Hemba peoples; Democratic Republic of the Congo
Ca. 1820–70
Wood, metal, and beads; H. 26 in. (66 cm)
Private collection

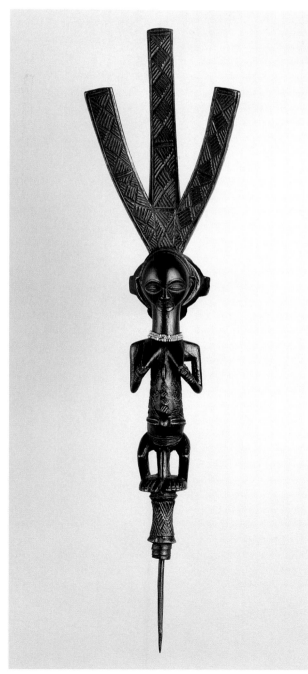

Front

At the core of the Luba peoples' account of their origins is a watershed event that permeates their thought, religion, and history: the arrival of a handsome hunter-prince named Mbidi Kiluwe, who introduces the art of sacred enlightened kingship and who initiates a cultural revolution that leads to a radically different political charter for the local populations. This new royal order, led by a single dynastic line, was founded at a center in the Kabongo region of what is now the Democratic Republic of the Congo.[1] These basic elements of the Luba epic captured the imagination of other peoples in the region, including the Lunda and the Chokwe, who appropriated aspects of it as a source of legitimization for their own political systems.[2]

Countless regional versions and individual interpretations of the Luba genesis myth have been recited over the centuries by erudite court officials referred to as "men of memory."[3] Some of these narratives have been recorded by missionaries, colonial officials, travelers, and researchers, and today the essential story is taught in schools and universities as part of Luba history.[4] Among the consistent features of the myth that may be distilled from its myriad tellings are the following: the primordial couple, a brother and sister, have twins through incest. One of the twins is characterized as a red-skinned man named Nkongolo, who makes himself ruler of the Luba. Nkongolo is a cruel and brutal tyrant with a propensity for drunkenness and incest. One day the handsome hunter-prince Mbidi Kiluwe arrives from the east at Nkongolo's court, where he remains as a guest for some time. During his visit, Mbidi, with his refined manner, proves a marked contrast to Nkongolo's despotism. Nkongolo's sisters are offered to the foreign prince as wives, and one of them conceives a child with him. Mbidi, who is planning to return home, makes arrangements for the diviner Mijibu'a Kalenga to care for the child's upbringing. When the child is born, he is recognized as Mbidi's son because of his shiny black skin and is given the name Kalala Ilunga. Tensions develop between Kalala and his uncle, escalating to the point where Nkongolo plans to eliminate his nephew by inviting him to dance over a covered pit filled with upright spears. Nkongolo's plan is thwarted, however, by the intervention of Mijibu'a Kalenga, Kalala's diviner guardian. After a series of challenges, Kalala ultimately prevails over Nkongolo, slaying him to become the first legitimate Luba king.[5]

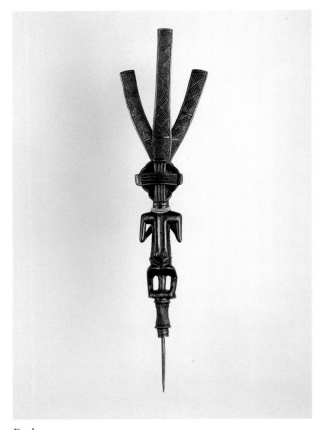

Back

In Luba society, the title of "king" is conferred upon individuals descended from Kalala Ilunga; "chiefs," by comparison, are indirect descendants whose integration into Luba kingship practices is a result of marriage. The Luba elite conduct ritual and performative reenactments of the Luba epic during which a state of spirit possession is induced, transforming them into incarnations of their mythical progenitors.[6] Their connection to the dawn of dynastic leadership is reinforced through the ownership of precious artifacts. The bow stand, for example, is a treasured emblem of Mbidi Kiluwe's legacy as a renowned hunter and the bearer of Luba kingship.[7] Elegantly designed and exquisitely carved, with three projecting wood branches and an iron shaft, bow stands were conceived as functional supports for bows and arrows but were actually a form of sacred regalia and were never displayed in public. Instead, they were guarded in the king's residence by a female dignitary called the Kyabuta, who followed the king at public ceremonies holding a simple bow between her breasts. Bow stands were kept in a

shrine along with relics of past rulers and were the focus of elaborate rituals, prayers, and sacrifices.[8]

This example has been attributed to an exceptional sculptor known as the Warua Master, who created bow stands for kings and chiefs throughout the Luba region. His work was first collected there by the German adventurer Leo Frobenius. Belgian scholar Albert Maesen later proposed that the Warua Master belonged to a clan known as the Kunda, found throughout the region.[9] The Warua Master's distinctive hand has been discerned in at least seven other works, including bow stands and caryatid stools. Except for differences in wear, all the bow stands attributed to him are virtually identical. They are noteworthy for their extraordinary combination of organic humanism and abstract geometric features. The classic hands-to-breasts gesture depicted in this example alludes to the Luba belief that certain women guard the secrets of kingship within their bodies.[10]

Documentation accompanying this bow stand at the time of its collection states that the female figure represents the chief's mother, who led the migration of her people from the east to the Luvua River, where she established a village. It is possible that the female figures on all bow stands refer to the founders of specific royal clans, in which case bow stands also serve to commemorate clan origins and reinforce political legitimacy.[11]

Notes

1. Nooter 1991, p. 12.
2. Ibid., p. 13.
3. Ibid., p. 44.
4. Ibid., p. 13.
5. Ibid., p. 26.
6. Ibid., p. 272.
7. Ibid., p. 69.
8. Ibid., p. 20.
9. Roberts and Roberts 1996, p. 228.
10. Ibid., p. 225.
11. Ibid., p. 227.

Ex coll.

Queche(?); Jean Mestach, Brussels; Merton D. Simpson, New York

Published

Bastin 1984, p. 349, no. 372; Preston 1985, p. 78, no. 81; Sieber and Walker 1987, p. 109, no. 60; Bassani, Leoni Zanobini, and Zanobini 1990, fig. 2; Roberts and Roberts 1996, p. 227, no. 101; de Grunne 2001, p. 216, no. 72.

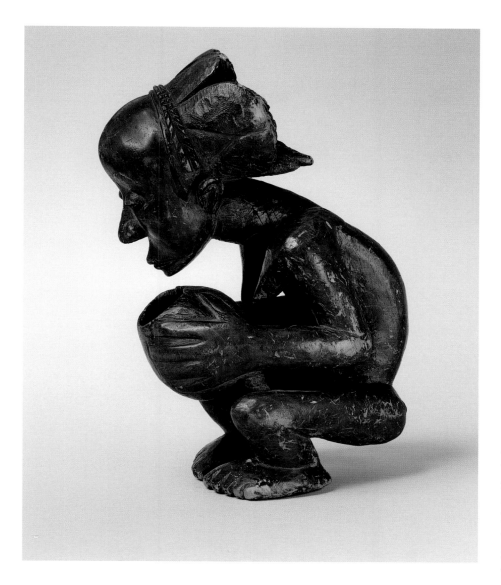

14. Female Vessel Bearer (*mboko*)

Buli Master
Luba-Hemba peoples; Kunda, Democratic Republic of the
Congo
19th century
Wood; H. 14⅝ in. (37.1 cm)
Private collection

In the Luba epic, it is the wisdom of the healer-diviner Mijibu'a Kalenga that ultimately assures a new era of leadership. Entrusted with the care and upbringing of Mbidi Kiluwe's son—the future king Kalala Ilunga—Mijibu'a counsels him in his struggle to overthrow his despotic uncle, Nkongolo.[1] Mijibu'a's guidance established a precedent for a complex form of divination whose practitioners were called *bilumbu*.[2]

Since that time, Luba kings and chiefs have relied on the wisdom of these royal diviners for insights into decisions critical to the stability of their territories. *Bilumbu* are also responsible for overseeing annual renewal rites of kingship, regulating access to natural resources, and medical and judicial affairs.[3]

Oral traditions characterize Mijibu'a Kalenga as sensitive, enlightened, and endowed with an exceptional ability to discern things that go unseen by ordinary humans. Just as a Luba king comes to embody Kalala Ilunga, all *bilumbu* are regarded as personifications of Mijibu'a Kalenga, and their professional instruments are faithful reproductions of the prototypes he introduced.[4] Among these are various sculpted figures called *bankishi*, which serve as receptacles for medicinal substances.

The most important type of *bankishi* is a representation of a woman holding a vessel, known as *mboko*. The *mboko*—which is the name of both the figure and the vessel, a sacred calabash—is used during divinations as *bilumbu* enter a state of possession to address the great spirits of Luba worship.[5] The diviner interprets the shifting contents of the *mboko* as a response from the spirit world.[6]

Female vessel bearers serve *bilumbu* in a number of different capacities: they possess therapeutic properties; act as investigative agents; and serve as mouthpieces for the spirits that guide him. During divinations incantations, songs, and percussive sounds are directed toward the figure, which is placed to the left of the *bilumbu,* opposite his wife.[7] Indeed, the female vessel bearer is sometimes identified as the wife of the spirit who possesses the diviner over the course of a consultation.[8] Other accounts

claim she is Mijibu'a Kalenga depicted as a woman, a reflection of the fact that in Luba society a woman's body is considered the ultimate spiritual receptacle.[9]

Vessel bearers, originally the strict prerogative of *bilumbu,* were ultimately appropriated by Luba kings and chiefs as part of their royal insignia.[10] Collections of royal insignia are bestowed upon a leader at the time of his investiture and kept within *mubu,* a small sanctuary within the royal compound.[11] Although such insignia are the identifying marks of a leader's chieftaincy, they are nevertheless considered imitations of the original set that Mbidi Kiluwe bestowed upon Kalala Ilunga at the time of his investiture. That prototypical set is said to have included a memory board (*lukasa*), stool (or throne, *lupona*), spear (*mulumbu*), staff (*kibango*), adze (*kafundishi*), and relic basket (*dikumbo*) containing the remains of past rulers.[12]

More than just an item of Luba regalia, this work is a profound commentary on the human spirit's desire to obtain knowledge and influence the course of history. The crouching female figure, depicted in a delicately held position, holds the *mboko* balanced on her knees. Her eyes are closed in a meditative expression and her body is oriented so that her right shoulder rises higher than the left and her head is slightly turned. The body leans forward, the angled neck creating a continuous arc with the dramatically curved back. This posture, along with her intense facial expression, show her fully absorbed in the act of enclosing the precious *mboko* within a concavity created by her body. Where most examples of this genre illustrate the *mboko* as a prominent appendage to a figure, here it is positioned at the very core of the subject's being.

During the first half of the twentieth century, colonial administrators were required to list the insignia of local chiefs in their government reports, the source of much of our knowledge of the Luba treasuries as ensembles.[13] The dispersal of African artifacts during the colonial era generally makes it difficult, however, to reconstruct the specific works in a particular historical treasury. This extraordinary vessel bearer presents an exception. It is documented to have been among the items in the treasury of Chief Kalumbi of the Sanga clan, whose territories were situated near the confluence of the Niombo and Lukuga rivers.[14] In 1895 the contents of Kalumbi's treasury were acquired by Fernand Miot, a member of the Belgian Anti-Slavery Society, during a dispute over slave raiding. In addition to this vessel bearer, the treasury included three bow stands (two of these in Luba style, the other more characteristic of the northern Hemba peoples), three Luba staffs, a Kuba cup, an ivory pestle, and a headrest.[15]

The mixture of eclectic styles represented in Kalumbi's treasury was typical of such ensembles. Because many artists specialized in certain object types, the insignia of a single ruler was never the work of a single artist.[16] Among the most notable of the individual hands discerned by art historians is the celebrated Buli Master, who carved this vessel bearer, and the Warua Master (see cat. no. 13). These two sculptors' expressive idioms could not represent more different visions. The Warua Master's work embodies a cool perfection and timeless beauty. The Buli Master, in contrast, imbued his creations with emotional intensity; this exemplary female vessel bearer is one of the earliest works attributed to him.[17] Mary Nooter Roberts has noted that the signature Buli Master approach is probably that of an individual master who carved the majority of the Buli oeuvre in the mid-nineteenth century and who was succeeded several decades later by one or two disciples who perpetuated the style.[18]

Notes

1. Nooter 1991, p. 188.
2. Ibid., p. 187.
3. Ibid., p. 189.
4. Ibid., p. 188.
5. Ibid., p. 176.
6. Ibid., pp. 193–94.
7. Ibid., p. 198.
8. Ibid.
9. Ibid., p. 199.
10. Ibid., p. 198.
11. Ibid., p. 131.
12. Ibid.
13. Ibid., p. 20.
14. Roberts and Roberts 1996, p. 232.
15. Ibid.
16. Nooter 1991, p. 39.
17. Roberts and Roberts 1996, p. 232. The village of Buli is in the southeast of present-day Democratic Republic of the Congo near the confluence of the Luvua and Lukuga rivers, where several objects of this style have been collected.
18. Ibid., p. 245.

Ex coll.

Treasury of Chief Kalumbi; Fernand Miot; Ralph Nash, London

Published

Vogel 1980, p. 138; Bastin 1984, p. 4; Bassani 1989, p. 25; Neyt 1993, pp. 30–31; Pirat 1996, pp. 54–77, fig. 18; Roberts and Roberts 1996, p. 232, no. 107; de Strycker and de Grunne 1996, pp. 48–52, fig. 4; Pirat 2001, fig. 5.

15. Memory Board (*lukasa*)

Luba peoples; Democratic Republic of the Congo
19th–20th century
Wood, iron, and beads; H. 10 in. (25.4 cm)
Brooklyn Museum of Art, New York

A *lukasa,* or memory board, is a flat, handsize wood object into which beads and pins have been inserted in abstract, seemingly random configurations. In fact, the design elements represent different aspects of Luba civilization, from icons of royal insignia and sacred regalia to significant events in Luba history and myth. The *lukasa* is used to instruct initiates of the Luba Mbudye association about Luba culture heroes, clan migrations, and the introduction of sacred rule.

The overall form of the *lukasa* is that of a *kasanji,* a rectangular wood thumb piano with metal keys used to accompany songs recounting Luba history and praising the founders of Luba kingship. According to oral history, the *kasanji* was handed down by the tyrant Nkongolo to subsequent chiefs for use at their courts.[1] Trained court specialists play the *kasanji* in public to celebrate the king. The content encoded within the *lukasa,* in contrast, is highly esoteric knowledge restricted to high-level Mbudye initiates.[2]

Although a *lukasa* is owned collectively by each regional Mbudye chapter, a chief or king who is a member of that body may choose to commission a personal *lukasa* for his royal treasury. They are the joint creation of a skilled sculptor, himself a Mbudye member, and a spirit medium, who receives divine instructions for the details of its form and design.[3] Protagonists from the Luba origins myth, represented by different colors and configurations of beads, are prominent features of the *lukasa.* The tyrannical antihero Nkongolo, for example, is always represented with a red bead for his association with bloody violence. Mbidi Kiluwe, the bringer of culture, is indicated by blue beads (described as black) that evoke his radiant, shiny black skin. Chiefs, counselors, sacred enclosures, and important landmarks are indicated by circles of beads, while signifi-

cant events, relationships, and migration paths appear as lines or bead clusters.[4] This *lukasa* has iron hairpins inserted into its edges and surface. The presence of an iron hairpin usually makes reference to a sacred place where a Luba king is memorialized. The pins around the perimeter of this work may refer to related memorials for diviners and Mbudye association chapters.[5]

Notes

1. Nooter 1991, p. 75.
2. Ibid., p. 76.
3. Ibid., p. 75.
4. Roberts and Roberts 1996, p. 37.
5. Ibid., p. 65.

Published

Roberts and Roberts 1996, p. 65, no. 17.

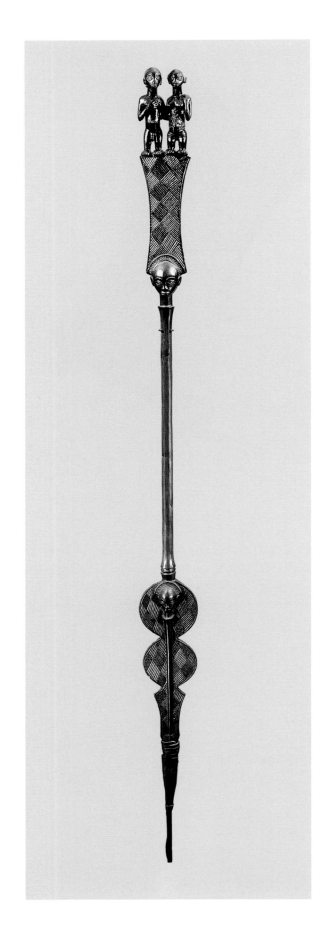

16. Titleholder's Staff (*kibango*)

Luba peoples; Democratic Republic of the Congo
19th–20th century
Wood and iron; H. 66 in. (167.6 cm)
Private collection

Luba royal staffs of office, known as *kibango,* are inspired by the prototype presented by Mbidi Kiluwe to his son, Kalala Ilunga, in the epic of Luba origins.[1] That original staff is said to be preserved in the royal treasury at the court of Kabongo, where it has been handed down from generation to generation.[2] Throughout the territories within the Luba sphere of influence, ownership of staffs of office extends to kings, chiefs and titleholders, governors, village leaders, and female spirit mediums.[3] The ubiquity of the staff as a symbol of authority illustrates how the Luba epic remains a central point of reference in Luba society.

No two *kibango* are identical. The myriad interpretations of the form reflect the degree to which the ideal original has been modified and customized to express a unique relationship between an individual and the central narrative of Luba beginnings. The specific experiences that inform a staff's design constitute an intimate body of knowledge, apparent only to the owner and the spirit medium who consecrates it. The graphic format may also serve as an aide-mémoire for a complex narrative recalling the life and family history of a particular leader.

The visual text manifested in a *kibango* staff is vertical in format, beginning at the top and unfolding as the eye travels down.[4] As an introduction, the apex of the staff invariably features a representation of a female subject who has been described as the embodiment of the spirit of Luba kingship. In this example, the pair of female figures, depicted arm-in-arm, have been identified as the mediums for a pair of Luba tutelary spirits.[5] The broad flattened passage below them designates a Luba political center; here this takes the form of a memory board, or *lukasa* (see cat. no. 15), the preeminent emblem of the charter of Luba government. It has been integrated into this regional leader's staff as part of the owner's claim to power.[6] At the base of the *lukasa* form is a set of janus heads that refer, like the female forms at the summit, to the twin spirits of kingship.[7] The long uninterrupted shaft that extends down from the base of the janus head stands for an expanse of uninterrupted savanna. The staff terminates in an iron spike that may be driven into the ground to stand it upright. Iron is a metaphor for the stable, durable, and resistant nature of

the Luba leader who wields the staff. The staff's authority is thus metaphorically and literally rooted deep in the soil into which it is embedded.[8]

At a king's investiture, his sister and wife plant a spear and *kibango* staff in the ground at his left and right sides. The king grasps the staff and spear as he swears his oath of office.[9] High-level officeholders carry staffs to a range of public proceedings, using them to honor their ancestors and instruct descendants about the nature of their relationship to Luba kingship.[10] This *kibango* passed through the hands of many individuals who succeeded to a family's leadership. In the event of theft, damage, or a dissipation of its power, the staff would be revitalized or replaced. The substitute staff would be sanctified by a ritual specialist at the royal capital of Kabongo, thus reconfirming the legitimacy of its owner's authority as having derived from the line of Luba kings.[11]

Notes

1. Roberts and Roberts 1996, p. 164.
2. Ibid.
3. Ibid.
4. Ibid., p. 169.
5. Ibid., p. 172.
6. Ibid., p. 164.
7. Ibid., p. 161.
8. Ibid., p. 166.
9. Nooter 1991, p. 133.
10. Roberts and Roberts 1996, p. 162.
11. Ibid., p. 166.

Ex coll.

René Mendes, Paris; Jean Roudillon, Paris; Jean-Claude Bellier, Paris

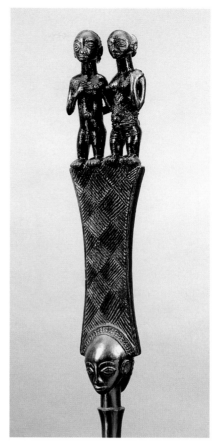

Detail of finial

17. Ceremonial Adze (*kibiki* or *kasolwa*)

Luba peoples; Democratic Republic of the Congo
19th–20th century
Wood, iron, and brass; H. 14⅜ in. (36.5 cm)
Private collection

Iron artifacts and blacksmiths feature prominently in the Luba peoples' account of their cultural origin. Although there are many variations of the Luba epic, the introduction of iron technologies and the adoption of iron implements are most commonly traced to the culture heroes Mbidi Kiluwe and his son, Kalala Ilunga, through their blacksmith, Kahasa Kansengo. According to many accounts, Kalala Ilunga, upon beheading his despotic uncle, Nkongolo, and ascending to power, established his court at Munza, the site of what became one of the most important iron-producing districts in precolonial times. There he summoned Kahasa Kansengo to instruct the Luba people in the art of iron smelting.[1]

Adzes (a type of axe) are among a series of weapons and tools—including spears, knives, bow stands, and bells—that are created as important insignia of Luba leadership and power. These objects are sacred emblems representing two of the great innovations given to the Luba by their culture heroes: advanced metalworking technologies and the hunt.[2] Because of these profound connections to the origins of enlightened leadership, Luba elites commissioned ornate, nonfunctional versions to serve as indicators of status during ceremonies. Such elegant prestige items could be worn over the shoulder or wielded in dances reenacting the Luba origin myth.[3] In Mbudye initiation rites, they were deployed symbolically to clear the path leading to civilization and enlightenment.[4]

Ceremonial adzes, known as *kibiki* or *kasolwa,* come in a range of shapes and styles that generally emphasize their aesthetic qualities over their utilitarian sources of inspiration. The wood handle, for example, may be engraved or wrapped with coiled copper. Especially elaborate figurative adzes with finely carved heads are the prerogative of the king or extremely powerful chiefs. The flared blades are also decorated and are comparable to artifacts that have been found in ancient burial sites.

Mary Nooter Roberts has noted that the undulations in an adze blade's thickness and the incising used to enhance its surface are called *ntapo,* the same term the Luba use to refer to women's scarification patterns.[5] In this example, the blade is inserted into a rounded wood finial whose surface is covered with dense, abstract linear designs carved in relief. The long handle terminates in a woman's head; her eyes are closed and her neck has pronounced folds. The female imagery derives from the notion that women were considered ideal vessels or receptacles for spiritual power.

Notes

1. Roberts and Roberts 1996, p. 62.
2. Ibid., p. 72.
3. Nooter 1991, p. 134.
4. Roberts and Roberts 1996, p. 77.
5. Ibid., p. 76.

Ex coll.

Baudouin de Grunne, Brussels

18. Ceremonial Vessel

Luba peoples; Democratic Republic of the Congo
19th–20th century
Wood; H. 4⁷/₈ in. (12.3 cm)
Collection of Jeff Soref

At the center of the Luba epic is the pro-longed conflict between Kalala Ilunga, the founder of the Luba royal dynasty, and his uncle, Nkongolo. Their struggle climaxes when Kalala decapitates his despotic uncle, whose head is wrapped in a cloth and placed in a basket, referred to as *dikumbo,* which is then guarded in a special house. Kalala's triumph marked the beginning of a new era of enlightened leadership. He was ceremonially invested with Nkongolo's blood as the first Luba sacral king, and the *dikumbo* became a symbol of political authority and legitimate succession.[1] Subsequent Luba royal investiture rites have been conceived as reenactments of this and other episodes of the origin myth.[2]

In the past, when a Luba king or chief died, all the requisite funerary preparations were completed before the news was divulged to the public because the interval between the death of the former king and the installation of his successor was considered a precarious time, full of spiritual vulnerability and political uncertainty.[3] As part of the mortuary process, certain vital body parts of the former king, including the head and sexual organs, were preserved and prepared for placement in a *dikumbo* basket modeled on the one created after Nkongolo's death.[4] It is forbidden for anyone to peer at the crania and other relics of past chiefs and kings held within a *dikumbo.*[5] Of the objects within a Luba treasury, it is the *dikumbo,* used only at a king's investiture, that serves as the critical element responsible for transferring the power of kingship to an anointed successor.

A candidate for Luba royal succession is required to undergo investiture rites in order to achieve the status of a *mulupwe* (plural *bulupwe*), meaning a sacred king or chief who is considered to have superhuman qualities and to become divine upon his death.[6] In the past these rituals of enthronement included the consumption of human blood from his predecessor's dried skull. This usually occurred several days after the enthronement, during which time members of the royal family and other nobility presented the king with gifts.[7] The vessel derived from a royal cranium was considered a locus of power and wisdom to be assumed by the new sovereign, and the blood the sacrificial agent that infused his being

with new life.[8] The blood was seen to link the king to the *bavidye,* or the spiritual forces that govern Luba religious experience and that are associated with the culture heroes responsible for founding the Luba state. The connection established between the king and these spirit entities transformed him into a sacral being who represented continuity between past and present.[9]

The ritual consumption of blood in investiture rites later became ceremonial. A carved wood vessel such as this example might have been created to replace the actual human crania. Although a great deal of secrecy surrounds the use of these carved vessels, their almost lifesize scale suggests this was the case. The elaborate female coiffure may refer to the fact that kings wore female hairstyles on the day of their investiture because women were considered ideal vessels for supernatural forces.[10] The bodily transformation of the king was thus symbolic of his becoming a semidivine being.

Notes

1. Nooter 1991, p. 26.
2. Ibid., pp. 19, 139.
3. Ibid., p. 38.
4. Ibid., p. 139.
5. Ibid., p. 135.
6. Ibid., p. 126. All chiefs who claim allegiance to the original Luba royal dynasty, either by direct descent or marriage, are called *bulupwe.*
7. Ibid., p. 142.
8. Roberts and Roberts 1996, p. 18.
9. Nooter 1991, p. 8.
10. Roberts and Roberts 1996, p. 18.

Published

Neyt 1993, p. 212.

19. Seat of Leadership (*lupona*)

Luba peoples; Democratic Republic of the Congo
19th–20th century
Wood; H. 12⅝ in. (32.1 cm)
The Schorr Family Collection

Carved wood seats, or thrones, are a powerful expression of the sanctioned power of Luba sacred royalty. Historically, Luba kings and chiefs ascended to power and acquired the symbols of their office over the course of a demanding period of investiture rites. At the conclusion of these rites, the new leader, cleansed and in full regalia, emerged from a ritual house. A stool—conceptually a throne or seat of leadership—was placed upon a leopard skin for him to sit upon as he swore his oath of office and addressed his people for the first time as king.[1] The king's throne was subsequently used not as a functional seat but rather as a receptacle for his spirit. A vital symbol of his sovereignty, a Luba leader's seat of office was protected from potential theft or desecration by being hidden in another village. There it was wrapped in white cloth, safeguarded by an appointed official, and brought out only on rare occasions.[2] When the king died, his spirit was incarnated by a female medium called a *mwadi,* who took custody of his royal insignia and symbolically perpetuated his reign. The role of *mwadi* was always performed by a woman because a woman's body is considered the only receptacle powerful enough to contain such a potent spirit.[3] The entire royal residence was also preserved for posterity as a "spirit capital," also known as a *kitenta,* or "seat" of power and remembrance. A king's throne remains a concrete symbol of the immortality of important past rulers and of the cumulative nature of Luba leadership.[4]

Not all Luba royal thrones are figurative, but most examples in Western collections have imagery of female figures as caryatid supports. These figures may be related to the role of the *mwadi* and to the fact that women, through childbearing, perpetuate dynastic lineages.[5] The integration of female imagery into all forms of Luba royal regalia reflects the critical role that women have played as political and religious mediators since the origins of Luba kingship.[6]

Stylistically, this throne is nearly identical to a work in the University of Iowa Museum of Art, Iowa City; both are attributed to the same sculptor. The Iowa seat is said to have been given to Cecil Rhodes by the Matabele chief Chittiwayo at the end of the nineteenth century.[7] In both examples, the kneeling female figure, arms raised, supports the seat with the fingertips of both hands. The rims of the circular seat and base that

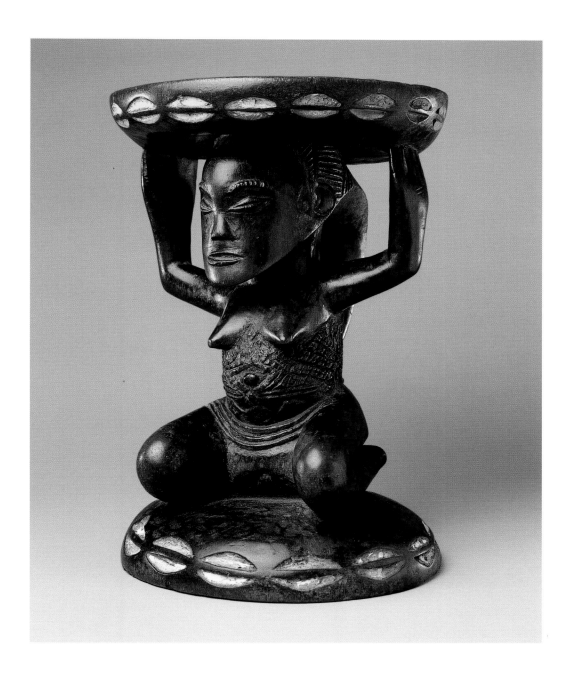

frame the composition are accented with a continuous carved motif reminiscent of cowrie shells. The extended hair braid curves outward from the back of the caryatid figure's head and terminates at the lower back, creating a loop that unifies the upper and lower tiers of the composition. At the base, the figure's feet are positioned so that the toes meet in the back.

Notes

1. Roberts and Roberts 1996, p. 156.
2. Ibid., p. 154.
3. Nooter 1991, pp. 255–56.
4. Roberts and Roberts 1996, p. 17; Nooter 1991, p. 156.
5. Nooter 1991, pp. 225–26.
6. Ibid., p. 249.
7. Roy 1985, no. 21.

Ex coll.

Baron C. Deschamps, Brussels

Published

Maes and Lavachery 1930, pl. 34; Roberts and Saar 2000, p. 31, no. 29.

20. Spear Bearer

Chokwe peoples; Angola
19th century
Wood, metal, and human hair; H. 44¼ in. (112.4 cm)
Private collection

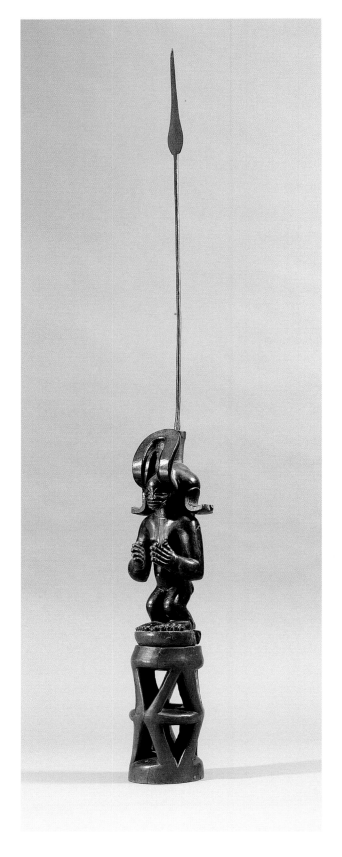

T he epic of the origins of Ruwund civilization describes an ancestry that is shared by the Lunda, Chokwe, Lwena, Luchazi, Ovimbundu, and Mbunda peoples, who inhabit a vast expanse of central Africa. Manuela Palmeirim emphasizes that the "myth of the foundation of Ruwund kingship is both a tale of the creation of humanity and that of the passage from a primitive mode of life to one considered superior."[1] Although there are innumerable versions of this celebrated genesis myth, they all relate a fairly consistent sequence of events that begins with two ancestors, Mbar and his wife, Musang, who live in a cave. Mbar weaves mats and sieves for manioc, and together Mbar and Musang cultivate the land and master hunting and fishing techniques. To this original couple are born two children, who marry and have two sons and two daughters. Each brother takes one of the sisters as his wife, and these couples are parents to a vast progeny. The population becomes so large, the descendants of Mbar and Musang eventually leave the dark cave and emerge into the light, populating the surface of the Earth at a site referred to as Kasal Katok.[2]

This account of the birth of humankind is in turn tied into the origin of kingship. A great-grandchild of Mbar and Musang, Nkond, becomes a ruling chief at Kasal Katok. Nkond has five children, three sons and two daughters. One day Nkond's sons return from a hunting trip to find their father weaving a mat. At his side is a basin filled with water used for dipping fibers. The sons mistake the milky liquid for palm wine and ask their father for a drink. When Nkond explains that it is water, they do not believe him and beat him. His daughter Ruwej comes to his aid. As punishment for his sons' injustice, Nkond curses them and names his daughter as his successor. Ruwej and her people live peacefully under her leadership until an exotic prince, Chibinda Ilunga, the son of the great Luba leader Kalala Ilunga, ventures into their region over the course of a hunting expedition.[3] In order to quench his thirst, Chibinda taps some palm wine from a tree belonging to

a notable at Ruwej's court. In the spirit of reciprocity, he leaves game at the foot of the tree. That gesture of deference and evidence of his skill as a hunter is reported to Ruwej, who invites him to share a meal with her. Ruwej subsequently marries this foreign prince and entrusts to him the sacred *lukano* bracelet, her peoples' emblem of chieftaincy. Ruwej's brothers consider this a betrayal and migrate southwest to found new communities. The issue of Ruwej and Chibinda Ilunga's union becomes a sovereign whose reign marks the institution of a new line of leadership and the founding of a Lunda Empire in what is conceived to be about the sixteenth century.

The success of the Lunda dynasty, it has been suggested, derived from a synthesis of indigenous traditions with innovations introduced by Chibinda Ilunga,[4] including a set of rules and teachings that established a more sophisticated form of sacred leadership and the promotion of better hunting methods. For these critical advancements, Chibinda Ilunga is celebrated by many central African peoples as a civilizing hero. The Lunda Empire established by his descendants prospered from the seventeenth to the early nineteenth century, partly as a result of the Atlantic slave trade, and was the dominant power in what is today eastern Angola and the southeastern Democratic Republic of the Congo. With the abolition of the slave trade in the 1830s, however, the fortunes of peoples in the region changed. Instead of slaves, Portuguese traders along the coast demanded ivory, rubber, and wax. The immediate beneficiary of this shift was the Chokwe peoples, who supplied most of these materials. The Chokwe population expanded and eventually challenged the power of the Lunda Empire, which they conquered in the 1880s.[5]

The author of this depiction of a Chokwe chief has distilled his subject to essential features to suggest an august and dynamic leader. A sense of vitality is conveyed by the chief's gesturing hands, which he holds before his torso. The feet and hands, rendered almost identically, echo one another. The contours of the horizontal, coffee-bean-shaped eyes are accented above by eyebrows that rise in a broad arc from the bridge of the nose. His overall form is defined by a series of rounded, flowing contours: shoulders, bent knees, and bent elbows, surmounted by a dramatically undulating headdress of leadership whose schematic treatment of flowing forms is beautifully balanced and elegant. Known as *mutwe wa kayanda,* the headdress consists of wings that curve out laterally and upward above either shoulder. A flared oblong panel extends above the forehead, with three conjoined lobes at back. At the base of the center lobe is a tapered cone that falls over the nape of the neck.

The figure stands on a horizontal, cylindrical openwork platform. In the crown of his head is another cylinder, this one vertical, into which a long metal lance is inserted. The spearlike form points up, its flat blade narrowing from the rounded base to the tip. As an attribute, the spear invokes the hunter-prince Chibinda Ilunga, the idealized forefather of Chokwe leadership.

Notes

1. Palmeirim 1994, p. 34.
2. Summary as cited in ibid., p. 35.
3. Ibid., p. 38.
4. Palmeirim in Jordan 1998, p. 21.
5. Miller 1970, pp. 175, 195.

Ex coll.

Fondation Yuto, Geneva; Doris and Eric Beyersdorf, New York

Published

Sotheby Parke Bernet 1980, lot 125; Bastin 1982, p. 122.

21. Portrait of a Chief

Chokwe peoples; Angola
19th–20th century
Wood; H. 14⅝ in. (37.1 cm)
The Clyman Collection

Chokwe leaders rose to unprecedented heights of economic and political power in the nineteenth century. Beginning in the 1830s, Portuguese traders along the coast at Luanda abandoned the slave trade in favor of ivory and wax. As the principal suppliers of these products in the region, the Chokwe were ideally positioned to take advantage of this new economic opportunity.[1] Initially they collected resources in their own territories, but they quickly exhausted what was available. The Chokwe leadership proved adaptable, and within several decades they took on the role of middlemen, operating trading caravans that collected ivory and rubber from Luluwa and Luba sources north-

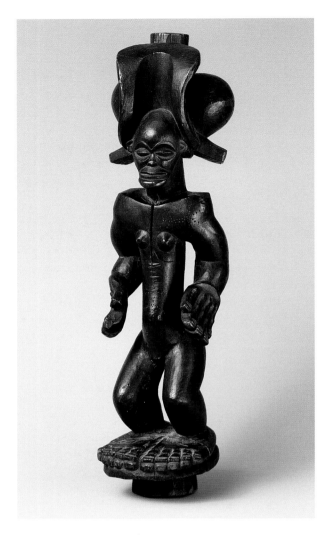

east of the Kasai River.[2] By the late 1880s the Chokwe had displaced the weakened Lunda Empire as the premier power in the region, and their leaders assumed positions of greater influence.[3] During this period Chokwe chiefs commissioned sculptures that reflected this newfound status. The chiefs were depicted as heirs to the culture hero Chibinda Ilunga, who introduced innovative and enlightened governance to the Chokwe, Lunda, and other peoples of Ruwund heritage.[4]

Unlike the Lunda, who were ruled by a single, supreme leader known as *mwata yamvo,* the Chokwe were governed by a number of *mwanangana,* or "lords of the land,"[5] who became sacred persons through rituals of enthronement. They were venerated as absolute masters and were held accountable for the community's well-being. Chokwe chiefs were regarded as representatives of God on Earth and as intermediaries not only between humans and the realm of ancestral and nature spirits but also between their peoples' past and present. In this capacity, Chokwe chiefs performed propitiatory

ceremonies commemorating the achievements of the founders of their lineages.

Portraits of chiefs are the main genre of Chokwe court art. In this classic example, the subject is depicted wearing the striking and complicated headdress of leadership called *mutwe wa kayanda,* worn only by great Chokwe potentates. Headdresses of this kind are made of a framework of sticks bound together with fibers and covered with cloth. A sort of horn rises from the main cap and bends backward, and a fillet stands up in front. Two bands of cloth hang down to the cheeks. The cap was sometimes decorated with beads, brass wire, and nails.

In this figure, the delicacy of the finely chiseled facial features and the body's slender cast contrasts with the baroque exuberance of the headgear. Composed of a series of interconnected arabesques and an intricate juxtaposition of negative space, the *mutwe wa kayanda* is impressive from any angle. The central lobe frames the perimeter of the head and curves inward. Directly behind it is a conical form flanked by two broad, rounded volumes with extensions that gently project from their bases. Passages of the body are articulated as a series of independent but essentially interconnected masses. The smooth surface of the torso is uninterrupted save the small conical nipples. The sculptor's rendering of the arm and knees as a series of angles extends the torso forward and backward and enlivens it with dynamic undulations. The view from the back is of repeated, rounded curves with angled lines.

The exaggerated scale of the feet reveals carefully articulated toes. A rounded platform beneath them, which follows their contours, is supported underneath by a raised cylindrical base. The hands are similarly rendered, so that each finger and nail is defined. The flex of the legs, the raised arms, and the exaggerated proportions of the hands and feet convey a sense of readiness for action. The gesture of the hands in front of the chest, referred to as *taci,* is a sign of power and strength that symbolizes the chief's vitality and the prosperity of his kingdom.[6]

Notes

1. Miller 1970, pp. 175, 178.
2. Ibid., p. 182.
3. Ibid., p. 196.
4. Bastin in Jordan 1998, p. 29.
5. Bastin 1982, p. 43.
6. Ibid., p. 112.

Published

Hôtel Drouot 1992, lot 33.

22. Chibinda Ilunga Figure

Chokwe peoples; Angola
19th–20th century
Wood; 15⅝ in. (39.7 cm)
Collection of Laura and James J. Ross

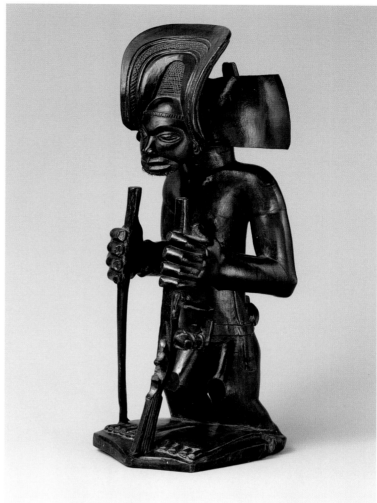

The Chokwe once lived in the interior of what is today Angola, a forested area where elephants abounded, and were renowned as the best hunters in the region.[1] With the increase in demand for ivory in the early nineteenth century, the Chokwe acquired great wealth through the elephant hunt. Their efficacy was such that by 1854 they had wiped out elephants in their own territory and had begun to move north in pursuit of fresh herds.[2]

In Chokwe culture the archetypal hunter, or *yaga,* is the mythical hero Chibinda Ilunga. As a result of this strong identification with Chibinda's vocation, and the appeal of his legacy as a civilizing agent, Chokwe chiefs commissioned depictions of him as a princely hunter. Chibinda figures are generally nude except for a hunter's belt, implements held in either hand, and one of the two distinctive headdresses associated with the title *mwanangana,* or "lords of the land," held by Chokwe chiefs. In this version, the figure's head is crowned by the flaring, trilobed *cipanya mutwe* headdress, whose design is said to evoke metaphorically the black stork, or *khumbi* (*Sphenorhynchus abdimii*), a symbol of life, fecundity, and dynastic continuity.[3] It features a broad, central rectilinear panel that bends to conform to the sides of the head and two lateral wings that curve horizontally toward the back. The figure's features are unusually fine and naturalistic. A serene, handsome face is combined with a powerful body that seems capable of forceful physical action. The knees are bent in a stance of readiness.

Chibinda Ilunga was famed for his skill with a bow and arrow. Since the eighteenth century, however, when firearms were introduced into central Angola, the Chokwe hunter's preferred weapon has been the flintlock musket and, more recently, a percussion gun.[4] In this work, the figure holds a flintlock vertically in his left hand, barrel up. In his right hand he carries a stick known as a *cisokolu,* which has a hook where a sort of wallet, or *mukata,* may be hung. He wears a belt for carrying other essential hunting implements, such as a cartridge pouch, powder flask, hatchet, and knife.[5]

Notes

1. Miller 1970, p. 175.
2. Ibid., p. 179.
3. Bastin 1982, p. 137.
4. Ibid., p. 39; Miller 1970, p. 176. The Chokwe imported significant quantities of guns at the beginning of the eighteenth century, when the Atlantic slave trade dominated the region's economy.
5. Bastin 1982, p. 40.

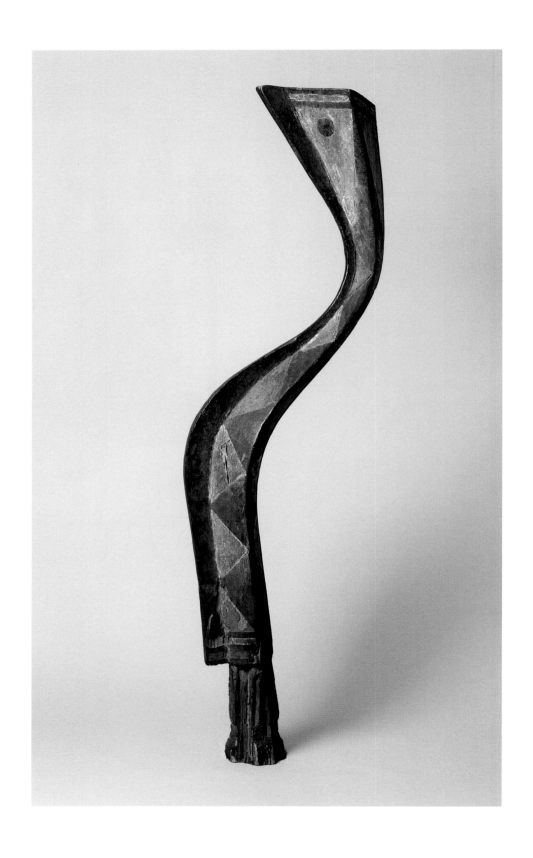

23. Headdress (*a-Mantsho-na-Tshol*)

Baga peoples; Guinea
19th–20th century
Wood and pigment; H. 65½ in. (166.4 cm)
Collection of Shelly Mehlman Dinhofer

Peoples of Baga and related cultural heritage, including the Kakissa, Kalum, Bulunits, Landuma, and Nalu, reside along the Atlantic coast in present-day Guinea. Baga oral histories recall how their ancestors were expelled from their homeland—in the highlands of the mountainous Fouta Djallon region in Guinea's interior—by the Fulbe peoples. According to this tradition, the Baga were forced to migrate because of the disruption of their farming lifestyle by destructive Fulbe cattle-herding practices and also because of their refusal to convert to Islam. Although Baga conceptions of this episode situate it in the eighteenth century, written sources and archaeological evidence suggest that it might have occurred sometime before the fifteenth.[1]

Frederick Lamp notes that each Baga subgroup and village has its own account describing Fouta Djallon as their point of origin, their journey's trajectory, and the names of the individuals who led them in the migration.[2] Baga villages are divided into between two and four sections that are ranked according to the order in which they arrived from Fouta Djallon in the oral narratives. Each section comprises five or six clans ranked in the same manner. The clan to which the village section's founding ancestor belonged is preeminent. Village affairs and governance are managed through the clan as a unit or through an elder designated to represent each clan.[3]

All Baga migration histories trace their artistic traditions back to Fouta Djallon and affirm that they brought sacred masks with them to the coast.[4] Among these was a serpent spirit headdress called *a-Mantsho-na-Tshol,* which is credited with guiding the ancestors toward new lands and protecting them by inspiring fear in outsiders.[5] The headdress was carved to resemble a mystical serpent entity whom the Baga refer to as Nininanka, a spirit common to the beliefs of many peoples in the region. Although the Baga revere Nininanka for his heightened sense of perception and his ability to provide rain, bestow riches, and bring children to the infertile, a heavy cost is exacted from those who benefit from his association.[6] The sculpted *a-Mantsho-na-Tshol* headdress was distinct from its source of inspiration, however; as Lamp notes, the Baga appropriated Nininanka's power to yield their own spiritual being.[7]

The spiritual force represented by *a-Mantsho-na-Tshol,* which has been translated as "master of medicine," is greatly feared by the Baga and their cultural relatives and reigns supreme.[8] Its primary physical manifestation is a brilliantly colored, larger-than-life aquatic serpent resembling a boa constrictor. His form is mutable: he may materialize as a being with human attributes, or as a rainbow that "after having drunk comes out again at the river sources."[9] The Baga consider the rainbow both the source of rivers and the end of rains. The appearance of the *a-Mantsho-na-Tshol* headdress at initiations was thus consistent with these associations of beginnings and conclusions, life and death, and the perpetuation of lineages.[10] The headdresses also appear to have been emblems of a clan's identity and power, used in clan competitions or danced at any time to enliven the community.[11] In performance, the massive wood sculptural element would be set vertically on top of a conical framework of palm branches, which was covered with a palm fiber costume that fell to the ground. The ensemble was then placed over the dancer's head. Brilliantly colored textiles were wrapped directly below the base; at the summit, feathers and cloth streamers flew in the air as the dancer moved.[12] The performers, all strong young men, would take turns dancing to demonstrate varied styles and approaches.

The sinuous curves and undulating contours of this especially elegant example capture Nininanka's unyielding power, elusive grace, and flexibility. From base to summit, the broad vertical column rises, bends to one side, rises at an angle, and ascends again, culminating in a bold head. A chain of lozenges is incised and painted up the length, the interstices in red and white. In this interpretation the bend is particularly pronounced; the

subject appears to be simultaneously yielding to and defying the force of gravity.

Notes

1. Lamp 1996, p. 49.
2. Ibid., p. 50.
3. Ibid., p. 65.
4. Ibid., p. 52.
5. Ibid., p. 76.
6. Ibid., p. 77.
7. Ibid., p. 80.
8. Ibid., p. 76.
9. Appia 1944, p. 41.
10. Lamp 1996, p. 82.
11. Ibid., p. 80.
12. Ibid., pp. 77, 83.

Ex coll.

Pierre Matisse, New York

Published

Sieber and Walker 1987, p. 53, no. 15; Robbins and Nooter 1989, p. 142, no. 243.

B W A

24. Buffalo Mask

Bwa peoples; Burkina Faso
19th–20th century
Wood, paint, and fiber; H. 25 in. (63.5 cm)
Collection of Drs. Daniel and Marian Malcolm

According to the Bwa peoples of Mali and Burkina Faso, the world was created by Difini (or Dobweni), who abandoned the Earth after he was wounded by a woman pounding millet with a pestle. He sent his son, Do, to be his representative among humankind. Since that time, Do, who is visually manifested through leaf masquerades, has been central to all ceremonies seeking to ensure the renewal of life.[1] He also serves as an intermediary with the forces of nature and is the source of agricultural staples—both functions critical to the Bwa, who consider farming the noblest of occupations.

Although Do is the primary divine force responsive to the needs of all members of a Bwa community, Bwa religion also embraces relationships with powerful nature and bush spirits.[2] In contrast to the communal worship of Do, Bwa families identify themselves with specific, individual spirit forces. This relationship is made manifest through the ownership of wood masks, each of which represents one of the powerful spirit forces honored by the group.[3]

According to Bwa oral histories, wood masks were adopted within the last two centuries.[4] The same histories recount the origins of relationships between individual families and particular mask forms. Emily Hanna-Vergara notes that Bwa origin myths tend to follow one of three formulas.[5] In the first, a mask is encountered outside the village by a blacksmith or griot, who brings it to the attention of his family's leadership. These elders determine the significance of the find by making sacrifices to the ancestors and by consulting diviners. The mask is eventually brought to the village and becomes the family's property. A second formula involves a villager who has a dream or vision of a spirit in the form of a mask. The dream is interpreted by a diviner, and a mask is commissioned to honor the spirit.[6] The third type of narrative describes an encounter between a villager and a spirit who appears in the form of an animal. The spirit renders aid by leading the person to water or offering nourishment, and a mask is subsequently created to embody and honor the spirit.

Following a mask's discovery and integration into a family's spiritual life, it becomes their exclusive property. The myth of its origin is carefully guarded knowledge, kept secret from other members of the community but passed down to successive generations of the family and re-created in performances.[7] Hanna-Vergara notes that although these mythical accounts of mask origins describe idealized interactions between the human and spirit worlds, in practice masks are often bought, adopted, copied, or even stolen from neighboring groups. The circumstances surrounding the acquisition of a particular mask genre is another type of secret information that is usually guarded by a family's elders and never revealed to younger uninitiated members or outsiders.[8]

This buffalo mask belongs to a tradition of Bwa animal representations in which the head is rendered as a long rectangular element with a triangular muzzle and large round eyes surrounded by concentric circles.

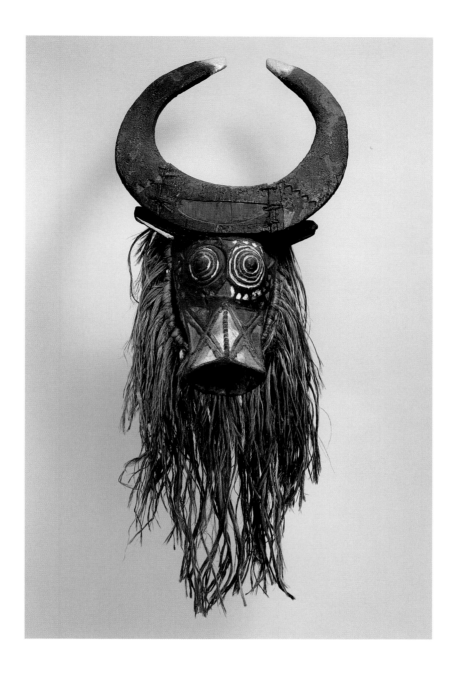

These powerful graphic features are deeply incised and painted with bold pigments. The buffalo mask is distinguished from that of the antelope, a similar genre, by the horns at its summit, arranged so that they curve inward to make a perfect circle.

A dancer wearing this mask in performance would rapidly toss his head up and down, the mask barely touching the ground in front of him, to evoke the vigorous movement attributed to buffalo. The tips of the horns would strain toward his back as he steadied himself with two wood canes, held in either hand to represent the animal's forelegs.[9]

Notes

1. Roy 1987, p. 262.
2. Hanna-Vergara 1996, p. 126.
3. Ibid., pp. 116, 133, 181.
4. Ibid., pp. 116, 118.
5. Ibid., p. 127.
6. Ibid., p. 128.
7. Ibid., p. 127; Roy 1999, pp. 223, 240.
8. Hanna-Vergara 1996, p. 218.
9. Roy 1987, p. 295.

Published

Anderson and Kreamer 1989, p. 115.

25. Butterfly Mask

Bwa peoples; Burkina Faso
19th–20th century
Wood and pigment; L. 96½ in. (245.1 cm)
Collection of Thomas G. B. Wheelock

The vast corpus of Bwa masquerades includes a rich profusion of forms, styles, and sizes. This is explained in part by Bwa culture's openness to adaptation and innovation,[1] which afforded their sculptors the latitude to draw freely on the traditions of neighboring ethnic groups for stylistic inspiration. Among these varied genres are both representational and abstract wood masks. The representational forms incorporate a single identifying attribute of a human character, bush spirit, or animal—such as the antelope, bush buffalo, monkey, bush pig, crocodile, fish, snake, butterfly, hawk, or vulture—into a face mask worn with an attached fiber costume that covers the head. Most Bwa masks, especially the plank masks (see cat. no. 27), are two-dimensional and do not extend to the back of the head. During a performance, the dancer secures the mask to his face by biting down on a thick fiber rope that passes through holes in the mask.[2] The unique character of each mask is elaborated through expressive musical accompaniment, movements, and dance choreography.[3]

Among the most essentialized of Bwa mask forms is that of the butterfly, which consists of a broad horizontal plank decorated with large concentric patterns. Known as *yehoti* in the Bwa center of Boni, they symbolize the new life that attends spring, when butterflies hatch and cluster around pools left by the first rains of the year.[4] The ten enormous target patterns covering the surface represent colored markings on the butterfly's wings.[5] In performance, the dancer would rotate this monumental sculptural element in rapid horizontal movements.[6]

Notes

1. Hanna-Vergara 1996, p. 116.
2. Roy 1987, p. 272.
3. Roy 1999, pp. 236–40.
4. Roy 1987, p. 295.
5. Ibid.
6. Ibid.

Ex coll.

René Rasmussen, Paris

Published

Zwernemann 1978, p. 55, fig. 6; Rasmussen sale 1979, lot 9; New York 1996, pp. 160–61, no. 83.

26. Serpent Mask

Bwa peoples; Boni, Burkina Faso
19th–20th century
Wood and pigment; H. 180 in. (457.2 cm)
Collection of Thomas G. B. Wheelock

The awesome vertical extension of the serpent mask, whose undulations project high into the sky, is unparalleled among Bwa masquerade genres. The serpentine rippling effect of the form is dramatized in performance as the dancer twists his head rapidly from side to side.[1] The myth describing the origins of this mask, documented by Christopher Roy, relates that many years ago the men of Dossi raided a neighboring

village and were routed in the attempt. An elder member of the raiding party hid from his vengeful pursuers in the burrow of a great serpent. He reassured the serpent that he was not there to harm it but to save his own life, and the serpent fed him during the two market weeks he was forced to hide there. Upon his return to Dossi he consulted a diviner, who told him to carve a mask and to respect the serpent as a protective spirit.[2]

Wood masks like this one relate to the identity and well-being of a specific clan. (This specificity is in contrast to the leaf masks dedicated to Do, who as the representative of the creator is widely worshiped in Bwa society.) Among the southern Bwa, performances of wood masks are highly competitive events organized by individual clans, who seek to obtain more impressive masks than their rivals and thus mount the most spectacular and innovative performances.[3] These displays sometimes incorporate the simultaneous performance of up to nine masks. Roy notes that for the Bwa, building a family's arsenal of masks is an ongoing and vital process. A spectator who admires a mask in a nearby village may be inspired to add it to his own family's repertoire. In order to do so, he would purchase the rights to acquire the mask, commission its carving, and consult a diviner so that the spirit entity represented by the mask would be incorporated into his own clan's mythic history.[4]

Wood masks play an important role in the initiations of young men and women as well as in burials and commemorative tributes. They also appear at many events during the dry season, including the introduction of newly carved masks, market-day dances, and harvest celebrations, when performances tend to feature masks representing spirits associated with fertility, including the serpent mask and the *bayiri* plank mask (see cat. no. 27).[5] These generally serve to thank the spirits and ancestors for watching over the village and for providing good harvests.

Notes

1. Roy 1987, p. 293.
2. Ibid., p. 268.
3. Ibid., p. 288.
4. Ibid., pp. 295–96.
5. Ibid., p. 292.

Published

Huet and Paudrat 1978, p. 162; Roy 1987, p. 294, fig. 257; Anderson and Kreamer 1989, pp. 68, 119, fig. 76; Roberts 1995, p. 121, no. 30; Nunley and McCarty 1999, pp. 90, 309, no. 30 (colorpl.).

27. Plank Mask (*bayiri*)

Bwa peoples; Burkina Faso
19th–20th century
Wood and pigment; H. 46½ in. (118.1 cm)
Collection of Thomas G. B. Wheelock

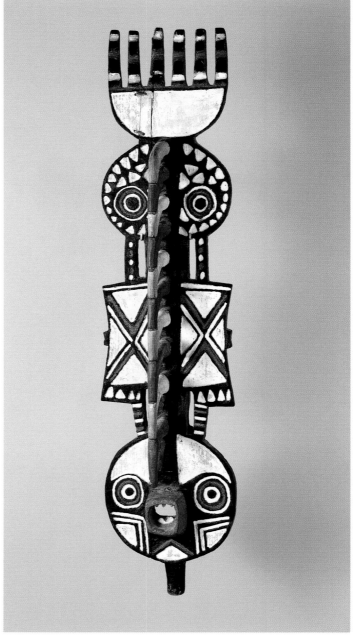

Among the nonrepresentational Bwa mask genres is *bayiri,* a plank mask with many hooks that evokes an elderly female spirit of growth and renewal. *Bayiri* are not intended to look like any natural being; rather, they embody supernatural forces that act on behalf of the Bwa clans that own them.[1] When a clan's elders commission a *bayiri* mask, they carefully describe to the artist the abstract patterns that are to be carved onto its surface. This surface ornamentation is deliberately conceived as an esoteric text whose vivid graphic language, it has been suggested, is derived from designs inscribed on the human body during initiation rites.[2] The notations have also been interpreted as signs marking the passage of time, phases of the moon, and relationships among human beings, ancestors, and the divine forces that rule the universe. Ultimately these geometric red, white, and black motifs function as a symbolic vocabulary of the spirit world.[3] Understanding of the language is furthered through initiation-based instruction, and fluency is acquired over time.

Although each graphic element of a *bayiri* mask has a specific definition, the meaning of an element can vary depending on its relation to other symbols on the mask and on the interpreter's level of insight. To help explain these meanings, elders employ rectangular didactic boards, on which the same geometric signs have been painted, in conjunction with the actual masks. The boards help to elucidate the signs first as independent symbols and then as part of a combined meaning derived from a specific mask's composition. The signs' colors relate to the exchange of knowledge in Bwa society. Black, for example, is the color of wisdom accumulated by men and women throughout their ongoing participation in the spiritual life of the community; white is associated with those who have just embarked upon a course of initiation.[4]

The visual program of a particular mask communicates precepts established by a family's ancestors, such as the myth of the clan's founding, and preserves them from one generation to the next.[5] It also gives expression to moral or historical lessons and to rules of social behavior that members of a family must follow if they are to receive God's blessings.[6] Each mask's particular combination of motifs has a name known only to initiates that is never used to address the mask during performances; the owner chooses a separate name for use in the public arena.[7]

In this example, the plank has been subdivided into a series of distinct, stacked units that constitute a boldly articulated notational system of black and

white elements. At the base is a circle with eyes and a mouth, surmounted by a rectangle, an oval, and, at the summit, a semicircle with a row of six projecting vertical elements. Although each passage is autonomous in its graphic treatment, the formal elements are all unified by the white background. The passages are further integrated by a column of superimposed, hooklike projections at the center of the mask that disrupt the flat plane of its underlying structure. Interpretations of what the hooks signify—from the circumcised penis of an initiated adolescent to the beak of the hornbill, a magical bird ascribed divinatory powers—vary depending on the perspective of a particular family, village, or initiation level. Indeed, the contextual relationships that inform a sign's meaning may differ from mask to mask, depending on the relationship of the mask to the history of a particular clan.[8]

Christopher Roy provides general definitions for a number of the motifs emblazoned across the surface of this work. He interprets the concentric targets on the round facial area at the base as the eyes of an owl, a bird symbolizing magical power. The circles farther up the

plank have been identified as sacred wells in Boni that were discovered by the ancestors and which never go dry. The mouth at bottom also reads as a sacred well, one whose water may be drawn only by the mask-owning clans of the village. The large white crescent at the apex is the "moon of masks," which shines throughout the season when the masks are performed.

Notes

1. Roy 1987, p. 296.
2. Coquet and Regis in Hanna-Vergara 1996, p. 151.
3. Roy 1999, p. 235.
4. Ibid., p. 248.
5. Roy 1987, p. 290.
6. Roy 1999, p. 223.
7. Roy 1987, p. 296.
8. Ibid., pp. 296–98.

Published

Kamer 1973, p. 125; Zwernemann 1978, p. 55, fig. 6; Anderson and Kreamer 1989, p. 116, fig. 70; Nooter 1993, p. 58, no. 19.

KURUMBA

28. Headdress (*adoné*)

Kurumba peoples (Nyonyose clan); Burkina Faso
19th–20th century
Wood and pigment; H. 42⅜ in. (107.6 cm)
The Metropolitan Museum of Art, New York; The Michael C. Rockefeller Memorial Collection, Bequest of Nelson A. Rockefeller, 1979 (1979.206.253)

Relatively naturalistic antelope headdresses known as *adoné* are primarily attributed to the northernmost Kurumba region of Burkina Faso, which encompasses the towns of Toulfe, Djibo, and Aribinda.[1] Leadership in these communities has traditionally been decentralized, with lineages of the same clan living together in large neighborhoods.[2] *Adoné* related intimately to the lives of these extended families;[3] it is possible they were commissioned to honor the memories of leading elders upon their deaths. During the sacrifices made to inaugurate such a work, it was given

the name of the deceased and became a memorial infused with its own life force. *Adoné* may also have served as sites for offerings and prayers to the ancestors as well as visual highlights of a series of honorific performances. They could be used as portable altars or placed on an existing altar in the ancestral spirit house within a family compound. When danced in performance, they were worn on the top of the head as crests.

The appearance of *adoné* generally accompanied three major annual events. They represented clan ancestors when the bodies of male and female elders were led to burial; they served as tributes to those deceased elders at commemorative celebrations organized during the dry season; and they were celebratory emblems at collective sacrifices, held just before the first rains in late May and June, which paid homage to the spirits of the ancestors and to the protective antelope (*Hippotragus koba*) that is the totem of most Kurumba clans.[4]

The design of these graceful antelope forms emphasizes the slender features of the animal's horns, neck,

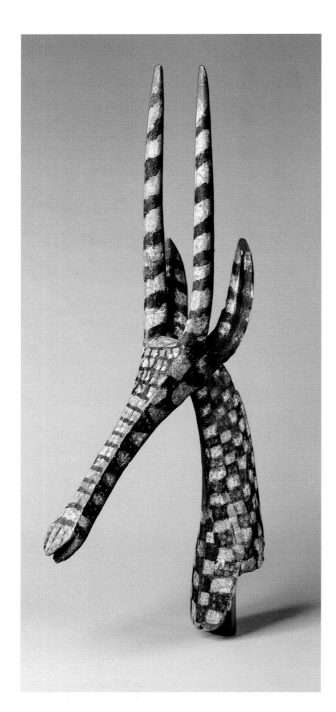

and snout. Typically the surface is enlivened with extensive geometric patterns of brilliant ocher brown, red, yellow, and kaolin pigments. In this example, the antelope's neck is relatively long, and the graceful sweep of the horns rising from the top of the head is echoed by the long ears. Black and white pigments have been applied to the surface in a checkerboard pattern along the neck and in broad horizontal stripes along the horns and muzzle. Red is used to accent parts of the inner ears and in the passages of white.

It has been suggested that the symbols painted on *adoné* masks make reference to major episodes in clan histories and may represent cosmological myths of origin.[5] For example, the antelope could have been considered the protagonist responsible for saving the life of that family's founding member as recounted in the narrative concerning the clan's origins. Some of these conclusions were drawn by Annemarie Schweeger-Hefel by comparing the symbols on *adoné* to similar graphic symbols used by the Dogon. There is uncertainty about the specific meanings of these graphic elements, however, because Kurumba sources were unwilling or unable to interpret them.[6] As a consequence, the purported meanings of the Kurumba painted motifs may be problematic, particularly given that contemporary scholars have questioned some of the Dogon sources on which they are based.

Notes

1. Roy 1987, p. 197.
2. Ibid., p. 196.
3. Skougstad 1978, p. 10.
4. Roy 1987, p. 200.
5. Ibid., p. 202.
6. Schweeger-Hefel 1966.

Published

Roy 1987, p. 201, no. 164.

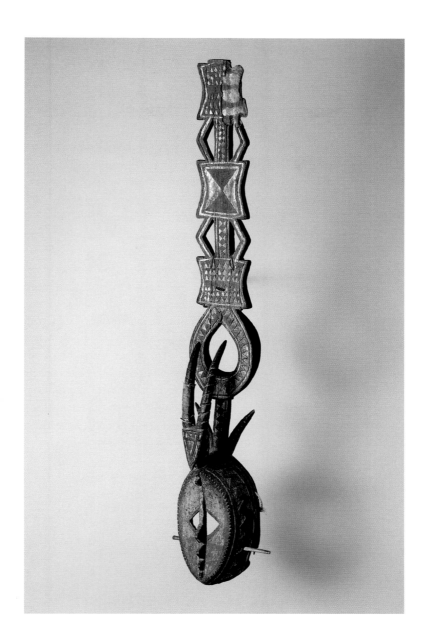

MOSSI

29. Mask (*karanga*)

Mossi peoples; Burkina Faso
19th–20th century
Wood and pigment; H. 42¼ in. (107.3 cm)
Collection of Thomas G. B. Wheelock

In Mossi society, the male head of a clan often owns a mask that evokes an important being or animal from his family's origin myth.[1] This type of relationship underlies a series of totemic animal masks used by clans in central Burkina Faso, particularly in Yatenga, Risiam, and the old Ouagadougou kingdom.[2] The clan and its totemic animal, or *sigha,* are profoundly and inextricably linked. They share the same life force, and each clan member's soul is inseparable from the clanic animal. Any illness or injury that befalls one will affect the other.[3] The origin myth of the Sawadogo clan of the village of Goupana, for example, recounts how the clan's founding ancestor became lost while hunting deep in the bush and was unable to find a water hole. A small antelope suddenly appeared before him and headed into the bush. The hunter raised his weapon to kill the animal, but he was unable to do so. Instead, the

animal led him to water and saved his life. The antelope thus became his family's totem, and members of that clan no longer hunt or eat antelope.[4]

The most common totemic animals of the mask-owning families in the Yatenga area are two different varieties of antelope, whose features have been integrated into *karanga,* the region's most prominent masking tradition. This type of mask is produced exclusively in the northeastern area of Mossi country.[5] The overall form consists of a round or oval facial mask surmounted by a tall, thin wood plank that is usually 1–1 ½ meters high. An antelope's head and horns are depicted where the face mask intersects with the vertical extension. Heads with short S-shaped horns represent the small antelope (*Gazella rufifrons*), which the Mossi call *nyaka;* those with longer, straight horns represent the large antelope (*Hippotragus koba*), or *wid-pelago.*[6] The concave face and the geometric motifs inscribed in the surface of the plank are painted with white chalk, red earth, and hematite pigments. Abstract patterns incised on the sides may imitate traditional facial cicatrization.[7] These works are stylistically akin to the vertical plank masks of the Dogon, who are relatives of the Nyonyose clan of Yatenga and who occupied the region until about 1500, when they migrated to the Bandiagara in Mali.[8]

This *karanga* mask is especially bold in its sculptural and graphic design. The convex head suggests a gourd-like form and the antelope an emblematic coat of arms. The recognizable antelope representation is embedded in an otherwise highly abstract composition that includes concentric circles around the eye cavities, alternating triangle motifs, a zigzag emblazoned on the side, and ridges along the length of the horns. The openwork extension of the plank is composed of a series of interconnected oval, rectangular, and trapezoidal forms.

Totemic masks of this kind are intended to serve as direct lines of communication between their owners and the founding members of their owners' extended family. When stripped of its costume, which is stored separately, the mask may serve as the personal ancestral altar of the owner and his clan.[9] Each year the clan applies libations to its masks at a community ritual known as *suku,* which occurs in May, just before the beginning of the rainy season. These sacrifices and prayers invoke the protection and blessings of all the clan's ancestors. Appeals are made for an early and abundant rainy season as well as for the general well-being of the entire clan during the coming year. Over the course of *suku,* the clans honor their ancestors by moving the masks through the village to visit each clan spirit house in the neighborhood.[10]

Mossi masks, so central to a family's origins as well as to its more recent past, present, and future, also play a prominent role in assuring a smooth transition to the afterlife. During the burial of any male or female clan elder, masks escort the body to the grave and ensure that all burial procedures are properly followed. In the dry season following the burial, when a ceremony is held to commemorate all clan members who died over the course of the preceding year, the masks belonging to the clan of the deceased are used again to honor that individual and assure his or her final passage to the ancestral realm.[11] At the conclusion of the rites, the spirits' union with clan ancestors is joyfully celebrated with dances in which performers imitate the motions of the animals their masks represent.

Notes

1. Roy 1983–84, part 2, p. 11; Roy 1987, p. 143.
2. Roy 1983–84, part 2, p. 12.
3. Ibid.
4. Dim Delobsom as cited in Roy 1983–84, part 2, pp. 11–12.
5. Another kind of antelope headdress, called *adoné* (see cat. no. 28), was sculpted by the Kurumba, the Mossi's northern neighbors in Burkina Faso. Following their incursions into the region in the sixteenth century, the Kurumba remained politically independent of the Mossi. However, the ancestors of the northeastern Mossi were Kurumba, and the two peoples in the region share many important cultural affinities.
6. Roy 1983–84, part 2, p. 12.
7. Roy 1987, p. 114.
8. Roy 1983–84, part 2, p. 16.
9. Roy 1987, p. 145.
10. Ibid., p. 146.
11. Roy 1983–84, part 2, p. 12.

30. Reliquary Figure

Fang peoples (Ngumba); Cameroon
19th century
Wood and brass; H. 22 in. (55.8 cm)
Private collection

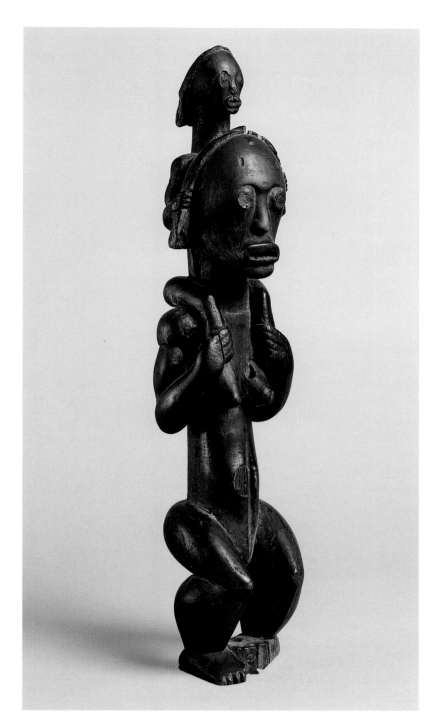

The Fang participated in a series of mass migrations of peoples across central Africa that profoundly informed their cultural identity. These epic population shifts—generally toward the ocean along a northeast to southwest axis across southern Cameroon, Río Muni, Gabon, and the northeastern portion of the Republic of the Congo (Brazzaville)—occurred in several waves. The first took place in the fourteenth or fifteenth century; a series of later shifts began after 1830.[1] James Fernandez discerns three consistent elements among the innumerable versions of what evolved into the Fang's mythological history or *nkande,* the Fang term for an accurate accounting of events witnessed:[2] an awareness that they once lived in a savanna country to the northeast from which they were chased; the crossing of a great river with the supernatural aid of a chthonic being, crocodile, snake, or hippopotamus; and a giant *azap* tree that blocked their advance farther into the equatorial rain forest.[3]

The Fang genesis myth is altogether more abstract than their mythological history as a peoples. Creation began with the descent of a spider from the sky into the waters below. Termites poured forth from the spider's egg sac and made the Earth. Humans were created later in an act characterized as something only God, Mebege, can comprehend. Mebege first made humans from clay in the shape of a lizard, which he placed in a pool of water. After a number of days he summoned his creation from the water, and Nzame, the son of God, emerged as the first man.[4] Mebege is thus directly linked to every family's extended history because Nzame, who is both divine and human, is the founder of all clan genealogies.[5] Fang genealogies, which average fifteen generations, list ancestors in the patrilineal line back to mythological

times. Among northern Fang, who historically have enjoyed greater stability than their southern counterparts, they can reach up to thirty. The recitation of genealogies was the centerpiece of traditional Fang education.[6]

Within northern Fang patrilineages, the house family, or *ndebot,* is the primary social group. A *ndebot* traces its parentage back to the woman "out of whose womb it was born," and the cohesion of the group derives from this uterine origin.[7] Within this conceptual frame of reference, conferring strangers could arrive at a common ancestry and express the discovery in sayings such as "we are of common birth" or "we are of one stomach."[8]

The Fang ancestor cult, Bieri, was responsible for clearing lines of communication between men and their ancestors.[9] Bieri rites focused on the initiation of new members, the reestablishment of protective benevolence in village affairs, and the according of vitality and honor to the ancestors.[10] The rituals were organized around sacred relics of lineage ancestors—eight to ten crania assembled over several generations of an integrated *ndebot*—along with other related sculptural artifacts. The relics were kept in a bark container, and carved wood figures were placed on top of the container lids to warn off women and children and to provide focus for periodic offerings.[11]

The Bieri cult was also responsible for the assurance of a kin group's fertility, a reflection of the strong association between ancestors and infants. The crania, for example, were looked upon with an almost paternal indulgence by the elders who cared for them and who on occasion took them in their arms, rocking and singing to them.[12] Fernandez suggests that this association is expressed visually in Bieri sculptures, which combine features of idealized maturity with infantlike proportions.[13] The main protagonist in this work carries a miniature figure on her shoulders that, despite its reduced scale, displays an adult physiognomy. The larger figure holds the calves and feet of the smaller figure, who in turn grasps the sides of the main figure's coiffure and faces forward. Both stare out intensely in the same direction, their heads almost superimposed.

Bieri sculptures were not themselves the focus of adoration; rather, they were the instruments through which the Fang connected with the ancestors to promote vitality and equilibrium,[14] concepts that underlie their physical dynamism and bilateral symmetry. Bieri sculptures may also be seen to articulate Fang cultural associations of the body as a metaphor for social structure. According to such analogies, the clan rises in the chest or heart and spreads out through one or both arms to the fingertips, which represent the clan's living members.[15] The clear delineation of body segments in this example complements the manner in which these figures were used as templates for describing lineage and kin relationships. Here the limbs are rendered in a careful and exacting manner. Rounded shoulders, upper arms, and forearms are depicted as contiguous but discrete elements, as are thighs, calves, and feet. Each independent mass bursts with autonomous energy, but they are all gracefully integrated into the overall composition.

This work, which Louis Perrois has attributed to the Fang (Ngumba) of southern Cameroon because of its relatively elongated, slender torso,[16] may depict the female ancestor associated with the origins of a *ndebot.* She is somewhat asexual aside from her gently curving, conical breasts. Her eyes are accented with circular units of cut-brass sheeting that have been attached to the wood surface, and her open mouth is an abstract rectilinear orifice directly above a rounded chin. Each facial feature exhibits the same bold clarity and pronounced compartmentalization that distinguishes the limbs and other body segments.

Notes

1. Vansina 1990, pp. 136–37.
2. Fernandez 1982, p. 53.
3. Ibid., p. 54.
4. Ibid.
5. Ibid.
6. Ibid., p. 76.
7. Ibid., pp. 89, 90, 95.
8. Ibid., p. 76.
9. Ibid., p. 255.
10. Ibid., p. 256.
11. Ibid.
12. Ibid., pp. 254–55.
13. Ibid., p. 254.
14. Ibid., p. 257.
15. Ibid., p. 88.
16. Phillips 1995, p. 321.

Ex coll.

George de Miré, Paris

Published

Phillips 1995, p. 321, fig. 4.93.

31. Ancestral Figure

Bwende peoples; Democratic Republic of the Congo
19th–20th century
Wood, pigment, and faience; H. 8⅝ in. (22 cm)
Collection of Adam M. Lindemann

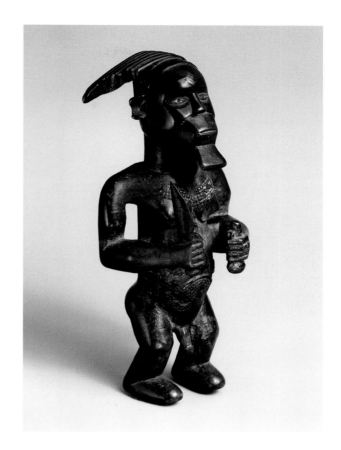

Bwende ancestors who played instrumental roles in the origins of a clan or village or who established social precepts are immortalized in myths recounting their accomplishments. They also become part of the pantheon of Bwende divinities who act as mediators in influencing superior forces on behalf of their progeny. The significance of ancestors in Bwende society is further acknowledged through sculptural representations that bear specific signs and symbols of their rank. These works, which appear to have been commemorative, were empowered to intervene in matters of concern to their owners, usually family heads or ritual specialists.

In this work, a standing male figure holds a knife in one hand and a calabash in the other. A similar figure holding the same attributes—carved by a Bembe sculptor (related to the Bwende through a shared Kongo heritage)—is documented to have been collected from a diviner who specialized in the identification of wrongdoers through an ordeal by poison. This has lead Raoul Lehuard to suggest that the calabash depicted in similar works represents the container holding the poison, or *nkasa*—a mixture of bark and palm wine used as a truth serum—and that the knife is a related symbol of justice.[1]

In this Bwende work, the figure's head is crowned by a dynamic, asymmetrical headdress whose lines draw into a spiral at the top and terminate abruptly in an angled plane. Even on a miniature scale, the figure's physical presence commands great power and stature. The upper body is especially imposing, with its broad neck, square shoulders, and powerful upper arms. The back is rendered so that the shoulder blades are particularly prominent, and the vertical line of the spine is enhanced by a continuous column of lozenges. The torso is covered with extensive and elaborate cicatrization. At the base, the relatively diminutive legs are bent in a stance that suggests imminent movement. The finely rendered face, which has a lozenge motif embedded in its smooth, rounded forehead and a beard that extends to the base of the chin, expresses intense concentration.

Note

1. Lehuard 1989, p. 120.

Ex coll.

John Graham, New York

Published

Lehuard 1989, p. 178; de Grunne 2001, p. 177, no. 50.

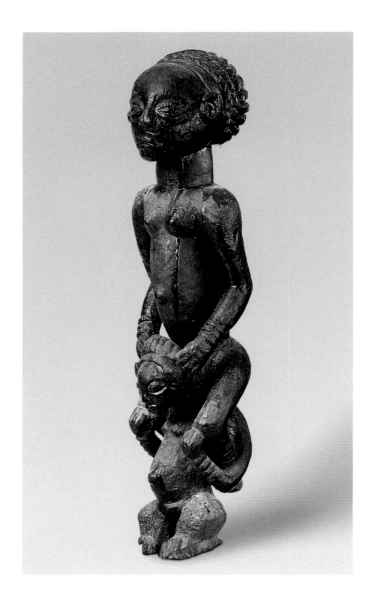

TABWA

32. Ancestral Figure

Tabwa peoples; Democratic Republic of the Congo
19th–20th century
Wood and oil; H. 22 in. (55.9 cm)
Collection of Drs. Daniel and Marian Malcolm

Tabwa conceptions of origins address two distinct beginnings: the creation of the universe, and the establishment of kinship systems.[1] The main protagonist of the Tabwa creation story, which is set at the beginning of time when Earth was a cold, dark, and silent place, is a humanized aardvark named Mutumbi. One day while hunting, Mutumbi was led on a journey through a long subterranean tunnel that took him to Leza, the supreme deity and the source of light. Leza called on him to describe his existence on Earth and sent Mutumbi back to the surface with a man, a woman, and a basket of gifts. When they reached the surface, the man built a fire that brought an end to the cold and darkness. Together with the woman, he then released the contents of the basket: the Sun, the Moon, and the stars. Mutumbi fled from all of these intense light sources and thereafter emerged only during the cover of darkest night.[2]

The story of the origins of Tabwa society varies according to the identity and perspective of the narrator.

In most versions, a progenitor, or "father of clans," emerges from a body of water to set familial relations in motion.[3] He becomes the model for Tabwa chieftaincy and is credited with the introduction of fire and iron smelting. The Tabwa system of descent is matrilineal. A man's heirs are not his biological children, who are considered to be in his wife's family's lineage, but rather his sister's sons. Allen F. Roberts has noted that in Luba society, which is patrilineal, ancestral veneration focuses on female figures, whereas among the Tabwa male ancestral depictions dominate. Roberts suggests that both approaches reflect the interdependence of men and women in their respective descent systems.[4]

The Tabwa live in an area southwest of Lake Tanganyika. They accrued great economic and political power in the mid- to late 1800s as the result of an expanding ivory and slave trade with the East African coast. Wanting to affirm their improved status and emulate their more established neighbors in the centralized Lunda and Luba kingdoms, Tabwa chiefs founded traditions of royal authority within their own territories and promoted new forms of prestige or "statement" art. These visual tributes, which served to consolidate and legitimize their leadership, took the form of figurative sculptures that associated Tabwa chiefs with beauty, wisdom, and ultimate power.[5]

In this two-tiered arrangement of figures, the dominant male protagonist is seated on the shoulders of a diminutive female figure, who grasps his knees. His idealized proportions—a powerful rounded torso and slender arms with hands that rest on the lower figure's head—are made all the more monumental through juxtaposition with the caryatid figure, her head downcast by the weight she bears. The work's most elegant and complex passages occur at the sides, where the two figures intersect. The elaborate interlacement of limbs is gracefully rendered so that, from a lateral view, the upper figure's forearms and thighs are parallel and the woman's upper arms curve around from the shoulders, reaching over the male figure's calves to support his knees. The slight turn in the caryatid's body helps to create a dynamic alignment.

The elegantly repeating, interwoven curves of the figures imbue this work with a lyricism not found in other examples of Tabwa figural pairings. The hierarchical arrangement, on the other hand, is not uncommon in Tabwa and Luba sculptural representations. This may allude to the notion in Luba, Luba-Hemba, and Bemba society that a chief cannot come into contact with the ground during performances of certain rituals and therefore must be carried on the shoulders of a slave.[6] The practice of placing a person on another's shoulders is also a widespread tradition applied to newly initiated youths during rites of passage and to kings and chiefs during investiture rites and other ceremonies of state.[7]

Notes

1. Maurer and Roberts 1985, p. 23.
2. Ibid., p. 24.
3. Ibid., p. 25.
4. Roberts and Roberts 1996, p. 214.
5. Maurer and Roberts 1985, p. 23.
6. Ibid., p. 80.
7. Roberts and Roberts 1996, p. 215.

Ex coll.

Gaston de Havenon, New York

Published

Vogel 1988, p. 26; Robbins and Nooter 1989, p. 448, no. 1153.

33. Ancestral Figure

Hemba peoples; Democratic Republic of the Congo
19th–20th century
Wood; H. 25 in. (63.5 cm)
Collection of Laura and James J. Ross

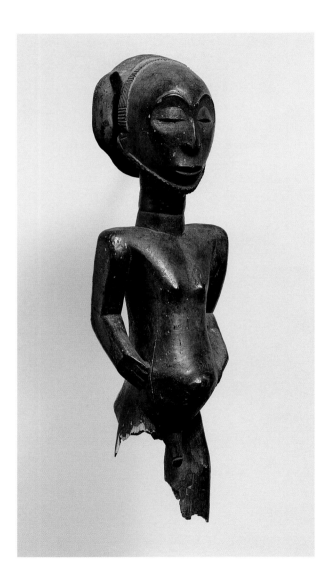

No Hemba account of creation has been documented to date; instead, family genealogies are the overarching frame of reference used by Hemba peoples. Prayers and libations are directed to the spirits of ancestors and to various natural elements.[1] It is the ancestors, however, who are believed to be most responsive to the daily needs of the clan and who assure the health and fertility of its members. Appeals for intervention are followed by an offering that is applied to the ground and to the surface of an ancestral sculpture.[2]

All peoples of Hemba heritage recognize a region known as Lwama na Lulindi, situated near the Hundu Mountains to the north of Kabambare, as their place of origin.[3] Despite significant divergences in the recent past, Hemba families, clans, and chiefdoms share a collective memory of this common place of origin. François Neyt suggests that the Hemba enjoyed the height of their influence toward the end of the eighteenth and the beginning of the nineteenth centuries, the period when the great masterpieces of Hemba sculpture were produced.[4] According to Neyt, Hemba ancestral figures were created at two great centers, one of which involved the Niembo subgroup in the Mbululu region.[5] Niembo work is characterized by its purity of conception and full, volumetric, extremely pared-down forms. This work, with its simplicity of line and balanced proportions, is a classic example of the style.[6] The perfectly oval face is framed by a beard and a cruciform coiffure. The facial expression is meditative, with closed eyes and high, arched brows bisected by the long, narrow ridge of the nose and delicate nostrils. The pronounced creases of the strong neck heighten the realism. The torso is narrow at the summit and swells below. The arms are at the figure's sides, the hands resting on the rounded stomach.

These tall, naturalistic male representations with serene faces are referred to as *singiti.* They were conceived as idealized images of leadership that captured the essence of a particular chief and immortalized him upon his death, after which he influenced the well-being of his descendants as an ancestral force. To ensure the sculpture's longevity, the author used a very hard wood such as *lukulwa* or *kiweba.* Hemba artists generally worked from life, using either the subject as a model or, if he were no longer alive, a member of his family who resembled him.[7]

Each *singiti* situated its subject in a branch of a carefully constructed genealogical tree and related the family's historical ties to the land they inhabited.[8] When a Hemba chief died, his funeral ceremonies were followed by the investiture of his successor. As part of this transfer of power, the new chief inherited the clan's ancestral figures, which were kept in a hive-shaped funerary hut within the clan's compound, near the chief or the chief's primary wife's home.[9] On the occasion of their transfer to a new chief, the history of the clan would be retraced and an appeal addressed to past generations: "Today we install your son as chief. Give him the intelligence, power, and courage to lead this village."[10] Hemba chiefs living between the Lufutuka and Luika rivers generally possessed three or four figures; the southern Niembo, in the Mbulula, Nyanzu, or Makundu communities, had up to twenty or thirty figures that could be divided among several important members of a lineage.[11]

Notes

1. Neyt 1977, p. 433.
2. Ibid., p. 488.
3. Neyt and de Strycker 1974, p. 10.
4. Neyt 1977, p. 505.
5. Ibid., p. 26.
6. Neyt and de Strycker 1974, p. 16.
7. Ibid., p. 14.
8. Neyt in Maurer and Roberts 1985, p. 293.
9. Bastin 1984, p. 349; Neyt 1977, pp. 481–83.
10. Neyt 1977, p. 489.
11. Neyt in Maurer and Roberts 1985, p. 70.

Ex coll.

René Withofs, Brussels

Published

Berjonneau, Sonnery, and Fondation Dapper 1987, no. 229.

BOYO

34. Ancestral Figure

Boyo peoples; Kimano, Democratic Republic of the Congo
Ca. 1750–1800
Wood; H. 34 in. (86.4 cm)
Private collection

The Boyo communities within the Democratic Republic of the Congo, situated along the western banks of Lake Tanganyika, are a complex blend of peoples and cultural identities. The extensive cultural interaction that underlies their heritage has led to some dispute regarding the definition and place of Boyo sculptural traditions within the broader context of the region's art history.[1] Although scholars have described Boyo sculpture as "proto-Luba," suggesting that it might have served as the basis for related traditions in present-day southwest Democratic Republic of the Congo, there is also the idea that it was significantly informed by those same traditions.[2]

Boyo communities were once renowned for their series of majestic royal ancestral representations that varied stylistically from one community to another.[3] As with comparable traditions among the Tumbwe, Tabwa, and Hemba peoples, these ancestral ensembles, which comprised between four and seven works each, were protected in small funerary enclosures.[4] Individual sculptures were named after the particular ancestors they invoked. It seems that the largest and most impressive of the works in a particular group was invariably also the oldest, depicting a founding ancestor. That sculpture, it has been suggested, served as the model or prototype for the others, which represented successive generations of chiefs. Unlike portraiture, which seeks a certain specificity, this method of commemorative representation recast contemporary leaders in the highly idealized, abstract idiom of their forebears. By preserving and perpetuating an artistic approach associated with the origins of the community, the current generation built a powerful bridge to the past. The later works

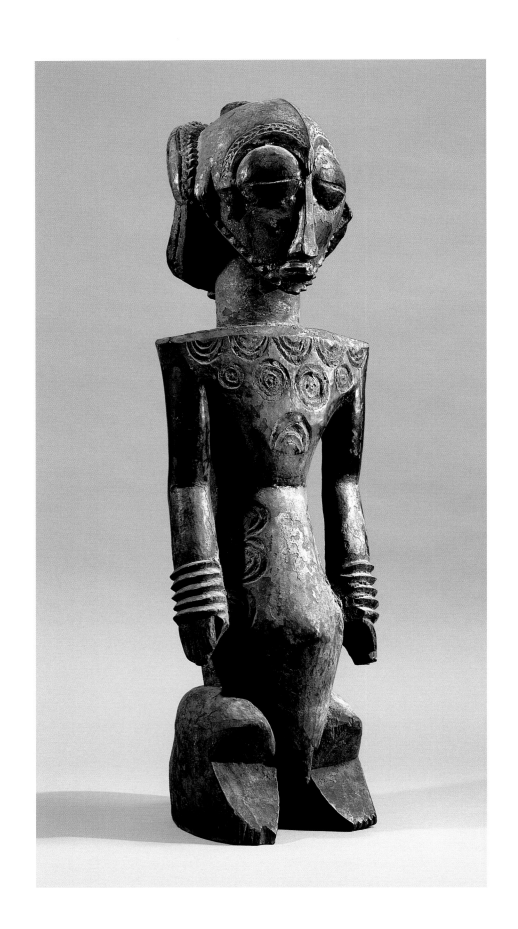

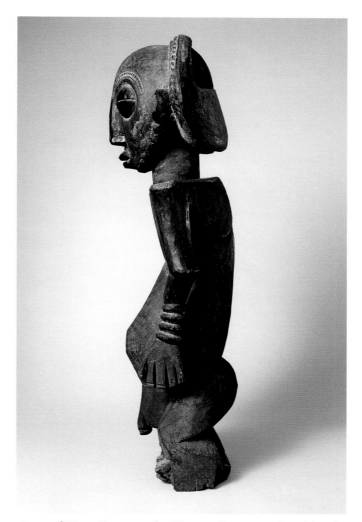

Ancestral Figure. Boyo peoples; Kimano, Democratic Republic of the Congo. 19th century. Wood and kaolin, H. 30½ in. (77.5 cm). The Metropolitan Museum of Art, New York; The Michael C. Rockefeller Memorial Collection, Gift of Nelson A. Rockefeller, 1964 (1978.412.424)

in the ensemble were not copies, however; although several figures were sometimes by the same hand, more than one sculptor was usually in evidence, and the sculptures were further differentiated by stylistic features such as coiffure and posture.

This monumental ancestral figure (cat. no. 34) was collected in the village of Kimano between 1958 and 1960 by a Belgian mining engineer. It had been photographed earlier, in its original funerary sanctuary, as one of a group of four. Contextual photographs of such works often show them with textile wraps fastened around their shoulders and lower body. Two of the figures photographed along with this example—one in the collection of The Metropolitan Museum of Art (above) and one

in the Menil Collection, Houston—appear to have been made by the same hand.[5] Over the course of his research in the region, Belgian scholar Luc de Heusch asked the owner of a related group of works to position them in chronological sequence. He referred to the largest of the figures as the oldest—"the prime object"—and confirmed that the others were later creations inspired by the first.[6]

From head to feet, this formidable representation is very much self-contained, a classic example of the Boyo artistic tradition in which distinguished leaders are depicted simultaneously as being serenely introspective and as possessing an awesome, otherworldly physical presence. The perfectly balanced facial features are

dominated by large, bulging round eyes that are closed and bisected by a long, narrow nose. The prominence of the closed eyes refers to the subject's status as a being endowed with a heightened sense of the spiritual realm. The face tapers sharply along the sides to the chin and is circumscribed by a serrated rim suggesting a beard. The torso has an hourglass configuration—from the horizontal shoulders down to a narrow chest to the full, rounded area of the stomach. A dense inscribed motif of bold concentric circles covers the surface of the chest and extends across the shoulders and the length of the back. The arms hang at the sides, providing the form with a rectilinear contour.

Notes

1. Daniel Biebuyck suggests that this amalgamation is the result of an early influx of hunting groups into the region, an area of plateaus and plains rich with game. The hunting groups mingled with the diverse populations already living there to yield the distinctive cultural identity that has been labeled Basikasingo, which includes villages in Bembe, eastern Lega, Boyo, southern Binja, and Bangubangu districts. Biebuyck 1981, p. 13.

2. Neyt in Maurer and Roberts 1985, p. 73; de Kun 1979, p. 34; de Heusch as cited in de Grunne 2001, p. 93.

3. Biebuyck 1981, p. 20.

4. Neyt in Maurer and Roberts 1985, p. 73.

5. De Grunne 2001, p. 183.

6. De Grunne in Maurer and Roberts 1985, pp. 72, 93.

Ex coll.

Gustave and Franyo Schindler, New York

Published

De Kun 1979, fig. 7; Rubin 1984, vol. 1, p. 56; Maurer and Roberts 1985, p. 72, fig. III.36–37; Sieber and Walker 1987, p. 142, no. 82; Bacquart 1998, p. 154, fig. A; Germain 1998, p. 49, pl. III.J; de Grunne 2001, p. 201, no. 56.

PART II
THE INVENTION OF AGRICULTURE:
CI WARA'S DIVINE GIFT

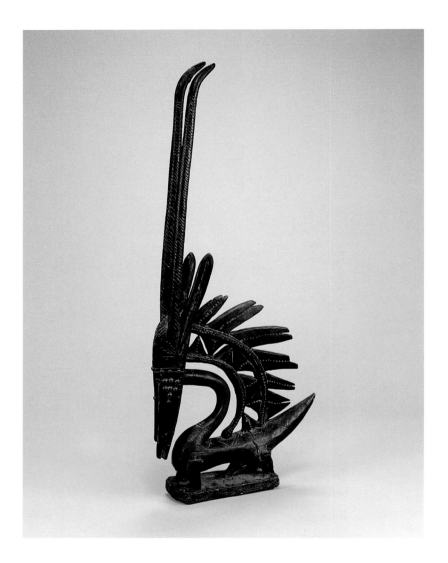

35–36. Pair of Male and Female *Ci Wara* Headdresses

Bamana peoples; Baninko region, Mali
19th–20th century
Wood, brass tacks, metal, and quills; male H. 38½ in.
(97.8 cm), female H. 31¼ in. (79.4 cm)
The Art Institute of Chicago; Ada Turnbull Hertle
Endowment (1965.6–7)

This pair of *ci wara* headdresses epitomizes what art historian Robert Goldwater describes as the "vertical" style, one of the three distinctive regional idioms developed by Bamana blacksmiths that draw upon the form of the antelope to interpret the mythical figure Ci Wara. Goldwater elaborates the formal attributes of works in this group:

The sculptor reduces the body and legs of the animal to minimal proportions, and develops the neck, muzzle, horns, and mane in an openwork pattern of flowing lines and smaller staccato accents, the whole with an elongated vertical curve...most elaborate are the males, whose mane gives the artist an opportunity for a complication of design, coupled with a repetition of unit shapes, inside an

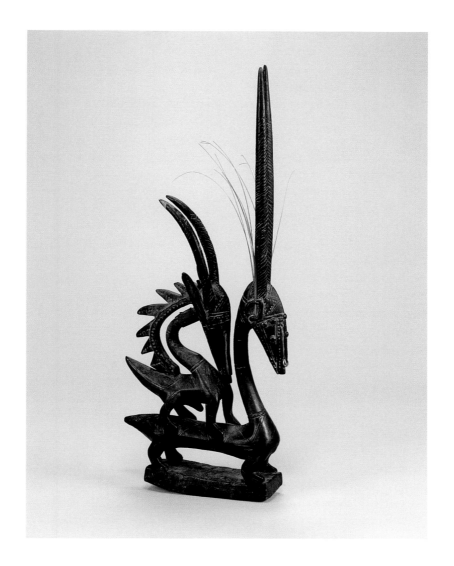

overall long oval. The result is a form, abstract yet precise in detail, that suggests the bounding life of the original "model" restrained by an extraordinary dignity. Lacking the mane, the females are simpler, with delicate neck and drawn out snout; like African mothers everywhere, they carry a small child on their backs. Even in those pairs of male and female quite clearly made by the same hand to perform together, there is an obviously intended difference in the emotional character of the two sexes.[1]

In *Antilopes du soleil,* his 1980 survey of *ci wara,* Dominique Zahan classifies this corpus of works in group I, which comprises pairs that overtly emphasize the differentiation of the male and female forms. Zahan notes that the social distinctions between men and women that suffuse Bamana society are referenced in the antelope sculptures through sexual attributes: the male's penis and the infant carried by the female.[2] Female *ci wara* headdresses are also generally smaller than the males. The fawn depicted on her back is invariably a miniature representation of either the adult male or female.[3] The fundamental differences underlying the designs of the male and female headdresses in this style derive from the fact that they are modeled on different species of animal. The head, neck, ears, and horns of the male form draw upon features of the roan antelope (*Hippotragus*

equinus), known as *dage,* and its lower part refers to the aardvark (*Orycteropus afer*). The female form is inspired by the oryx antelope (*Oryx beisa*).

These two headdresses are considered exceptional for their artistic virtuosity and as a rare example of a pair surviving intact. The linear precision and overall fluidity of the design, clearly inspired by close observation of nature, has been imbued with an expressive dynamism that suggests these humanized creatures are responding to natural forces exerted upon them. They derive their vitality as a pair from the lyrical elegance with which they embody contrasting and complementary principles and forms. Conceived as components of an ideal union, they represent independent artistic statements whose significance is enhanced through pairing.

The soaring vertical axis of the male antelope's horns (cat. no. 35) suggests power and grace. They angle ever so slightly as they rise, bending sharply at the summit in hooked tips. That upward movement is echoed by the ears, which are elongated, narrow vertical volumes. The rest of the headdress, in contrast, is wavy lines and rounded curves. The line of the neck extends from the base of the head to the body in an S-curve accentuated by successive radiating bands (including one made by negative space). The ridge of the back comprises two alternating and interlocked dentate patterns, and the mane, conceived as a series of torque-like tufts, radiates off the perimeter of the back. The abbreviated body at the base curves upward and terminates in a narrowed sharp point of a tail. The down-angled projection of the penis suggests that it intersects with the earth.

The female headdress (cat. no. 36) is comparatively simple in design. Its horns are perfectly vertical with pointed tips, and the head is joined to the torso by a gently curving neck. The body is composed of a horizontal extension that serves as a support for a miniature, abbreviated representation of the male (note that the openwork band on the back's ridge is absent). In addition, his horns, unlike those of the larger male, curve backward, enlivening the composition of the female figure. The near repetition of the male form within the female headdress interlocks the two distinct motifs within one simple, more minimalist, composition. The idea that the female headdress represents a microcosm of interdependent relationships—male and female, parent and child—is thereby given lucid expression.

In these examples of *ci wara* the masterful handling of plastic qualities is complemented by a careful and precise application of detail. Delicately incised linear designs and geometric patterns animate the solid surfaces so that they harmonize with the lively contours. Selected passages are accented with brass tacks, and there are remnants of symbolic matter originally added to the wood superstructures. Wisps of what have been referred to as quills (which actually may be tall, stiff grasses) embellish both sides of the female's ears, and she also sports metal ear and nose rings. At one point both the male and female were festooned with necklaces of cord strung with cowries.[4] *Ci wara* headdresses were often augmented with jewelry in anticipation of performances. James Brink comments that "men are responsible for preparing the headdresses and dressing the performers; women take care of washing the costume and providing the jewelry that will make the headdresses 'beautiful.'"[5]

In Bamana culture, the male and female antelope personages also served as multifaceted metaphors for the elemental forces upon which all humanity depends. The infant on the female's back, for example, has been interpreted as the embodiment of humanity and as a visual treatise on the relationship between the powerful Sun (the male) and the gentle, nurturing Earth (the female). The male's majestic upward extension and the quivering energy and movement suggested by the openwork zigzag carving of his neck and mane invoke the Sun's corona and the full force of its radiance. At the same time, it makes subtle reference to the sun's arced trajectory between the two solstices and to the darting movements of the roan antelope as it runs. Although we now see these two sculptural elements divorced from the dance arena, it is not difficult to imagine how they once converged in performance to evoke the elemental union of fire, earth, and, through the rivulets of the raffia costume, water.

Notes

1. Goldwater 1960, p. 16.
2. Zahan 1980, p. 63.
3. Ibid., p. 67.
4. The vestiges of ornamentation seen in Sieber and Walker 1987 were subsequently removed. Kathleen Bickford-Berzock, personal communication with the author, 2002.
5. Brink in Vogel 1981, p. 25.

Ex coll.

[Henri Kamer, Inc., Paris, 1965]

Published

African Arts 4, no. 1 (1970), cover ill.; Zahan 1980, pl. 26, IM 74 and IF 74; Sieber and Walker 1987, pp. 64–65; Bickford and Smith 1997, p. 113.

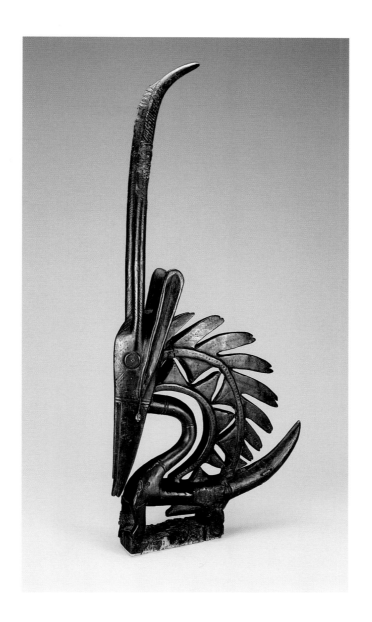

37. Male *Ci Wara* Headdress

Bamana peoples; Kénédougou or Baninko region, Mali
19th–20th century
Wood, metal, fiber, hide, and cowrie shells; H. 44¾ in.
(113.7 cm)
National Museum of African Art, Smithsonian Institution,
Washington, D.C.; Bequest of Eliot Elisofon, 1973 (73.7.56)

Collected by the photographer Eliot Elisofon in Mali's Kénédougou region, this male headdress was likely carved by the same Baninko carver or workshop that made the pair in the collection of the Art Institute of Chicago (cat. nos. 35–36) and a work published by Hans Himmelheber in 1960.[1] As a group, these headdresses share an unusually graceful fluidity that suggests a single template or an individual author's sensibility. A close comparison of them reveals how the carver's approach—to subtract from the original solid mass of wood to yield soft edges, rounded contours, and a gentle blurring of negative and positive design elements—resulted in an almost identical articulation

of features, including the sinuous curve of the neck; the upward arc of the tail; the manner in which the ears are conceived as elongated leaflike forms with rounded tips; and the tufts of mane, depicted as if they are windblown. There are some minor differences—such as the angle of the horns at the tip, which in this example is far more gradual than in the others, and the orientation of the penis, here horizontal to the body—but these are deviations that could naturally arise within a sculptor's oeuvre.

38. Male *Ci Wara* Headdress

Bamana peoples; Kénédougou region, Mali
19th–20th century
Wood; H. 57 in. (144.8 cm)
Seattle Art Museum; Gift of Katherine White and the
Boeing Company (81.17.24)

This male headdress is impressive for its graphic power and clarity of line, especially the perfect vertical extension of the horns from the crown of the head. The tips curve back at the summit, with parallel offshoots below that create a double-pronged finial. This passage, relatively unusual for a *ci wara* headdress, gives the horns an organic quality, as if they were sprouting extensions and multiplying. At the base, the ears are boldly articulated as broad rectilinear bands.

In contrast to the soaring appendages, the dense mass representing the neck and mane is defined by an intricate network of abstract linear designs that frame negative space, including two prominent concentric bands. The innermost band is spanned along its width by a series of horizontal units similar to the spokes of a bicycle wheel. The outer band is filled with a zigzag motif. The resulting sets of rectangle and triangle patterns combine within the center of the figure to achieve a synergy that is accentuated by the dentate motifs of the mane and tail along the perimeter.

The design approach evident in this single male antelope, particularly the carefully controlled lines, is distinct from the more expressionistic male examples in catalogue numbers 35 and 37. Here the tail is conceived as a bold horizontal with no upward sweep, and the mane, rather than being depicted as windswept, is suggested by a serrated edge.

Published

McClusky 1987, p. 4.

Note

1. Himmelheber 1960, p. 88.

Ex coll.

Collected by Eliot Elisofon, New York, before 1957

Published

Goldwater 1960, no. 50; Robbins 1966, figs. 7, 7a; Washington 1973, p. 10, no. 19; Zahan 1980, pl. 26, IM 75; Park 1983, p. 373; Kotz 1999, p. 21, no. 5B.

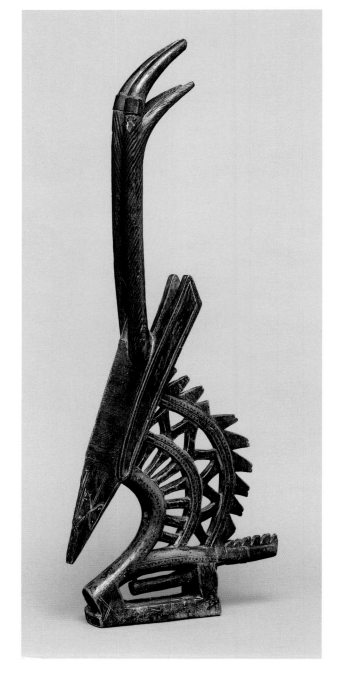

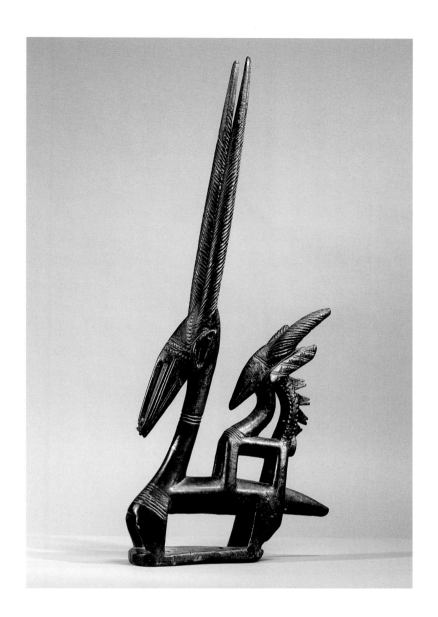

39. Female *Ci Wara* Headdress

Bamana peoples; Baninko region, Mali
19th–20th century
Wood; H. 28¾ in. (73 cm)
Private collection

In this tribute to motherhood, the sculptor has captured the nuanced interaction between a stately female antelope and her idealized male offspring. The mother's slight frame appears to be weighed down by the substantial young male form on her back; she seems to lean back in response to his mass. That slight pull instills in the figures a sense of vitality, as if mother and child were captured in a natural interaction.

Ex coll.

Baudouin de Grunne, Brussels

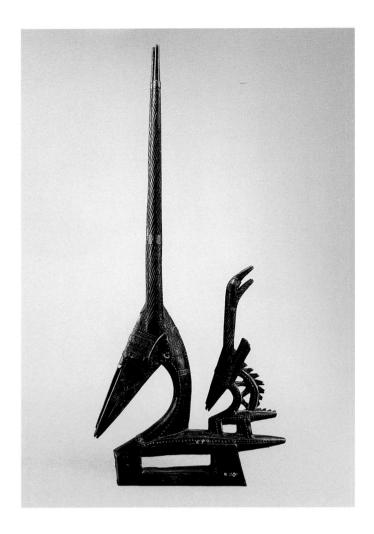

40. Female *Ci Wara* Headdress

Bamana peoples; Kinian, Kénédougou region, Mali
19th–20th century
Wood and metal; H. 28 in. (71.1 cm)
Collection of Laura and James J. Ross

In this *ci wara* maternity, the artist has achieved elegance through an economic use of line. The principal image, the female antelope, is essentially a vertical extension of horns, muzzle, and neck, abbreviated as a slight curve. The forms at each of the mother's extremities—her astonishingly long, fine horns, narrow muzzle, and projecting tail—taper harmoniously. The overall structure has a crisp, unwavering quality, and its design is extremely rectilinear. Consistent with this precision, the carver invested the form with finely carved details. Delicately inscribed lines flute the surface of the horns to just below the sharp, but smooth, pointed tips.

The forms of mother and child in this work are perfectly balanced. The parent's back is a horizontal shelf for the miniature male, who defies gravity by straddling the area where his mother's tail begins. The child exhibits on a smaller scale the same complex perfection of the adult male form. Its horns, for example, in contrast to the mother's, are sharply curved at their tips, and whereas the mother's neck is a simple, slender arc, the child's features the intricate openwork passage and mane associated with an adult male. The spacing between mother and child provides a degree of separation that allows them both to be read as highly individualized elements within a unified entity.

Ex coll.

Collected by F. H. Lem, Paris, in the Minianka region, Mali; Helena Rubinstein and Nortthorst Collections, Paris

Published

Lem 1949, p. 68, pl. 22; Rubinstein sale 1966, lot 69; Colleyn 2001, p. 209, no. 186.

41. Female *Ci Wara* Headdress

Bamana peoples; Minianka region (Baninko style), Mali
19th–20th century
Wood; H. 30¾ in. (78.1 cm)
Private collection

Distilled to essential lines, this spare female headdress eloquently invokes the relationship between mother and child. A comparison between this work and catalogue number 40, both collected in the Minianka region, reveals the astonishing range of approaches to the *ci wara* headdress found within a single area. Both of these works evidence the sophisticated level of Bamana sculptural talent, which was capable of producing masterful as well as subtly distinctive artistic creations.

This example is especially lithe and delicately attenuated. The mother's body is supported by legs that are unusually long and slender, and the arc of her neck, represented as a curve extending from the base of the head to the lower body, is comparatively gradual. The muzzle is oriented directly downward rather than at a 45-degree angle. The horns, impressive for their length and spiral surface texture, boast sharply pointed tips that could be lethal weapons. Except for its abbreviated horns, neck, and muzzle, the fawn is almost a mirror of its mother. The artist depicts it leaning back, delicately balanced on the mother's posterior, a posture that evokes how Bamana children, while securely carried on their mothers' backs, are also pulled away gently by gravity.

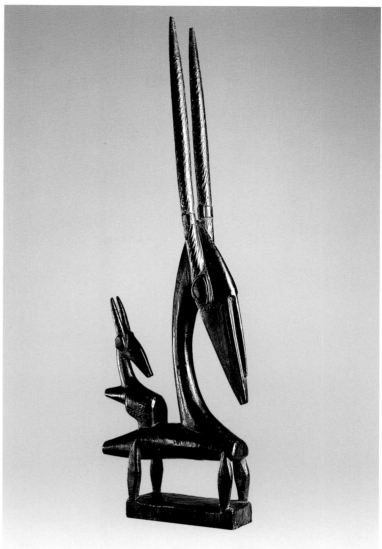

Ex coll.

Collected by F. H. Lem, Paris, in the Minianka region, Mali, 1934–35; Helena Rubinstein, Paris; Harry A. Franklin, Beverly Hills, California

Published

Lem 1949, p. 74, pl. 28; Rubinstein sale 1966, lot 70; Zahan 1980, pl. 12, IF 33; Franklin sale 1990, lot 22.

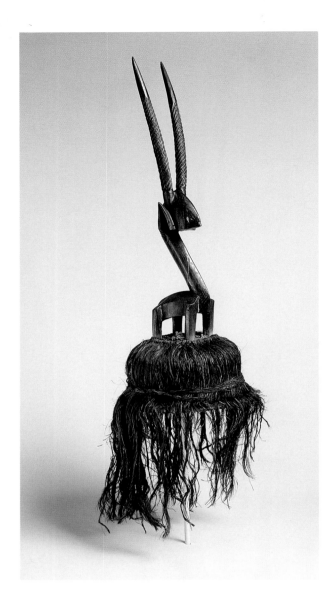

horns. The neck, depicted as a strong diagonal, meets the horizontal lower body at a sharp angle, giving the impression that the antelope is leaning back. In profile, the transitions from neck to head to lower body create a serpentine silhouette. The curved horns are inscribed with spiral grooves except for the tips, which are pointed and smooth. The only sculpturally articulated facial features in this relatively abstract representation from the eastern Bamana region are the triangular ears, which project from the base of the horns. Pascal James Imperato comments that hearing was of significant practical and symbolic value to *ci wara* initiates as the sense through which they were inspired to achieve extraordinary accomplishments. Through their ears they were informed of the achievements of their ancestors, "of their exceptional ability as farmers, of their total dedication to the land and to farming. On hearing of these exploits," Imperato continues, "present generations are stimulated to do as well as their forebears."[1]

The hood attachment extending around the bottom portion of this headdress is made of the same fiber as that worn over the dancer's body. The material is derived from a plant known as *da,* used in making rope. Its fibers are originally white and, for purposes of the dance, are dyed using one of two methods. In the first, the fibers are dipped into a solution made from the leaves and branches of the n'galaman (*Anogeissus leiocarpus*) and n'tjankara (*Combretum glutinosum*) trees, which dyes them a yellow color, and then soaked in a solution of mud for twenty-four hours. Alternatively, the fibers may be soaked in the mud solution for several months.[2] Dominique Zahan notes that the rivulets of raffia in the masquerade ensemble's costume make reference to the element of water, essential to all agricultural endeavors.[3]

42. Female *Ci Wara* Headdress

Bamana peoples; Kinian, Kénédougou region, Mali
19th–20th century
Wood and fiber; H. 33½ in. (85.1 cm)
Neuberger Museum of Art, Purchase College, State University of New York; Gift of Eliot Hirshberg from the Aimee W. Hirshberg Collection of African Art

F our diminutive but boldly planted legs poised atop the original headdress of cascading fibers support this antelope's towering neck and

Notes

1. Imperato 1970, p. 72.
2. Ibid., p. 75.
3. Zahan 1980, p. 97.

Ex coll.

Collected by F. H. Lem, Paris, in Kinian, Kénédougou region, Mali; Helena Rubinstein, Paris; Aimee Hirshberg, New York

Published

Lem 1949, p. 75, no. 29; Elisofon and Fagg 1958, p. 45, no. 36; Rubinstein sale 1966, lot 72; Zahan 1980, pl. 44, IM 164.

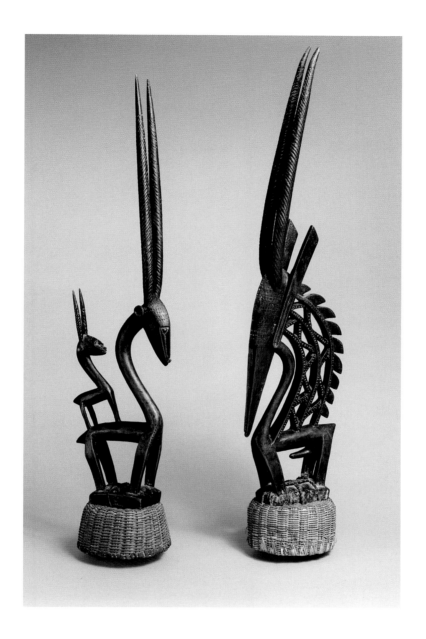

43–44. Pair of Female and Male *Ci Wara* Headdresses

Bamana peoples; Ségou region, Mali
20th century
Wood and fiber; male H. 46½ in. (118.1 cm),
female H. 42½ in. (108 cm)
Collection of Dr. and Mrs. Pascal James Imperato

Although both sexes in this pair are elegantly attenuated, the fluidity in the female form (at left) is exceptional. Relatively long legs support her horizontal lower body, upon which her fawn, a miniature rendition of its mother, stands in a backward-leaning position. The serpentine curve of the mother's neck is especially graceful. Her rounded head is elongated, with a narrow vertical nose ridge at the center of two flat cheeks, and her horns soar dramatically above her head. The male has a similarly curvilinear neck, backed by three concentric openwork bands that extend to the edge of a scalloped mane. The innermost band forms a negative space; the two outer bands contain alternating

zigzag lines. His ears begin at the summit of the neck and are positioned at a 45-degree angle, broadening toward squared tips; his horns are relatively vertical by comparison. A dense pattern of incised triangles accents both male and female forms.

The style exemplified by this pair is associated with Ségou, a region of central Mali as well as that region's eponymous capital. Ségou was also an important pre-colonial state, founded in the early seventeenth century by the Bamana when they arrived in the region from the east. According to tradition, the Bamana were led to the area by Chief Kaladian Coulibaly, whose diplomacy allowed them to settle peacefully among the indigenous Soninke peoples. The king of Ségou's power and wealth derived from his cereal harvests—millet and fonio—which the region's farmers still produce, along with rice, cotton, sugar, peanuts, manioc, beans, and kapoc.[1] Dominique Zahan suggests that the emphasis on verticality in Ségou *ci wara* headdresses relates to the height of the millet and fonio plants, the region's dominant cultivated crops.

Note

1. Zahan 1980, p. 63.

Ex coll.

Collected by Pascal James Imperato, New York, in Sanando, Ségou region, Mali, June 3, 1970 (inv. nos. 10734 [male] and 10735 [female])

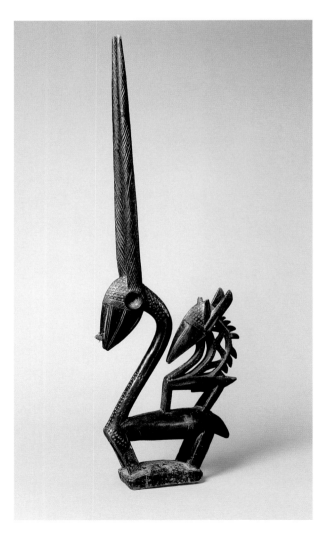

45. Female *Ci Wara* Headdress

Bamana peoples; Ségou region, Mali
19th–20th century
Wood; H. 36½ in. (92.7 cm)
Collection of Frieda and Milton F. Rosenthal

The aesthetic appeal of this work derives from its lucidity and suggestion of calligraphic notation, especially where the sheer vertical horns intersect with the serpentine configuration of the adult antelope's upper body. The mother's neck curves below the base of her unusual, relatively rounded head and becomes a diagonal that reaches down to the lower body. The male fawn leans back, balanced at the end of the strong hindquarter. The forms of mother and child are closely integrated so that he fits into the negative space between her neck and back. Circular indentations serve as visual accents at the base of her neck, the top of her head, and on the form of the child.

46. Female *Ci Wara* Headdress

Ségou Master style
Bamana peoples; Kala region, Mali
19th–20th century
Wood, metal, and fiber; H. 34¹⁄₂ in. (87.6 cm)
Seattle Art Museum; Gift of Katherine White
and the Boeing Company (81.17.23)

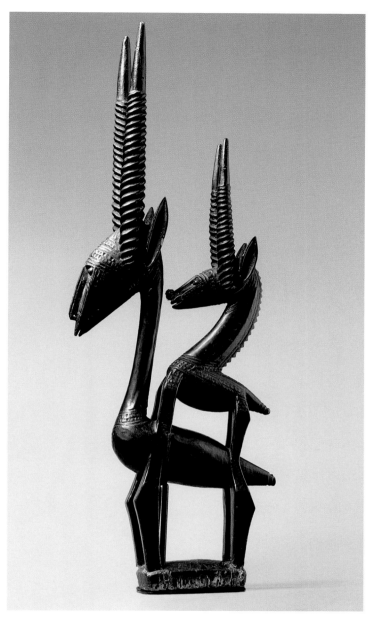

This design is informed by a multiplicity of pronounced angles. The headdress is constructed so that the diagonal line of the mother's neck intersects with her head to create a triangular negative space. The configuration is echoed below, where her lower body meets her neck to form a right angle. The fawn, standing on the incline of her back, completely fills the available space. Both mother and offspring are supported by long, tapered legs with subtly articulated joints.

Overall this headdress is more boldly carved and solidly constructed than the examples previously considered. The horns are deeply incised with prominent, spiraling ridges that resemble the threading of a screw or spring. A similar emphasis on textured definition is evident along the ridge of the fawn's back, where an alternating triangle motif creates a serrated-edge silhouette. The bold curvilinear design and jagged contour contrast with passages of surface pattern—composed of delicately incised bands of dense, alternating triangle motifs—on the head and neck.

This distinctive interpretation of the *ci wara* form has given shape to a fuller, more volumetric sculpture in the round than the preponderant style, which favors flatter, two-dimensional designs. The mother is powerful as a result, alert and poised for action. The same approach is evident in a corpus of closely related headdresses—including works in the British Museum, London; the Musée de l'Homme, Paris; and the Rautenstrauch-Joest-Museum, Museum für Völkerkunde, Cologne—and suggests the style of a Ségou Master or Kala region workshop.[1] Pascal James Imperato learned from Ségou region blacksmiths that the Ségou Master, or Kala, style originated in the Kala region but was later adapted by smiths in adjacent areas.

Note

1. Imperato, personal communication with the author concerning his research in the region between 1967 and 1974.

Ex coll.

Katherine White, Cleveland

Published

Seattle 1984, pp. 70–71.

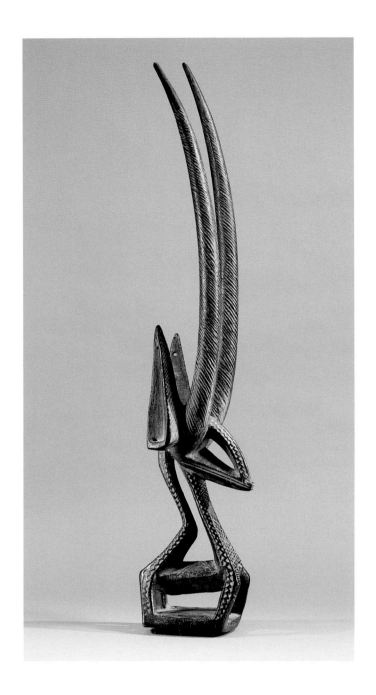

47. Male *Ci Wara* Headdress

Bamana peoples; Banimounitié region, Mali
1840–60
Wood; H. 30¼ in. (76.8 cm)
Private collection

This headdress suggests a symphony of interwoven concave and convex elements. The horns, with their powerful outward and upward thrust, harmonize with the elongated and hollowed triangular ears, and prominent negative spaces are distributed throughout as visual highlights. The reductive sculptural form, a striking departure from convention, is an essentialized, skeletal structure that frames empty volumes in the area of the head, neck, and lower body. The demarcation of these interior areas is accentuated

by finely carved surface patterns that include a chain of diamonds along the ridge of the nose and the sides of the mane and neck; dense cross-hatching along the front of the neck and surface of the ears; and spiraling lines that travel up the length of the horns. In this interpretation, the antelope's transparent being appears as an empty vessel waiting to be filled with life force.

Ex coll.

Gustave and Franyo Schindler, New York

Published

Delange 1967, fig. 13; Zahan 1980, pl. 39, IM 135; Robbins and Nooter 1989, p. 73, fig. 59; de Grunne 2001, p. 54, no. 11.

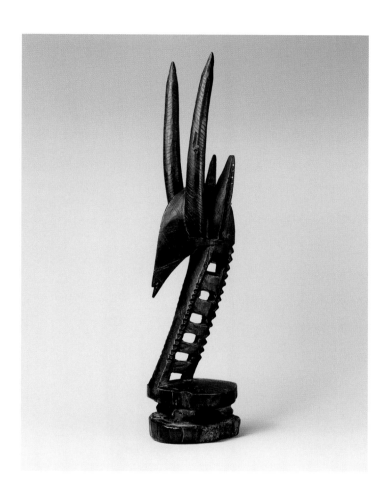

48. Male *Ci Wara* Headdress

Bamana peoples; Banimounitié region, Mali
19th–20th century
Wood; H. 18⅜ in. (47.3 cm)
Collection of Maureen and Harold Zarember

Despite its diminutive scale, this headdress projects a sense of strength and robustness. The horns are blunt defensive instruments, not elongated or attenuated decorative accents. The dominant feature, the broad diagonal band of the neck, is articulated along its length by an abstract pattern of alternating negative and positive rectangular units. Even with this open-work passage at center, the headdress commands a materiality that is unusual for the genre. The sturdy neck is surmounted by a weighty, domed head with a hard, beaklike mouth, and the mane is suggested by a delicately carved ridge along the dorsal perimeter. The flat, disclike lower body provides a solid, unperturbable base. Minuscule perforations along the rims of the ears were created for the attachment of decorative additions.

Ex coll.

Ernst Anspach, New York

SOGONI KOUN

49–50. Pair of Female and Male *Sogoni Koun* Headdresses

Bamana peoples; Bougouni region, Mali
19th–20th century
Wood and fiber; male H. 21¾ in. (55.2 cm),
female H. 22½ in. (57.2 cm)
Collection of Dr. and Mrs. Pascal James Imperato

Pascal James Imperato collected this pair of relatively abstract headdresses in the Bougouni region of Mali. Dominique Zahan classified them as "vertical" *ci wara*; Imperato identified them more specifically as examples of the *sogoni koun* genre. *Sogoni koun* headdresses, although inspired by the Bamana mythical ancestor Ci Wara, represent the convergence of the *ci wara* headdress genre with important elements of another distinct regional performance tradition: *sogoni koun.*

Imperato notes that *sogoni koun* originated among the Wassalunke peoples in the Wassalou, a region around the Sankarani River where the borders of modern Guinea and Mali meet. Its appeal led to its adoption by a number of western Bamana and Malinke villages, and the genre eventually spread east into the Baninko (the land south of Ségou between the Baule and Bagoe rivers), northeast into Massigi and Beleco (which lie in the modern Dioila district), as well as north into part of the Bougouni region and the southern portion of the Bamako district.[1] Over time this dance, performed by members of village age-set associations, or *ton,* was transmitted even more broadly so that it came to be performed in urban communities, including Bamako, the Malian capital. Although *sogoni koun* and *ci wara* coexisted in many Bamana communities, the former developed as a discrete form of expression, distinguished by its own choreography, costuming, musical accompaniment, and lyrics.[2] There are, however, important similarities between the two: both utilize headdresses that portray humanized

antelope protagonists, may be related to agricultural labor, and unfold against the setting of the fields.[3] The commonalities between the two traditions, along with *ci wara*'s greater prominence throughout Bamana society, have factored into *sogoni koun* invariably being overshadowed by *ci wara* in the art historical literature.

The many affinities underlying the two dances led to the development of a hybrid form of *ci wara* in the Bougouni and Dioila regions, one that absorbed aspects of *sogoni koun* into its performance.[4] Imperato suggests that this fusion of genres informed the sculptural design of a corpus of headdresses that, to varying degrees, evidence the influence of both traditions.[5] The pared-down simplicity of this pair, for example, appears to have been influenced by Wassalou *sogoni koun* prototypes. Both works have two pairs of horns that extend from the

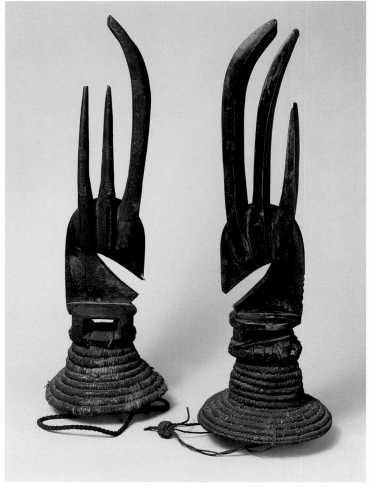

94

sides of the face in front of a pair of vertical spiky ears, which together read as a series of horns. The male and female headdresses are differentiated, albeit slightly, through the articulation of this group. The vertical elements crowning the male antelope (right) appear to converge: the foremost set of horns is vertical with a gradual curve at the tip, the second set is slightly longer and less curvaceous, and the ears in the back are much shorter with pointed tips. The vertical elements of the female antelope, in contrast, are more a series of parallel projections: the foremost set, curved at its tips, is by far the tallest, while the second set and the ears are of equal height, with needle-sharp points. A piece of mirror remains attached to one side of her beaklike head. A series of holes drilled into the shorter horn would have been used to attach other decorative elements.

Notes

1. Imperato 1981, p. 38.
2. Ibid., p. 42.
3. Ibid., p. 43.
4. Ibid., p. 46.
5. Ibid., p. 72.

Ex coll.

Collected by Pascal James Imperato, New York, in the Bougouni region, Mali, October 2, 1969 (inv. nos. 10622 [male] and 10611 [female])

Published

Zahan 1980, pl. 41, IM 145 and IM 146; Robbins and Nooter 1989, p. 73, no. 56.

51. *Sogoni Koun* Headdress

Bamana peoples; Bougouni region, Mali
19th–20th century
Wood; H. 22½ in. (57.2 cm)
Collection of Frieda and Milton F. Rosenthal

The simple design of this headdress, which suggests the healthy shoots of a sprouting plant, is closely related to that of catalogue numbers 49 and 50. There are subtle differences, however, such as the arrangement of the dense forest of horns. Here they are less autonomous vertical elements because of their crowded spacing and the manner in which they converge—the posterior, lateral, and frontal projections all bend proportionally— at the summit. This streamlined quality contributes to the work's sleek elegance and, with the pointed muzzle, endows the headdress with an avian character.

In Bamana society, the blacksmiths who create headdresses for performances of *ci wara* and *sogoni koun* masquerades often blend the two traditions. This example of such a hybrid is powerfully informed by the minimalist *sogoni koun* style adapted from the Wassalou region. It is difficult, however, to determine how this work was originally performed because no information concerning the context in which it was collected has survived. Zahan classified comparable examples simply as "vertical" Bamana *ci wara,* whereas Imperato has emphasized the influence of *sogoni koun.*[1]

Note

1. Imperato 1981.

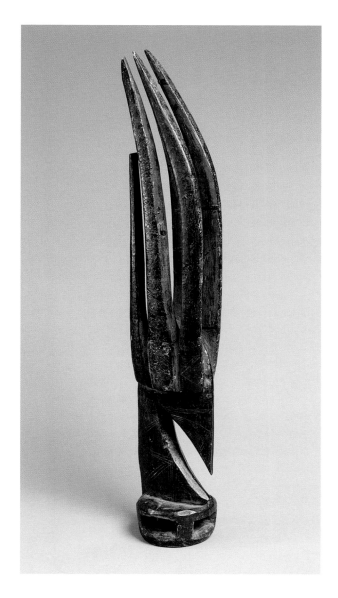

52. Female *Sogoni Koun* Headdress

Bamana peoples; Bougouni region, Mali
19th–20th century
Wood, metal, and fiber; H. 19¼ in. (48.9 cm)
Seattle Art Museum; Bequest of Lester W. Lewis (67.94)

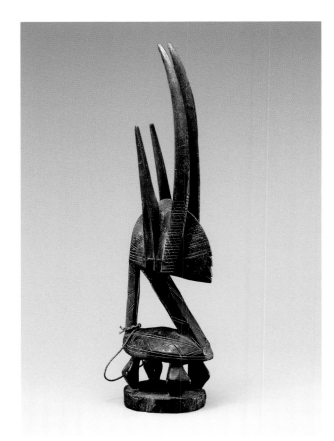

This work was created to enhance the performance of *sogoni koun,* a masquerade tradition performed by secular Bamana age-set associations known as *ton,* which bring together members of a community between the ages of thirteen and thirty. The *ton*'s collaborative activities promote social cohesion, provide social services, and organize popular public entertainments. Among the two major types of theatrical performances sponsored by *ton* is *wara deoun,* a series of danced animal personage masquerades that includes the antelope personage, *sogoni koun.* Traditionally *sogoni koun* performances took place at the end of the harvesting season, in late December, or just before the planting season, which runs from April to June. Over time, the dance became integrated into the cycles of urban life as well.

Sogoni koun performances can feature either a soloist or several individuals, but most often they consist of a pair of dancers who wear complementary male and female headdresses. The musical accompaniment often celebrates in song the memory of outstanding individuals, from historical and regional leaders to dancers and musicians. The dance is characterized by a demanding choreographic repertory of movements that includes daring acrobatics and passages of rapid, virtuoso footwork followed by handstands, forward and backward somersaults, and cartwheels. There is also a slower interlude in the middle of the performance that is framed by the fast, intense overall pace.[1] The dancers wear anklets of white goat hair or bells and carry white goat-hair fly whisks in either hand to dramatize their movements. Imperato notes that the physical demands of the dance necessitate well-fitting dress. Like the sculpted headdresses, the accompanying costume ensembles worn by *sogoni koun* performers vary considerably.

This female *sogoni koun* headdress has a skeletal structure that accentuates negative spaces. Seen in profile, the mouth, nose, and forehead are defined by a series of minuscule incised cuts. Attached to either side of the domed head are sets of sweeping horns and long, narrow ears. The abbreviated body, supported by knob-like legs, is joined to the head by a diagonal neck and a vertical element that extends from the nape of the neck to the antelope's posterior. The latter suggests both a tail and a mane. These two passages join upper and lower body to form a central triangular void.

At least three different types of antelope have been cited as the sources of inspiration for these relatively simple forms: the bush duiker (*Sylvicapra grimmia*), an extremely small, fawn-colored antelope known in the eastern Bamana region as *mankala;* the slightly larger oribi (*Ourebia ourebi*), known in Bamana as *n'goloni* or *n'koloni;* and the significantly larger bushbuck (*Tragelaphus scriptus*), known as *mina* or *mine.*[2] The gender of a headdress is expressed in a variety of ways, such as the inclusion of sculpted male or female figures, the scale and number of horns (according to Imperato, more horns and an aggressive scale indicate a male), or additional decorative elements (the string of beads in this example indicates it is a female).[3]

Notes

1. Imperato 1981, p. 72.
2. Ibid., p. 47.
3. Ibid., p. 43.

Published

McClusky 1977, no. 4; McClusky 1987, p. 3.

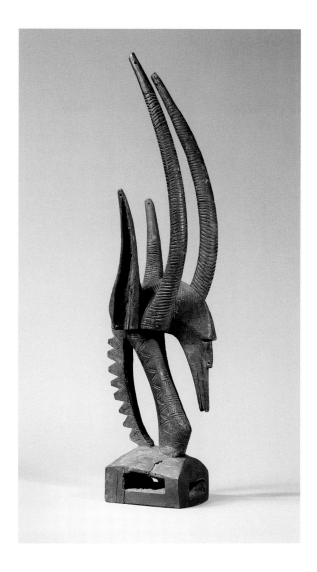

53. *Sogoni Koun/Ci Wara* Headdress

Bamana peoples; Bougouni region, Mali
Late 19th century
Wood and patina; H. 29¾ in. (75.6 cm)
Private collection

This headdress unfolds as a series of distinct but united arabesques, making the design as much an articulation of the surrounding space as it is an inwardly solid sculptural form. The interstices of the neck and mane form an ellipse, which is echoed by the area between the antelope's neck and the underside of its muzzle. The sculptor has employed a rich vocabulary of graphic strokes: the line of the neck, the curves of the head and horns, and the sharp, serrated dorsal contour. In such a sophisticated visual tribute to the *sogoni koun/ ci wara* tradition, the initiated eye can at once distinguish the separate animal references within the composite form and appreciate the masterful manner in which they have been combined into a single creation. As the eye travels across the sculpture, the features gradually but continually shift from the attenuated mouth, which is that of the anteater, to the humanized head, the vertical extension of elegant antelope horns, and the ridge of the back, which suggests simultaneously the scales of the pangolin and an abstract mane. Although these passages are recognizable as discrete zoomorphic references, they nevertheless blend convincingly into a harmonious vision of a transcendent being.

Ex coll.

Jay C. Leff, Uniontown, Pennsylvania; Merton D. Simpson, New York; S. Thomas Alexander III, Saint Louis

Published

Robbins and Nooter 1989, p. 73, fig. 57.

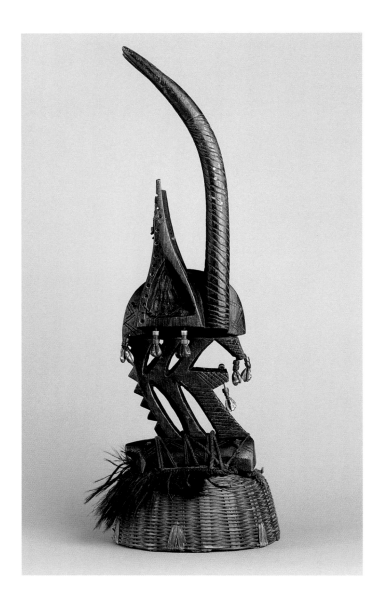

54. *Sogoni Koun* Headdress

Bamana peoples; Bougouni region, Mali
20th century
Wood, fiber, hair, beads, and cowrie shells; H. 25 in. (63.5 cm)
Collection of Dr. and Mrs. Pascal James Imperato

The two tiers of openwork diagonals that constitute the body of this headdress suggest an exposed skeletal structure. The mane, depicted as a serrated band, extends along the back edge from the base of the dome-shaped head to the lower body. The bold horns and ears are attached to the sides of the head and dominate the compqsition. The horns, incised with shallow spirals, rise vertically and curve back at the tips. The ears, directly adjacent, have broad triangular bases that narrow as they rise vertically to elongated, pointed tips. Multicolored tubular beads and cowrie shell clusters dangle from the tip of the mouth, base of the ears, and back of the head. Perforations along the perimeter of the outer edge of the ears suggest that other decorative additions were once suspended there as well. The original basketry cap is attached to the base of the headdress with cord; sandwiched between the two is a fringe of animal hair, probably goat or antelope, attached around the base of the sculpture.

Ex coll.

Collected by Pascal James Imperato, New York, in the Bougouni region, Mali, August 9, 1968 (inv. no. 10071)

Published

Zahan 1980, pl. 66, II 107; Imperato 1981, p. 45.

55. *Sogoni Koun* Headdress

Bamana peoples; Bougouni region, Mali
19th–20th century
Wood, fiber, and hair; H. 12½ in. (31.8 cm)
Collection of Mr. and Mrs. Harold S. Gray

The architecture of this *sogoni koun* headdress is especially elastic and fluid. The upper rim of its circular framework is punctuated by a series of vertically projecting horns that ascend, front to back, in height and physical intensity. Their graduated arrangement calls to mind a musical scale. The foremost horn is short and curves slightly forward; the second is bolder, centered, and vertical; and the third, a pair positioned at the outer edge of the rim, is much thicker than the others, surging upward and curving slightly back. Bundles of coarse animal hair, perhaps taken from an antelope tail or mane, are bound to the tips of the final set. The sculptural element survives with its original woven basketry cap intact.

In contrast to the sharp vertical elements, the overall configuration of the headdress body unfolds as a gentle loop. A narrow tip on the front extremity bears an extremely compressed, abbreviated face. From there the linear body continues up and around to where it almost comes full circle. The body turns abruptly inward, however, just at the point where the two parts might join, and terminates against the resulting circle's inner back side. Directly above this intersection, another band—a chord, geometrically speaking—extends across and terminates above the head, creating an additional internal loop. The two interior chords form a zigzag motif that unifies the upper and lower halves of the composition. This two-tiered scheme is typical of *sogoni koun* designs, but here it has been taken to an extremely abstract level.

The pronounced curvature of the sculptural form in this example evokes the manner in which the pangolin (*Manis tricuspis,* also known as the scaly anteater) may curl up in a ball, like a hedgehog, in order to protect itself. Dominique Zahan has outlined some of the physical attributes of the pangolin that are often evoked in the two-tiered *sogoni koun* design, which he considers a regional manifestation of *ci wara:* a long body covered with scales; a small head with a narrow, conical muzzle; and a long tail. The pangolin quality depicted most often is the animal's unusual corporeal flexibility.[1] The configuration of the pangolin's spinal column allows it to curl into a ball or rise up into a semicircle, and this physical suppleness, Zahan emphasizes, is especially apparent in this kind of *sogoni koun* headdress.

The choice of the pangolin also reflects a respect for the animal's physical power, which enables it to dig extensive underground tunnels.[2] Zahan suggests that these tunnels recall the root system of the sorghum plant, widely cultivated by Bamana farmers, and that both types of "arteries"—the tunnels and the roots—are referenced visually in this style of headdress by graphic elements linking the two tiers (in this example, the internal zigzag motif).

Notes

1. Zahan 1980, p. 75.
2. Ibid., p. 72.

Published

Robbins and Nooter 1989, p. 70, no. 47.

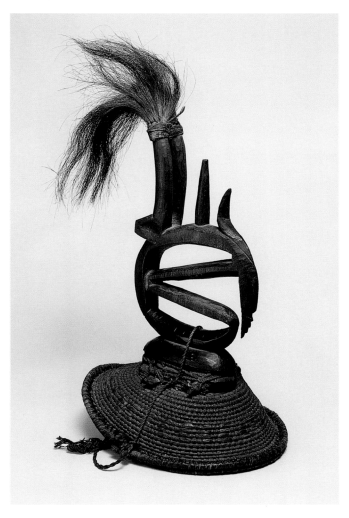

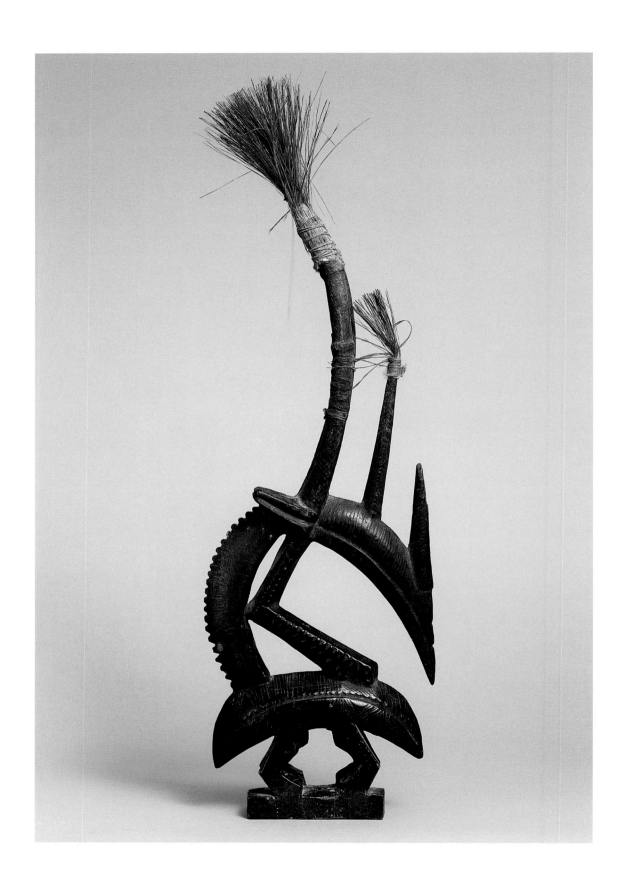

100

56. *Sogoni Koun* Headdress

Bamana peoples; Bougouni region, Mali
19th–20th century
Wood and fiber; H. 23 in. (58.4 cm)
The Clyman Collection

Ci wara and *sogoni koun* performances coexist in many Bamana communities. *Ci wara* is danced by adult initiates of the eponymous society, whereas the most talented dancers of a community's youth association perform *sogoni koun*. However, Pascal James Imperato emphasizes that there is a degree of overlap between the two traditions and that a rich range of expressive forms has developed combining elements of the *sogoni koun* genre, which originated in the Wassalou region, with aspects of *ci wara,* which is from eastern Bamana country.

This work, typical of the *ci wara/sogoni koun* hybrid form, embodies perfect balance and harmonious symmetry. It is distinctive even among exceptional examples of Bougouni-style *sogoni koun* for its degree of graphic unity. Although it is possible to read the composition as a series of discrete tiers, the features are so gracefully integrated that the dominant impression is one of a single zoomorphic being.

The author of this headdress drew repeatedly and skillfully on the formal vocabulary of the arc. Curves are positioned throughout the composition, including the soft horizontal crescent of the lower body, the vertical, sharply serrated arc of the back, and the gracefully elongated crowning horn at the summit. The narrow, downward-pointing snout continues the curve of the back ridge. The ears, here small appendages just below the top horn, are carved in relief. Just below the point where this carving stops, a right angle, which could be interpreted as an abstract neck, extends down and connects with the lower body. Its surface is inscribed with a very fine zigzag motif. The curved horn at top, which is also the tallest, is positioned in a row with two progressively smaller horns that project vertically from the perimeter of the muzzle. The foremost horn extends upward as a continuous line from the snout. The other two have brushlike finials of coarse animal hair, possibly from the mane of the roan antelope, tied to their tips.

According to Imperato, works in this style were created in the Bougouni region in response to the appeal of the *sogoni koun* dance, introduced by Wassalou communities farther south.[1] *Sogoni koun* was later integrated into a popular form of public entertainment referred to as *wara deoun*: a series of animal masquerades that included hyena, chimpanzee, buffalo, and porcupine dances. Within this context, however, *sogoni koun* possessed qualities that set it apart, notably demanding choreography and acrobatics. As a consequence, the dance required exceptionally well trained performers. Individuals who possessed the talent and necessary skills sometimes became celebrated beyond the confines of their immediate communities, and gifted performers often became itinerant *sogoni koun* professional entertainers. Prior to 1940, Imperato adds, the youth association festivals in which *sogoni koun* appeared took place primarily in December, at the end of the harvesting season. The timing of the performances later shifted so that events were scheduled during the preplanting and harvesting months.

Note

1. Imperato 1981.

Published

Robbins and Nooter 1989, p. 70, fig. 48.

57. *Sogoni Koun* Headdress

Bamana peoples; Bougouni region, Mali
19th–20th century
Wood; H. 20½ in. (52.1 cm)
The Schorr Family Collection

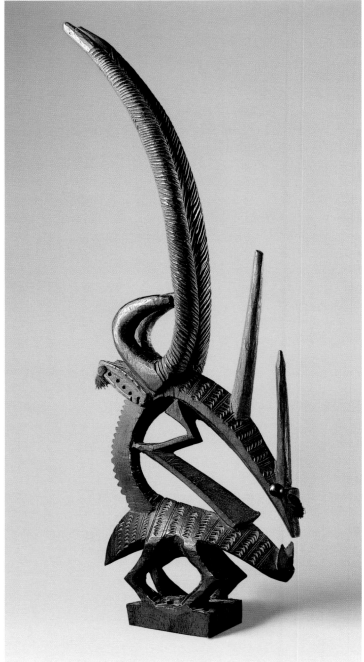

This daring creation exudes compressed energy, like a spring, giving the overall design an explosive graphic intensity. The horizontal arced lower body is narrower at the front and fuller at the back, where it meets a curved band whose outer edge is sharply serrated. The band terminates above in a complex intersection of features, including ears, a pair of small horns that bends sharply inward, and what are proportionally an astonishingly long pair of horns that arcs up and away from the summit. A narrow, curved, snoutlike feature extends down from this point and has two additional sharp pointed horns that project vertically from its center and tip. The snout is bent over so low it almost touches the lower body, creating an unusually narrow interval. The space between the two main body segments is filled with a dramatic zigzag whose acute angles suggest a bolt of lightning.

When Eliot Elisofon and William Fagg published this headdress in 1958, the middle horn still had what was probably goat hair tied to its tip. That addition softened the profile and lent an airy, almost whimsical aspect to the central projection. The added matter would have further eased the visual transition from the supple curve of the horns at the summit to the sharp point of the horn on the lower snout. Pascal James Imperato notes that the convention of depicting a row of two or three single horns, as seen in this example, evokes the tall tuft of hair on the head of the bush duiker antelope. In some instances, sculpted horns were surmounted by additions of actual antelope horn. Although a number of different types of antelope served as models for *sogoni koun* headdresses, the bush duiker's speed, cunning, and intelligence—qualities admired and commented on in the lyrics of some *sogoni koun* performances—made it a favorite subject. Other features of this headdress style appear to make reference to the aardvark (*Orycteropus afer*), especially the ears,

tapered snout, and arced back. A species of anteater, the aardvark has profound associations in Bamana culture with the Earth, great physical strength, and endurance.

According to Imperato, during the 1960s and 1970s *sogoni koun* performances incorporated a wide range of sculpted wood headdresses and costume ensembles that varied from region to region. The headdresses were often decorated with brightly colored beads and tufts of white goat hair that sometimes obscured

sculptural features. This accumulated matter made reference to the gender of a headdress: masculine was indicated by goat hair and silver or brass earrings, feminine by strings of beadwork.

The apparel worn by *sogoni koun* performers varied widely. Imperato describes how the goat hair accent of the headdress could be echoed in fiber and cloth armbands, anklets, and fly whisks carried by the dancer. He indicates that in some northern parts of the Bougouni region, where elaborate headdresses of this kind have been featured, the dance lacked some of the characteristically acrobatic *sogoni koun* choreography and instead incorporated elements of *ci wara.*

The number of dancers in *sogoni koun* performances, which were organized by a community's youth association, ranged from one to several; most featured a pair who wore male and female headdresses. Female

singers called out to summon *sogoni koun,* and the dancers, who required a great deal of flattery and encouragement, were welcomed and praised as they entered the arena. They danced tentatively until their confidence was bolstered, their movements gradually becoming more explosive. The songs accompanying the performance often extolled the talents of the dancers present in the arena or memorialized a deceased *sogoni koun* dancer or drummer.

Ex coll.

Collected by F. H. Lem, Paris, in the Bougouni region, Mali; Helena Rubinstein, Paris; Irwin Green, Detroit

Published

Elisofon and Fagg 1958, p. 49, no. 45; Rubinstein sale 1966, lot 78; Zahan 1980, pl. 51, II 15.

58. *Sogoni Koun* Headdress

Bamana peoples; Bougouni region, Mali
19th–20th century
Wood and fiber; H. 20½ in. (52.1 cm)
Collection of Herbert and Paula Molner

Light and airy, this headdress strikes a delicate balance of wispy lines arranged with flair. An exceptionally refined work, it was collected by F. H. Lem in the Djitoumou region of Mali between 1934 and 1935. Stylistically it is related to headdresses from the more southern Bougouni region that were commissioned by age-grade associations, or *ton,* for performances of *sogoni koun.*[1] In his catalogue raisonné of *ci wara* forms, Dominique Zahan includes this and all formally related works in his group II category (three-tiered), which some specialists consider a distinct corpus in light of their abstraction. Zahan marvels at the inventiveness apparent in such works and notes that in his opinion they represent the most conceptually sophisticated of the styles in his survey. He suggests that their abstraction was an intentional attempt to obscure the specific animal forms to which some parts refer and analyzes the different conventions that he proposes their authors used. To this end, he identifies three vertically superimposed registers and provides a diagram of how each of these

draws upon features of a different animal.[2] According to that breakdown, the bottom level often depicts the aardvark (*Orycteropus afer*), the middle may be related to the form of the pangolin (*Manis tricuspis*), and the summit features the horns of the roan antelope (*Hippotragus equinus*).[3] Zahan proposes that the aardvark was chosen for its powerful digging abilities and the pangolin for its physical flexibility and mutable form.[4]

Whether or not one accepts Zahan's attributions at face value, his argument for interpreting works of this kind as a bricolage of features woven together to create a single, fantastical being is compelling. The carver of this work certainly appears to have been conversant with those conventions. The towering, gently swaying appearance of this headdress derives in part from its top-heavy arrangement. There is a dramatic disparity between the small, compact animal at the base and the narrow, attenuated superstructure rising above. At bottom, the crouching creature with a crescent body (Zahan's aardvark) stands upon two pairs of bent legs. The second tier (the pangolin) emerges from that animal's posterior as a sharply serrated ridge that rises, curves, and descends, terminating in a long narrow snout. At the summit, a pair of elongated ears projects out at a 45-degree angle. These two levels are unified by a linear, bracketlike motif that extends from the summit of the supporting animal's back to the underside of the top creature's

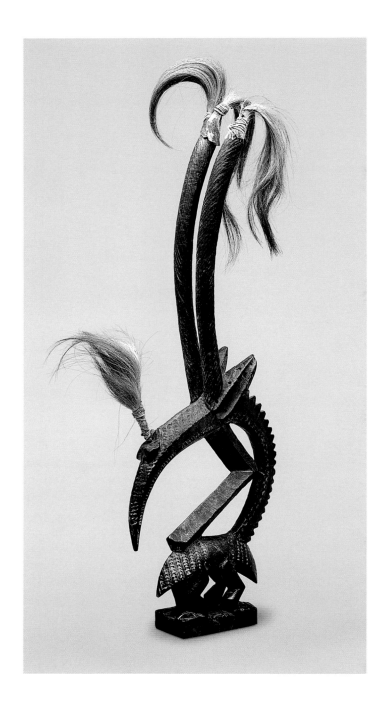

neck. The astonishingly tall, gently curved horns that soar above the two lower tiers may be seen to articulate a third tier. Their lightness is emphasized by attachments of what appears to be goat hair dangling from their tips. Similar tufts adorn the central tier, projecting up from the edge of the snout. Other surviving decorative accents include beads suspended at the extremities, metal studs on the nose, and red cotton tassels.

Notes

1. Pascal James Imperato attributed this headdress to the Bougouni region in a conversation with the author on October 25, 2001.

2. Zahan 1980, pl. 48, II.

3. Ibid., p. 70.

4. Ibid., p. 71.

Ex coll.

Collected by F. H. Lem, Paris, Djitoumou region, Mali, ca. 1934–35

Published

Lem 1949, p. 71, no. 25; Rubinstein sale 1966, lot 79; Zahan 1980, pl. 51, II 17.

59. Female *Sogoni Koun* Headdress

Bamana peoples; Bougouni region, Mali
19th–20th century
Wood and cotton; H. 16 in. (40.6 cm)
The Clyman Collection

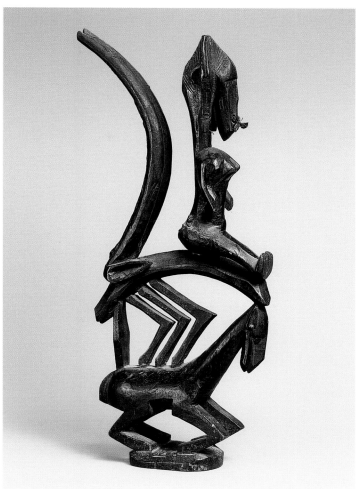

This harmonious composition is an exceptional example of the hybrid *sogoni koun* genre. Zahan categorizes this work in his group II of vertical *ci wara* forms, which are distinguished by three-tier designs that conflate antelope and aardvark features. This example, however—a collage of abstract and representational elements—provides a clear departure from that model as a result of the influence of *sogoni koun.* A crouching horse serves as the foundation of an arclike structure that supports a seated female figure. The woman faces forward on the surface of the arc, which extends back from the tip of the horse's head to its tail. Her back erect, she holds her hands at her sides and extends her legs. In this posture she is perfectly balanced, but her equilibrium seems tenuous. Behind and parallel to the vertical line of her upper body, antelope horns rise and curve gracefully back, whimsically suggesting a tail. A set of ears is depicted where the base of the horns intersects the surface of the arc platform. Just beneath them, in the space between the horse's back and the arc, three equispaced right-angle brackets connect the two bottom tiers of the headdress.

Unlike *ci wara* headdresses, which were designed for use by one of the six Bamana initiation societies, *sogoni koun* were part of secular entertainments performed by age-set associations, or *ton.* The playful presence of the figural element in this example—she looks as if she is about to be thrown off—is a conventional *sogoni koun* form. It also serves to denote the gender of the head-dress,[1] heighten the visual drama of the work, and demonstrate the talent of the artist. In her study of Bamana figurative traditions, Kate Ezra notes that the blacksmiths who made *sogoni koun* antelope head-dresses were inspired to add figurative elements as a *masiri,* or decoration, because "not only were they wonderful to look at . . . they demonstrated the carvers' tremendous skill. In this sense they were virtu-oso works."[2]

Notes

1. Imperato 1981, p. 72.
2. Ezra 1983, p. 44.

Ex coll.

Gaston de Havenon, New York

Published

Goldwater 1960, no. 75; de Havenon 1971, no. 51; Zahan 1980, pl. 70, II 130; Ezra 1986, p. 12, no. 8; Robbins and Nooter 1989, p. 70, fig. 49.

60. *Sogoni Koun* Headdress

Bamana peoples; Bougouni, Wassalou region, Mali
19th–20th century
Wood; H. 8⁷/₈ in. (22.5 cm)
Collection of Armand and Corice Canton Arman

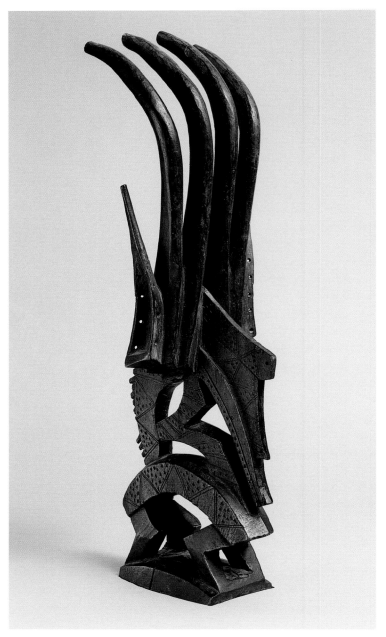

This headdress from the Wassalou region, collected near Bougouni, commands striking views from all vantage points. The style suggests that it was probably created to accompany performances of *sogoni koun.* Despite the flatness of the body, the headdress gains unusual depth and width as a result of the menacing crown of horns and ears, and the work's physical presence is one of exceptional power and strength.

At the base of the headdress, a relatively abstract form is used to suggest a crouching animal body supported by two sets of bent legs. Above, a deeper arc extends from the back, where it is a mane, to the front, where it becomes a mouth. This passage is connected to the lower body by a zigzag band that may be interpreted variously as a neck or a vertebral column. The distinctive ear design—a deeply hollowed-out volume with a rectilinear base and a narrow, hornlike summit—is considered a stylistic convention associated with works from the Bougouni region. Between the ears are four parallel horns that rise from the crown of the head and bend over at the summit. The battery of horns is so closely aligned that, when viewed in profile, they seem to merge into a single extension.

F. H. Lem notes that this headdress was originally adorned with metallic rings and colored beads. A triangular dentate motif, in which alternating units densely filled with dots limn pangolin scales, has been carefully incised across much of the surface. It is a masterfully executed work that seamlessly integrates features of the pangolin, antelope, and serpent—all classic *sogoni koun* animal forms—to yield one somewhat menacing creature embodying the full force of nature.

Ex coll.

Collected by F. H. Lem, Paris, near Bougouni, Wassalou region, Mali, 1934–35; Helena Rubinstein, Paris; Harry H. Franklin, Beverly Hills, California

Published

Lem 1949, p. 70, pl. 24; Rubinstein sale 1966, lot 75; Zahan 1980, pl. 65, II 101; Rubin 1984, vol. I, p. 272; Franklin sale 1990, lot 21; Arman 1996, p. 54, no. 3; Arman 1997, p. 56, no. 5.

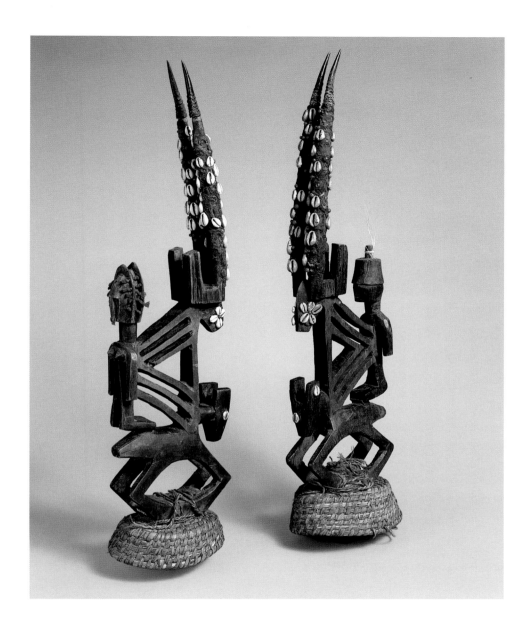

61–62. Pair of Female and Male *Sogoni Koun* Headdresses

Bamana peoples; Dioila region, Mali
20th century
Wood; male and female H. 27½ in. (69.9 cm)
Collection of Dr. and Mrs. Pascal James Imperato

Both works in this pair feature a double-headed beast with a human figure positioned at the edge of its back. In catalogue number 62 (right), a schematic male figure with a red cap stands facing forward in the direction of the animal. In number 61 (left), a female figure kneels and looks in the direction opposite her mount. Perforations around the edges of her coiffure are embellished with alternating red and green cotton thread. Both male and female protagonists are joined to their respective zoomorphic creatures: she at the back, he at the chest. These abstracted points of intersection each comprise two sets of radiating diagonals whose edges terminate in the creatures' heads. The lower heads face downward, integrating naturalistically with the body and its supporting pair of crouched legs. The superior heads, in contrast, are juxtaposed with the abstract passage of intersecting lines and angles. Both

animal heads are articulated with cowrie shells and beads. Tips of real bush duiker horn have been fitted to the summits of the vertical wood versions, whose carved surfaces are covered with a resinous substance to which cowrie shells and red seeds are attached. Shallow basketry caps are joined to the base of the sculptures with cord.

Ex coll.

Collected by Pascal James Imperato, New York, in Beleco, Dioila district, Mali, April 6, 1968 (inv. nos. 10175 [male] and 10582 [female])

Published

Imperato 1981, p. 47.

63. *Sogoni Koun* Headdress

Bamana peoples; Dioila region, Mali
19th–20th century
Wood, metal, and pigment; H. 24½ in. (62.2 cm)
Collection of Frieda and Milton F. Rosenthal

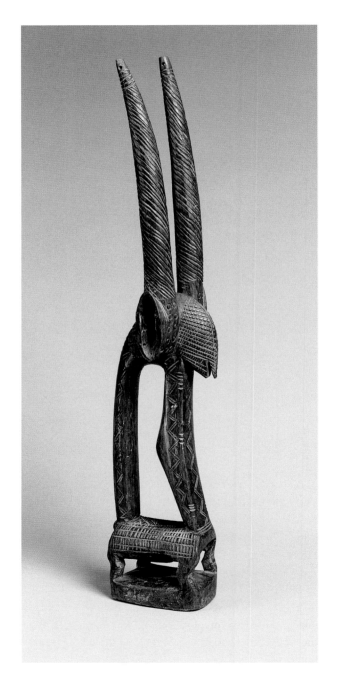

This headdress, from eastern Bamana country, combines an eloquent simplicity with strong architectonic form. Its minimalistic design—which must be seen in profile because straight-on it reads as a simple vertical—succeeds on subtle suggestion and innuendo. The mane has been distilled to a vertical bar that extends from the base of the head to the rear lower body, unifying the two, and the antelope's neck is a parallel element, inflected at its midpoint so that it appears to bend. The composition is streamlined; head, neck, lower body, and mane constitute a seamless continuum. Implicit in the design is the idea of open-endedness, which is expressed visually through the blank space at the figure's center and the fluid extension of the aligned neck and horns.

The spartan structure of this highly abstract *sogoni koun* is adorned with delicate accents. A zigzag motif is etched into the surface of the neck and mane, and other areas are enhanced by contrasting textures: a dense diagonal cross-hatching on the face; a rectilinear motif on the body; and spiral grooves along the length of the horns. Tiny metal eyes are inserted into the wood. Two small holes at the tips of the horns once held attachments, and traces of red pigment remain on the surface.

Ex coll.

F. H. Lem, Paris; Helena Rubinstein, Paris

Published

Rubinstein sale 1966, lot 81.

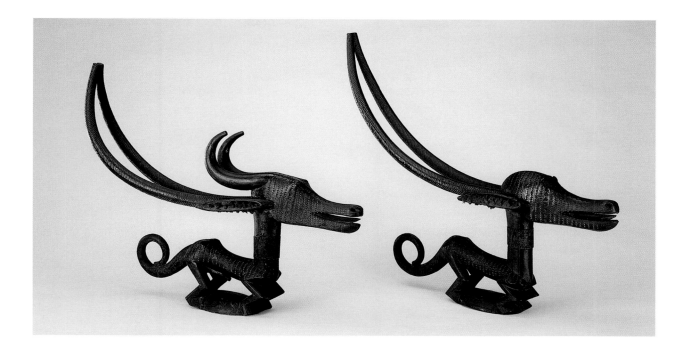

64–65. Pair of Male and Female *N'gonzon Koun* Headdresses

Bamana peoples; Djitoumou region, Mali
19th–20th century
Wood, iron, and cotton; male and female L. 21 in. (53.3 cm)
National Museum of African Art, Smithsonian Institution,
Washington, D.C.; Gift of Ernst Anspach and museum
purchase, 1991 (91.8.1.1–2)

These headdresses, which have survived intact as a pair, pay tribute to Bamana conceptions of the ideally harmonious union of male and female. They are defined by a strong series of horizontals: the horns and muzzle in the upper portion of the composition, and the parallel axis of the lower body beneath. Headdresses in this style have thus been designated by Zahan as "horizontal" *ci wara,* the third of his three categories of Bamana headdresses.[1] He attributes this corpus to the Bélédougou region, which is north of the Niger River, but Imperato situates the style slightly farther south in the adjacent Djitoumou region. Imperato notes that some villages there sponsored performances of abstract vertical *sogoni koun* headdresses but also possessed horizontal *ci wara,* which they referred to as *n'gonzon koun.*[2] During the 1990s, this attribution was corroborated by Stephen Wooten, who documented performances of comparable works in a village approximately forty kilometers from Bamako. Wooten emphasizes the ongoing vitality of dances in which works such as these are still performed to celebrate and promote the success of a community's agricultural endeavors.[3]

In this pairing, male and female have an identical set of horns that grow out alongside the ears, which are long, horizontal ellipses. The horns reach back and up in gentle sweeping curves and join at their tips. The male headdress (left) has an additional, shorter set of horns that extend out from the crown of the head and curve forward. His sex is otherwise indicated by his genitalia. With the exception of these details, male and female are perfectly symmetrical, mirror images of one another. Sharply bent knees suggest that they are poised to bound forward. Their facial expressions and slightly open mouths, which reveal long, horizontal tongues, contribute to the appearance of alertness. Broad cylindrical necks, each with a band of iron wrapped around it, literally and stylistically unify the upper passages with the lower

bodies. Both figures terminate in a flourish with tight, inwardly curling tails. Careful attention has been given to surface details, such as the fine spiral motif incised along the length of the horns and the dense, textured bands of geometric designs that cover the head and lower body.

Headdresses of this kind are distinctive for their formal qualities as well as for their idiosyncratic construction. All other related Bamana sculptural genres are monoxylic (carved from a single piece of wood), but these works are invariably carved as two separate units—the head and the body—which are subsequently joined together at the neck either with iron staples, U-shaped nails, or metal or leather collars attached with nails. Zahan proposes that because this bipartite approach was not a result of technical necessity, it reflects an underlying symbolic intention, perhaps related to the idea of unifying two separate elements into a coherent and balanced design. On a literal level, the dominant feature of the upper half are the horns, which Zahan suggests are inspired by those of the roan antelope.[4] They curve upward, in contrast to the horns in vertical *ci wara* that follow the plane of the animal's neck, as seen in

nature. The animal's lower body, with its short legs and thick tail, is generally assumed to be that of an aardvark.

On a more metaphorical level, Zahan suggests that a plant, probably one of the nourishing Bamana agricultural staples such as the Bamana groundnut (*Voandzeia subterranea*), is the dominant inspiration underlying the design of works in this style. He interprets the rendering of the tail, which curves in a direction anatomically impossible for most animals to achieve, to be an organic feature evocative of a plant tendril.

Notes

1. Zahan 1980.
2. Imperato 1981.
3. Wooten 2000.
4. Zahan 2000.

Ex coll.

J. J. Klejman, New York, 1962; Ernst Anspach, New York, 1962–91

Published

Kotz 1999, p. 20, no. 5A.

66. Male *N'gonzon Koun* Headdress

Bamana peoples; Djitoumou region, Mali
19th–20th century
Wood, metal, fiber, and cord; L. 23 in.
(58.5 cm)
Collection of Laura and James J. Ross

This male headdress appears to be from the same Djitoumou workshop that made catalogue numbers 64 and 65. In a slight departure from the male antelope in that pair, however, the upper pair of horns depicted in this example is less sharply pointed and does not curve as far forward. This sculpture also retains its accompanying flat fiber basketry cap tied to the base.

Ex coll.

Gaston de Havenon, New York

Published

Colleyn 2001, p. 228, no. 220.

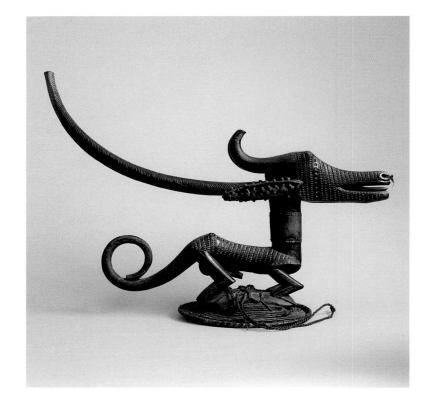

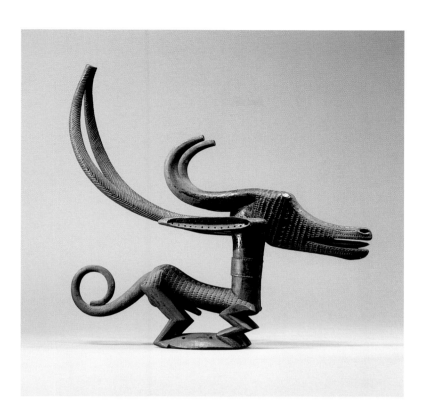

67. Male *N'gonzon Koun* Headdress

Bamana peoples; Djitoumou region, Mali
Early 20th century
Wood; L. 18 in. (45.7 cm)
Private collection

In this male headdress, apparently produced in the same Djitoumou workshop as catalogue numbers 63–65, the tail is less tightly curled and takes the form of an elongated spiral suspended behind the antelope. This treatment instills the work with a plastic elasticity so that the extended tail appears to be raised either in the act of curling up or straightening out.

68. Female *N'gonzon Koun* Headdress

Bamana peoples; Djitoumou region, Mali
19th–20th century
Wood, cloth, beads, iron, and brass; L. 19 in. (48.3 cm)
Collection of Edward and Marianne Burak

Documented *ci wara* and related performance traditions reveal that every generation of Bamana society has danced these masquerades differently and that each community, through its interpretation of the genres, gives expression to its own preferences and concerns. Studies suggest that as Bamana initiation associations such as *ci wara* declined in importance, the *ci wara* dance was appropriated into the popularized secular theatrical entertainments organized by a community's *ton,* or youth association. It seems clear, however, that the extent and pace of this transformation varied from village to village.

In October 1993, while researching Bamana communities in the Mande Plateau, Stephen Wooten documented a *ci wara* performance that featured a headdress stylistically related to this example.[1] The occasion for the performance was a public celebration following a day of heavy agricultural labor in the fields of a community member. After that individual had fed the laborers, the community's *ci wara* headdresses were performed as the highlight to the public entertainment. Intriguingly, Wooten describes another performance he observed several months later in a neighboring village, in which a *ci wara* dance overseen by local elders was performed in a more spiritual context.[2] That dance, Wooten notes, is an annual event held before the rainy season and serves as the culmination to (and public celebration of) prayers to ancestral forces for good harvests and for the health of the community. The coexistence of these distinct *ci wara* traditions within the same region reinforces the theory that such headdresses have for some time been used in multiple ways.

The gender of this work is made explicit through the inclusion of the female figure at its summit, but otherwise its overall style closely resembles that of the previous four examples (cat. nos. 64–67). Here the main pair of horns is described as an especially broad curve, and it appears that matter was added to the joined tips on the occasion of performances. The shorter upper pair

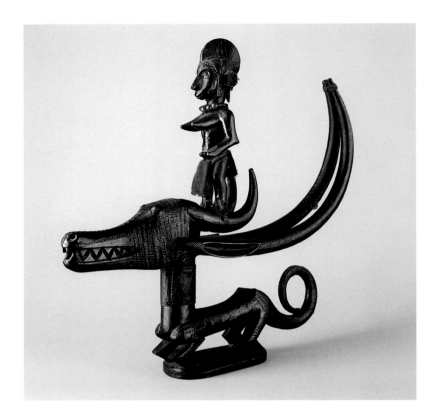

of horns that projects from the crown of the head serves as a ledge for the freestanding, forward-facing female figure. Her contours emphasize and repeat the horizontal curves of her mount, although on a smaller and more refined scale. This is particularly apparent in the broad crest of her coiffure, the curved horizontal arcs of her breasts, and the hands held at her sides.

The pairing of male and female *ci wara* headdresses reflects the Bamana emphasis on sexual complementariness, especially as it relates to biological and agricultural reproduction. The gender of a headdress is sometimes reinforced by the inclusion of miniature human representations at the summit, as is the case with this example. Imperato suggests this gender dynamic is also expressed physically in the performance arena,[3] where the actions that unfold appear to comment upon the dancers' unity (for example, they follow in one another's footsteps, even when featured individually). Imperato describes one dance in which both male and female figures, bent over their *sunsun* sticks, came out together and slowly circled the dance area while making the head and body gestures of the roan antelope. The female figure then exited, and the male made a series of rapid movements that continued to imitate those of the antelope. He screamed the cry of a wild animal, jumped into the air, and ran around the arena. This sequence ended when he jumped into the air and landed in a squatting position. After his exit, the female dancer reemerged and attempted to replicate his actions in a more subdued, tentative manner. At the conclusion, the male figure returned, accompanied by rhythmic, rapid drumming, and performed a dynamic sequence of acrobatic movements.

Notes
1. Wooten 2000, pp. 22–25, figs. 6, 7.
2. Ibid., p. 25.
3. Imperato 1970, p. 78.

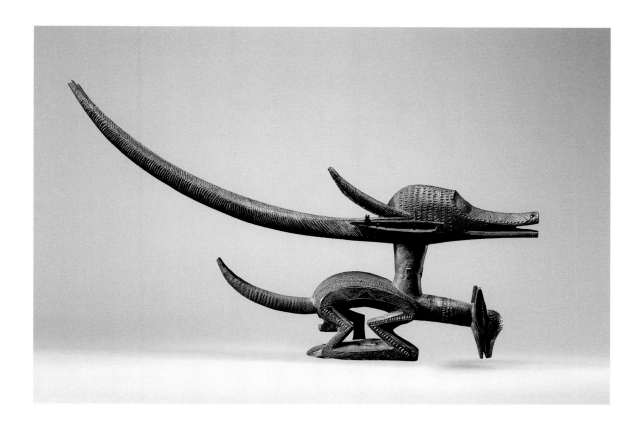

69. Double-Headed *N'gonzon Koun* Headdress

Bamana peoples; Banimounitié region, Mali
Early 20th century
Wood, patina, and smoke; L. 24¼ in. (61.5 cm)
Private collection

This especially complex, tiered horizontal headdress is exceptional for its expression of pent-up corporeal power. The compressed arc of the back and the crouching legs suggest an animal poised to spring upward. An unusual degree of attention was focused on the lower body, reflected in the ample negative space, in an hourglass shape, between the bent legs. The horizontality of the design is also more pronounced than most tiered horizontal forms because the head, neck, and tail of the lower body extend both forward and backward. This continuous line parallels the dominant upper horizontal that runs from the muzzle to the tip of the horns. The two necks emerge from the same spot in a right angle to one another. The head at the summit sits flat on a vertical neck, while the relationship is reversed below, so that the horizontal neck ter-

minates in a vertically oriented head. The elegant sweep of the main set of horns is echoed above by another pair of horns and below by the tail.

This work gives compelling evidence that horizontal headdresses were not modeled on a single animal found in nature but rather represent an abstract force expressed through an amalgam of zoomorphic features. Here the animal in the lower half, which appears to be an aardvark, is more fully realized than in others because of the inclusion of its head. Nevertheless, the syncretic approach that appears to inform this headdress and related works is made all the more overt because of the fantastical nature of the double-headed creature. It is as if the headdress captures the moment when the two entities were fused together.

It is possible this work was commissioned by a voluntary communal labor association known as *gonzon*. In the western part of the Bamana country, *gonzon* often coexisted with communal *ton* and initiation-based associations such as *ci wara*. Imperato notes that in some communities *gonzon* became active at a time when *ci wara* was undergoing a transition, whereas in others it was a secular organization distinct from but contemporaneous with the religiously oriented *ci wara* association. The name *gonzon* derives from the anteater, *n'gonzonkassan*,

renowned for its hardiness and strength. The *gonzon* association served as a charitable service to the community.[1] Much of their aid, for which they did not exact remuneration, took the form of agricultural labor offered to those they perceived to be in need. In many communities, *gonzon* membership, developed during colonial rule, was limited to individuals willing to contribute labor, self-sacrifice, and compassion. Perhaps as a result of this voluntary esprit de corps, the relationships that developed among *gonzon* members strengthened ties between men from different age groups within the village and were even more significant than those developed among *ton* members.

Gonzon owned headdresses called *n'gonzon koun*, or "anteater head," which were sculpturally identical to those used by the *ci wara* association of the same community. They were not danced in the fields, however, as were *ci wara* headdresses, but rather in the village on occasions when the *gonzon* performed charitable farmwork. To distinguish a *ci wara* headdress from a *n'gonzon koun*, it is generally necessary to be able to document its original use. According to Pascal James Imperato, when *gonzon* dissolved in certain areas, their headdresses became communal property of the village *ton*, which also inherited those of *ci wara*. As a consequence, a village *ton* that came to possess two sets of headdresses might also perform the *n'gonzon koun* and *ci wara* dances even though the circumstances and significances of the performances were considerably altered.

Note

1. Imperato 1970.

Ex coll.

Charles Ratton, Paris

70. *N'gonzon Koun* Headdress

Bamana peoples; Banimounitié region, Mali
Early 20th century
Wood and patina; L. 25⅝ in. (65.1 cm)
Private collection

The upper and lower bodies in this headdress are proportionally harmonious. The length of the strong neck and the vast upward sweep of the horns give this work a light airiness relative to the heavier and denser structures of other horizontal headdresses. A fine, delicate set of horns projects from the crown of the

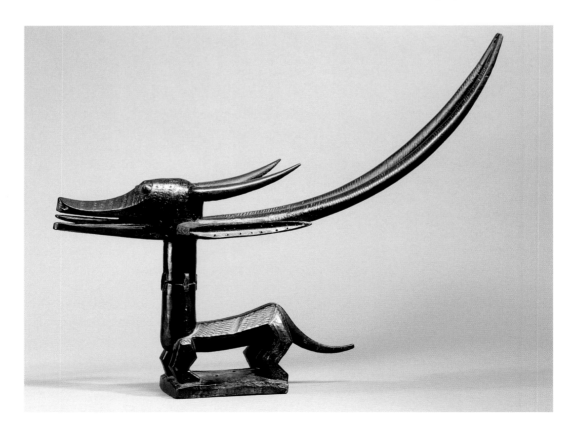

head parallel to and directly above the main set. The more robust principal set extends from the base of the head in a graceful arc. The ears, especially narrow and elongated, follow the same line. At the base, the legs are somewhat rectilinear and blocky within the overall composition.

Bamana blacksmiths charred the exterior of their sculptures with a hot knife or blade, the source of this work's dark, lustrous surface. Between performances, *ton* leaders often stored their headdresses suspended from the rafters of their cooking houses, where they accumulated layers of soot. The masks were generally refurbished for festivals, however; their surfaces were cleaned, washed with water, and smeared with shea butter, which accounts for this work's glossy sheen.[1]

Note

1. Imperato 1980.

Ex coll.

Bess J. Cohen, New York

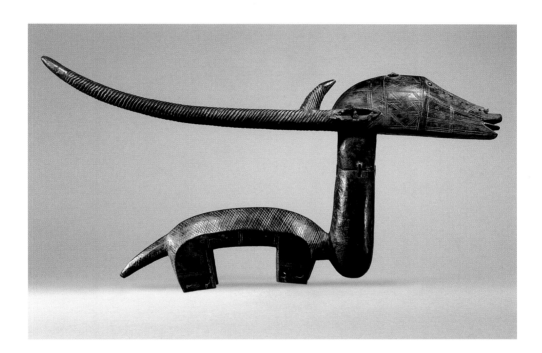

71. *N'gonzon Koun* Headdress

Bamana peoples; Bougouni region, Mali
19th–20th century
Wood; L. 25 in. (63.5 cm)
Private collection

The appeal of this unusual work, which represents the horizontal headdress in its most simple and elegant form, lies in its striking lack of equilibrium. The main pair of horns does not have the dramatic curves so prevalent in other examples. Instead, they are understated horizontal lines that curve ever so slightly at the tip. Directly behind the point where they emerge from the base of the head, a minuscule secondary pair of thornlike horns projects from the surface. These sharp elements resemble a kind of secondary growth, like buds sprouting from the primary set.

The columnar vertical neck, with its unnatural breadth, is this work's dominant formal feature. It extends out from the simple horizontal arc of the body so that the upper body and head appear to float in space. The independence of the neck within the overall composition reinforces the notion that these works were conceived as amalgams of discrete elements. The smooth, glossy neck, for example, stands in marked contrast to the carefully incised linear patterns that distinguish different textural passages, such as the dense cross-hatching that covers the back, the spiral grooves on the horns, and the rectilinear geometric pattern across the head.

Ex coll.

Gustave and Franyo Schindler, New York

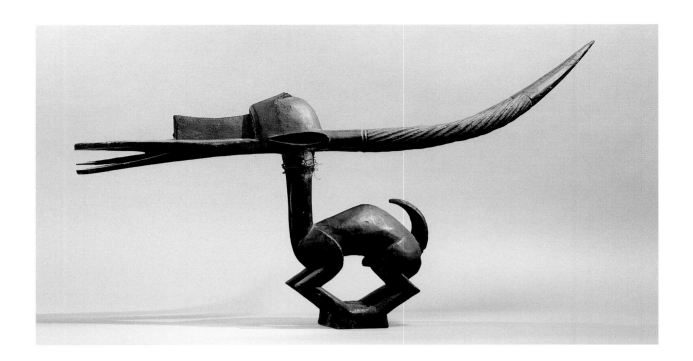

72. *N'gonzon Koun* Headdress

Bamana peoples; Bélédougou region, Mali
19th–20th century
Wood; L. 36 in. (91.4 cm)
Private collection

Headdresses in the Bélédougou style, from the northern sector of western Bamana country, are surreal representations that border on the grotesque. Imperato has proposed that they draw upon features of the hornbill, or *dyougo,* and the roan antelope.[1] The enormous head and maw of this indeterminate creature is positioned above a diminutive but powerful lower body. The forehead is a pronounced dome, the nose a long, narrow, horizontal ridge, and the mouth resembles a beak. Tip to tip, from mouth to horns, a continuous line can be traced that bends slightly toward the middle and curves up at the end. The tensed, muscular stance of the body is reminiscent of a small antelope or dog.

Note

1. Imperato 1970, p. 72.

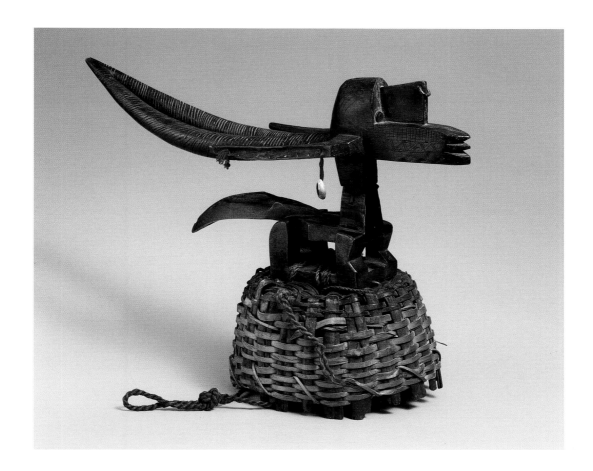

73. *N'gonzon Koun* Headdress

Bamana peoples; Bélédougou region, Mali
20th century
Wood and fiber; L. 18 in. (45.7 cm)
Collection of Dr. and Mrs. Pascal James Imperato

In this design, tail, ears, horns, and muzzle thrust backward in harmonious horizontals. The narrow prognathous face is surmounted by a domed forehead and bisected by the vertical plane of the flat nose. Long, narrow ears run parallel to the horns, which begin at the back of the head, curve slightly, and rise, joining at their tips. At the rear of the body, the tail curves slightly downward at its extremity. The broad, vertical neck is joined at midpoint with staples. At the base, the forelegs are articulated at the joints to suggest potential movement, and a broad basketry cap is tied to the headdress with cord.

Ex coll.

Collected by Pascal James Imperato, New York, in Kolokani, Bélédougou region, Mali, March 2, 1967 (inv. no. 10581)

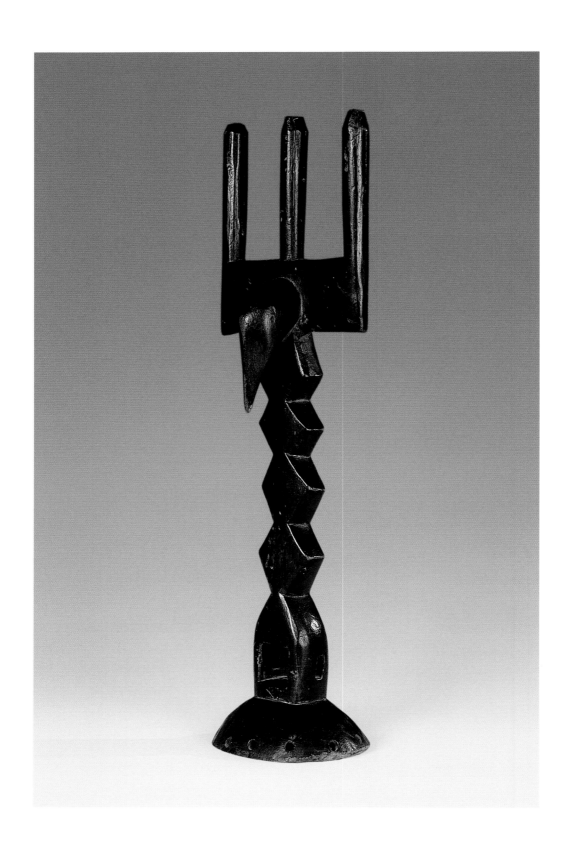

74. *Nama Tyétyé* Headdress

Bamana peoples; Banimounitié region, Mali
19th–20th century
Wood; H. 16⅛ in. (41 cm)
Collection of W. and U. Horstmann

In profile, this headdress reads as a simple vertical column interrupted by a beaklike head whose full, rounded volume stands out dramatically from the rest of the work's flattened, geometric architecture. The lateral contours, however, are actually zigzags: jagged edges that contrast with a pair of smooth extensions projecting from the head. At the base is a solid semicircular form that is perforated with holes drilled around the perimeter.

Bamana sculptures with these formal characteristics have usually been identified by connoisseurs in the West as examples of *ci wara.* This is because dynamic headdresses that integrate stylized zoomorphic features within an abstract graphic format have become synonymous in African art with the *ci wara* sculptural tradition. But this is an overgeneralization that reflects the poor documentation of the original performative contexts of such works and the fact that the Bamana *ci wara* tradition is the most familiar outside Mali. Through stylistic comparison, Pascal James Imperato has more precisely identified this work, which he attributes to the Banimounitié region, as one created to accompany *ton* performances of a dance known as *nama tyétyé.*[1]

Historically, *ton* were organized primarily as communal social fraternities responsible for village entertainment.[2] Although *ton* have undergone constant change in recent generations, in the past they included all the circumcised men and excised women of a particular community organized into subgroups arranged hierarchically by age. *Ton* members sponsored, organized, and performed two major forms of entertainment:

the *koteba,* a satirical comic theater, and dances incorporating masks or headdresses.[3]

Among the *ton's* diverse repertory of masquerades were some sculptural forms adapted from the Bamana initiation-based societies, including *ci wara.*[4] They integrated these forms, which already had great social significance, into their secular entertainments. Many *ton* masks also drew upon animals as metaphors for social behavior and moral lessons. This example appears to have been inspired by the hyena, or *nama,* an animal that in Bamana culture embodies the notion of imperfect knowledge.[5] There are several regional stylistic variations of this masquerade, in which the dance calls attention to *nama's* associations with deviousness and indirection.[6] *Nama* may appear as a special performance, but it can also emerge intermittently while other dances are being performed. In the latter instances, it gravitates around another masquerade form, often the *ton's* version of *ci wara.* As a performance unto itself, however, the *nama tyétyé* dance emphasizes the hyena's speed.[7] The headdress typically featured a wood or straw cap onto which two vertically oriented zigzag poles were attached. This example is an extremely sophisticated artistic interpretation of those basic formal requirements.

Notes

1. Pascal James Imperato, personal communication with the author, October 25, 2001.
2. Imperato 1980, p. 48.
3. Ibid., p. 51.
4. Ibid., p. 47.
5. Ibid., p. 55.
6. Ibid., p. 82.
7. Ibid.

Published

Bassani, Bockemühl, and McNaughton 2002, p. 50.

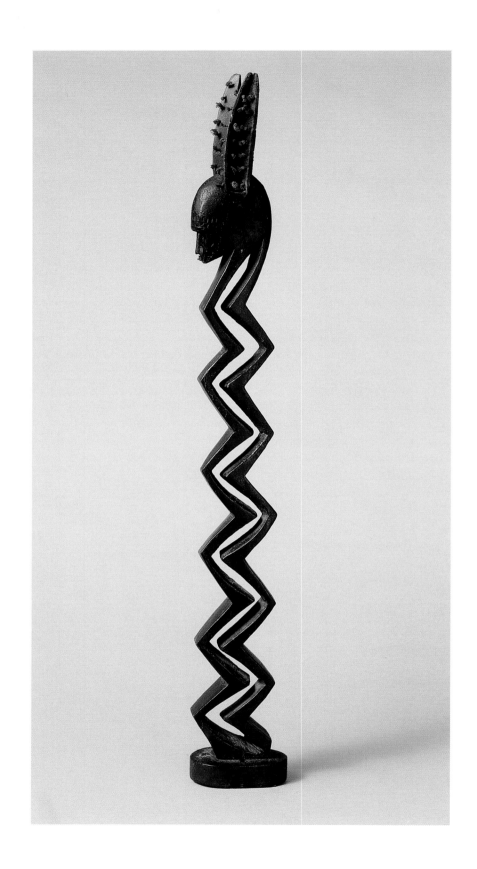

75. *Nama Tyétyé* Headdress

Bamana peoples; Djitoumou region, Mali
19th–20th century
Wood and string; H. 27¼ in. (69.2 cm)
Private collection

Lucid and graphically precise, the startling design of this headdress conveys a sense of kinetic upward momentum, like a release of energy. At the top, the rounded volume of the head is relatively human, with elongated oval ears that project vertically. The neck, mane, and body, however, are reduced to a vertical, accordion-like column—essentially a long zigzag—that is pierced along its central axis by a channel of negative space. The resulting "passageway" in the center is thus flanked on either side by complementary zigzag walls. The bisection of the column creates three powerful jagged lines inside one basic form and contributes to the work's apparent flexibility. The subtracted core also heightens the visual impact of the zigzag, otherwise a relatively simple graphic motif.

This headdress relates formally to several works Zahan illustrated in his survey as examples of vertical *ci wara.* Those comparative headdresses share the same vertical zigzag configuration as this one, but with a solid column and more compressed angles. Like this example, they lack antelope horns, which has led Imperato to suggest convincingly that they were created for a *nama tyétyé* dance.[1] According to his research in the region, such headdresses express the deviousness of the hyena (*nama*) and its inclination "to follow a twisted path rather than a straight one."[2] When worn in performance, the headdress is attached to a basketry cap that sits on the performer's head. The dancer's face may be covered with a cloth pierced by two viewing holes. During the short, swift dance, which features acrobatic stunts as highlights, the performer runs and jumps around the arena.

The zigzag motif has been interpreted by some scholars of Bamana culture as having great symbolic resonance, such as an illustration of the trajectory of the Sun around Earth. Zahan notes that this is referred to by the Bamana as *tle ka sira gondi,* or "the zigzag path of the sun."[3] The motif also relates to mathematical methods used by the Bamana and Dogon to represent geometrically, and to transpose onto a flat surface, empirically observed spiral motions of heavenly bodies.[4]

On another level, the zigzag has been described as a metaphor for accounts of epic journeys. Solange de Ganay notes that in the past, ideas of how Bamana culture heroes traveled through heaven and Earth within the sphere of cosmic space were so precise and detailed that diagrams were made to illustrate their passage.[5] In these traditions, Faro, who put the created world in order, and Mousi Koroni, the wife of the creator, are regarded as both complementary and antagonistic elements. According to de Ganay, the zigzag line was sometimes used to represent their journeys as well as the path of the planet Venus.

Notes

1. Pascal James Imperato, personal communication with the author, October 25, 2001.
2. Imperato 1980, p. 82.
3. Zahan 1951, p. 14.
4. Ibid., p. 15.
5. De Ganay 1951.

Ex coll.

Charles Ratton, Paris; Sam Wagstaff, New York; William Rubin, New York

Published

Rubin 1984, vol. 2, p. 359; Robbins and Nooter 1989, p. 71, fig. 51.

Anderson, Martha G., and Christine Mullen Kreamer

1989 *Wild Spirits, Strong Medicine.* Edited by Enid Schildkrout. Exh. cat. New York: Center for African Art.

Appia, Béatrice

1944 "Notes sur la génie des eaux en Guinée." *Journal de la Société des Africanistes* 14, pp. 33–41.

Arman

1996 *Arman et l'art africain.* Exh. cat. Marseilles: Musée d'Arts Africains, Océaniens, Amérindiens; Paris: Musée National des Arts d'Afrique et d'Océanie; Cologne: Rautenstrauch-Joest Museum. Paris: Réunion des Musées Nationaux.

1997 *African Faces, African Figures: The Arman Collection.* Exh. cat. New York: Museum for African Art. Translation of Arman 1996.

Bacquart, Jean-Baptiste

1998 *The Tribal Arts of Africa.* London: Thames and Hudson.

Bassani, Ezio, ed.

1989 *La grande scultura dell'Africa nera.* Exh. cat. Florence: Centro Mostre di Firenze, Forte di Belvedere.

1992 *Le grand héritage: Sculptures de l'Afrique noire.* Exh. cat. Paris: Musée Dapper. Translation of Bassani 1989.

Bassani, Ezio, Michael Bockemühl, and Patrick McNaughton

2002 *The Power of Form: African Art from the Horstmann Collection.* Milan: Skira.

Bassani, Ezio, Maria Teresa Leoni Zanobini, and Valerio Zanobini

1990 *Il Maestro del Warua.* Quaderni Poro, no. 6. [Milan.]

Bastin, Marie-Louise

1982 *La sculpture Tshokwe.* Meudon, France: Alain and Françoise Chaffin.

1984 *Introduction aux arts d'Afrique noire.* Arnouville, France: Arts d'Afrique noire.

Bedaux, Rogier M. A., et al.

1991 "Comments on 'Dogon Restudied' [Van Beek 1991]." *Current Anthropology* 32, pp. 158–63.

van Beek, Walter E. A.

1991 "Dogon Restudied: A Field Evaluation of the Work of Marcel Griaule" and "Reply [to Bedaux et al. 1991]." *Current Anthropology* 32, pp. 139–58, 163–67.

2001 *Dogon: Africa's People of the Cliffs.* New York: Harry N. Abrams.

Berg en Dal

1995 *Poppen: Spel en ritueel / Dolls for Play and Ritual.* Exh. cat. Berg en Dal, Netherlands: Afrika Museum in cooperation with the Horstmann Collection.

Berjonneau, Gérald, Jean-Louis Sonnery, and Fondation Dapper, producers

1987 *Rediscovered Masterpieces of African Art.* Boulogne: Art 135.

Bickford, Kathleen E., and Cherise Smith

1997 "Art of the Western Sudan." *Museum Studies* (The Art Institute of Chicago) 23, no. 2, pp. 105–19.

Biebuyck, Daniel P.

1981 *Statuary from the pre-Bembe Hunters.* Tervuren, Belgium: Royal Museum of Central Africa.

Blier, Suzanne

1998 *Royal Art of Africa.* London: Laurence King Publishing.

Cameron, Elisabeth Lynn

1996 *Isn't S/He a Doll?: Play and Ritual in African Sculpture.* Contributions by Doran Ross. Exh. cat. Los Angeles: UCLA Fowler Museum of Cultural History.

Colleyn, Jean-Paul, ed.

2001 *Bamana: The Art of Existence in Mali.* Contributions by Mary Jo Arnoldi et al. Exh. cat. New York: Museum for African Art; Zurich: Museum Reitberg.

Cornet, Joseph
1982 *Art Royal Kuba*. Milan: Edizioni Sipiel.

Delange, Jacqueline
1967 *Arts et peuples de l'Afrique noire*. Paris: Gallimard.

Dieterlen, Germaine
1970 "La serrure et sa clef (Dogon, Mali)." In *Échanges et communications: Mélanges offerts à Claude Lévi-Strauss*, edited by Jean Pouillon and Pierre Maranda, vol. 1, pp. 7–28. The Hague: Mouton.

Drewal, Henry John, and John Pemberton III
1989 *Yoruba: Nine Centuries of African Art and Thought*. Contributions by Rowland Abiodun. Exh. cat. New York: Center for African Art.

Elisofon, Eliot, and William Fagg
1958 *The Sculpture of Africa: 405 Photographs*. New York: Frederick A. Praeger.

Ezra, Kate
1983 "Figure Sculpture of the Bamana of Mali." Ph.D. dissertation, Northwestern University, Chicago.
1986 *A Human Ideal in African Art: Bamana Figurative Sculpture*. Exh. cat. Washington, D.C.: National Museum of African Art; Smithsonian Institution Press.
1988 *Art of the Dogon: Selections from the Lester Wunderman Collection*. Exh. cat. New York: The Metropolitan Museum of Art.

Fenton, William N.
1962 "This Island, the World on the Turtle's Back." *Journal of American Folklore* 75, no. 298, pp. 283–300.

Fernandez, James W.
1982 *Bwiti: An Ethnography of the Religious Imagination in Africa*. Princeton: Princeton University Press.

Franklin sale
1990 *The Harry A. Franklin Family Collection of African Art*. Sale cat., Sotheby's, New York, April 21.

de Ganay, Solange
1951 "Études sur la cosmologie des Dogon et des Bambara du Soudan français, II: Graphies de voyages mythiques chez les Bambara." *Africa* 21, pp. 20–23.

Geary, Christraud M.
1995 "Photographic Practice in Africa and Its Implications for the Use of Historical Photographs as Contextual Evidence." In *Fotografia e storia dell'Africa: Atti del convegno internazionale, Napoli—Roma, 9–11 settembre 1992*, edited by Alessandro Triulzi, pp. 103–30. Naples: Istituto Universitario Orientale; Paris: Istituto Italo-Africano.

Germain, Jacques
1998 "La statuaire des Basikasingo." *Arts d'Afrique noire*, no. 108, pp. 45–53.

Glaze, Anita
1981 *Art and Death in a Senufo Village*. Bloomington: Indiana University Press.

Goldwater, Robert
1960 *Bambara Sculpture from Western Sudan*. Exh. cat. New York: Museum of Primitive Art.
1964 *Senufo Sculpture from West Africa*. Exh. cat. New York: Museum of Primitive Art.

Griaule, Marcel
1965 *Conversations with Ogotemmêli: An Introduction to Dogon Religious Ideas*. London: Oxford University Press. First published in French, Paris, 1948.

Griaule, Marcel, and Germaine Dieterlen
1950 "La harpe-luthe des Dogon." *Journal de la Société des Africanistes* 20, pp. 209–27.

de Grunne, Bernard
2001 *Mains de maîtres: À la découverte des sculpteurs d'Afrique*. Exh. cat. Brussels: Espace Culturel BBL.

Hanna-Vergara, Emily
1996 "Masks of Leaves and Wood among the Bwa of Burkina Faso." Ph.D. dissertation, University of Iowa, Iowa City.

de Havenon, Gaston
1971 *The de Havenon Collection*. Exh. cat. Washington, D.C.: Museum of African Art.

Henry, Joseph

1910 *Les Bambara*. Munich: Aschendorffsche Buchhandlung.

Hewitt, John N. B.

1903 "Iroquoian Cosmology; First Part." *Twenty-first Annual Report of the Bureau of American Ethnology, 1899–1900*, pp. 127–339. Washington, D.C.: Smithsonian Institution.

Himmelheber, Hans

1960 *Negerkunst und Negerkünstler*. Braunschweig: Klinkhardt and Biermann.

Hôtel Drouot

1992 *Arts primitifs*. Sale cat., Hôtel Drouot, Paris, June 25.

Huet, Michel, and Jean-Louis Paudrat

1978 *The Dance, Art, and Ritual of Africa.* New York: Pantheon.

Imperato, Pascal James

1970 "The Dance of the Tyi Wara." *African Arts* 4, no. 1, pp. 8–13, 71–80.

1975 "Last Dances of the Bambara." *Natural History* 84, no. 4, pp. 62–71, 91.

1980 "Bambara and Malinke Ton Masquerades." *African Arts* 13, no. 4, pp. 47–55, 82–87.

1981 "Sogoni Koun." *African Arts* 14, no. 2, pp. 38–47, 72, 88.

2001 *Legends, Sorcerers, and Enchanted Lizards.* New York: Africana Publishing Co.

Iroquois Art

1998 *Iroquois Art: Visual Expressions of Contemporary Native American Artists.* Edited by Sylvia S. Kasprycki, with Doris I. Stambrau and Alexandra V. Roth. Ernas Monographs, 1. Exh. cat. Frankfurt am Main: Amerika Haus.

Johannesburg

1998 *Evocations of the Child: Fertility Figures of the Southern African Region.* Exh. cat. Johannesburg: Johannesburg Art Gallery.

Johnson, Rev. Samuel

1921 *The History of the Yorubas.* London: Routledge & Keegan Paul Ltd. Reprint ed., 1987.

Jordan, Manuel, ed.

1998 *Chokwe! Art and Initiation among Chokwe and Related Peoples.* Exh. cat. Birmingham, Alabama: Birmingham Museum of Art.

Kamer, Henri

1973 *Haute-Volta.* Preface by Toumani Triandé. Exh. cat. Brussels: Studio 44, Passage 44; A. de Rache.

Klobe, Marguerite

1977 "A Dogon Figure of a Koro Player." *African Arts* 10, no. 4 (July), pp. 32–35, 87.

Kotz, Suzanne, ed.

1999 *Selected Works from the Collection of the National Museum of African Art.* Vol. 1. Exh. cat. Washington, D.C.: National Museum of African Art, Smithsonian Institution.

de Kun, Nicolas

1979 "L'art Boyo." *Africa-Tervuren* 25, no. 2, pp. 29–44.

Lafitau, Joseph-François

1974 *Customs of the American Indians Compared with the Customs of Primitive Times.* Vol. 1. Translated and edited by William N. Fenton and Elizabeth L. Moore. Toronto: Champlain Society.

Lamp, Frederick

1996 *Art of the Baga: A Drama of Cultural Reinvention.* Exh. cat. New York: Museum for African Art.

Leff, Jay C.

1960 *Exotic Art from Ancient and Primitive Civilizations: A Selection from the Collection of Jay C. Leff.* Exh. cat. New York: American Federation of Arts.

1964 *African Sculpture from the Collection of Jay C. Leff.* Exh. cat. New York: Museum of Primitive Art.

1970 *The Art of Black Africa: Collection of Jay C. Leff.* Exh. cat. [Pittsburgh]: Museum of Art, Carnegie Institute.

Lehuard, Raoul

1989 *Art Bakongo: Les centres de style.* Vol. 1. Arnouville, France: Arts d'Afrique noire.

Lem, F. H.

1949 *Sudanese Sculpture.* Paris: Arts et Métiers Graphiques.

Le Moal, Guy

1980 *Les Bobo: Nature et fonction des masques.* Travaux et documents de l'ORSTOM, no. 121. Paris: Éditions de l'Office de la Recherche Scientifique et Technique Outre-Mer.

McClusky, Pamela

1977 *African Masks and Muses: Selections of African Art in the Seattle Art Museum.* Seattle: Seattle Art Museum.

1987 *African Art: From Crocodiles to Convertibles in the Collection of the Seattle Art Museum.* Exh. cat. Seattle: Seattle Art Museum.

McNaughton, Patrick R.

1988 *The Mande Blacksmiths.* Bloomington: University of Indiana Press.

Maes, Joseph, and Henri A. Lavachery

1930 *L'art nègre.* Exh. cat. Paris: Palais des Beaux-Arts; Brussels: Librairie Nationale d'Art et d'Histoire.

Maurer, Evan, and Allen Roberts

1985 *Tabwa: The Rising of a New Moon.* Exh. cat. Ann Arbor: University of Michigan Museum of Art; Washington, D.C.; National Museum of African Art, Smithsonian Institution.

Miller, Joseph C.

1970 "Cokwe Trade and Conquest in the Nineteenth Century." In *Pre-Colonial African Trade: Essays on Trade in Central and Eastern Africa*, edited by Richard Grey and David Birmingham, pp. 174–201. London: Oxford University Press.

New York

1961 *Traditional Art of the African Nations in the Museum of Primitive Art.* Introduction by Robert Goldwater. New York: Museum of Primitive Art.

1996 *Africa: The Art of a Continent / 100 Works of Power and Beauty.* Exh. cat. New York: Solomon R. Guggenheim Museum.

Neyt, François

1977 *La grande statuaire Hemba du Zaïre.* Publications d'histoire de l'art et d'archéologie de l'Université Catholique de Louvain, vol. 12. Louvain-la-Neuve.

1993 *Luba: Aux sources du Zaïre.* Exh. cat. Paris: Musée Dapper.

Neyt, François, and Louis de Strycker

1974 *Approche des arts Hemba.* Supplement to *Arts d'Afrique noire*, vol. 11. Villiers-le-Bel.

Nooter, Mary H.

1991 "Luba Art and Polity: Creating Power in a Central African Kingdom." Ph.D. dissertation, Columbia University, New York.

1993 *Secrecy: African Art that Conceals and Reveals.* Contributions by 'Wande Abimbola et al. Exh. cat. New York: Museum for African Art.

Nunley, John W., and Cara McCarty

1999 *Masks: Faces of Culture.* Exh. cat. New York: Harry N. Abrams in association with the Saint Louis Art Museum.

Palmeirim, Manuela

1994 "Of Alien Kings and Ancestral Chiefs: An Essay on the Ideology of Kingship among the Aruwund." Ph.D. dissertation, School of Oriental and African Studies, University of London.

Park, Edwards

1983 *Treasures of the Smithsonian: National Museum of American History, National Museum of Natural History, National Air and Space Museum. . . .* Washington, D.C.: Smithsonian Books.

Parke-Bernet

1967 *African, Oceanic, American Indian, Pacific Northwest Coast, and Pre-Columbian Art: Duplicates from the Collection of Governor Nelson A. Rockefeller and the Museum of Primitive Art, New York.* Sale cat., Parke-Bernet Galleries, New York, May 4.

Parker, Arthur C.

1912 "Certain Iroquois Tree Myths and Symbols." *American Anthropologist* 14, pp. 608–20.

Phillips, Ruth B.

1998 *Trading Identities: The Souvenir in Native North American Art from the Northeast, 1700–1900.* Seattle: University of Washington Press; Montreal: McGill-Queen's University Press.

Phillips, Tom, ed.

1995 *Africa: The Art of a Continent.* Contributions by Daniel P. Biebuyck et al. Exh. cat. London: Royal Academy of Arts; Munich: Prestel-Verlag.

Pirat, Claude-Henri
1996 "The Buli Master: Isolated Master or Atelier?" *World of Tribal Arts* 3 (summer), pp. 54–77.
2001 "The Buli Master: A Review of the Case." *World of Tribal Arts* 7, no. 1 (summer–autumn), pp. 82–95.

Preston, George Nelson
1985 *Sets, Series, and Ensembles in African Art.* Introduction by Susan M. Vogel; entries by Polly Nooter. Exh. cat. New York: Center for African Art.

Rasmussen sale
1979 *Succession René Rasmussen, 1^{ère} vente: Tableaux et sculptures modernes . . . meubles, arts primitifs.* Sale cat. Paris: Drouot Rive Gauche, December 14.

Robbins, Warren M.
1966 *African Art in American Collections / L'art africain dans les collections americaines.* Contributions by Robert H. Simmons; French translation by Richard Walters. New York: Frederick A. Praeger.

Robbins, Warren M., and Marietta Joseph
1979 *Traditional Sculpture from Upper Volta.* Exh. cat. Washington, D.C.: Museum of African Art, Smithsonian Institution.

Robbins, Warren M., and Nancy Ingram Nooter
1989 *African Art in American Collections: Survey 1989.* Washington, D.C.: Smithsonian Institution Press.

Roberts, Allen F.
1995 *Animals in African Art: From the Familiar to the Marvelous.* Contributions by Carol A. Thompson. Exh. cat. New York: Museum for African Art; Munich: Prestel-Verlag.

Roberts, Mary Nooter, and Allen F. Roberts, eds.
1996 *Memory: Luba Art and the Making of History.* Exh. cat. New York: Museum for African Art.

Roberts, Mary Nooter, and Alison Saar
2000 *Body Politics: The Female Image in Luba Art and the Sculpture of Alison Saar.* Exh. cat. Los Angeles: UCLA Fowler Museum of Cultural History.

Rosenstock, Laura
1984 "Léger: 'The Creation of the World.'" In Rubin 1984, vol. 2, pp. 475–84.

Roy, Christopher D.
1979 "Mossi Masks and Crests." Ph.D. dissertation, Indiana University, Bloomington.
1983–84 "Forme et signification des masques Mossi / Form and Meaning of Mossi Masks," parts 1, 2. *Arts d'Afrique noire*, no. 48 (1983), pp. 9–23; no. 49 (1984), pp. 11–22.
1985 *Art and Life in Africa: Selections from the Stanley Collection.* Exh. cat. Iowa City: University of Iowa Museum of Art.
1987 *Art of the Upper Volta Rivers.* Meudon, France: Alain and Françoise Chaffin.
1999 "The Laws of Man and the Laws of God: Graphic Patterns in Voltaic Art." *Baessler-Archiv* 47, pp. 223–58.

Rubin, William, ed.
1984 *"Primitivism" in 20th Century Art: Affinity of the Tribal and the Modern.* 2 vols. Exh. cat. New York: Museum of Modern Art.

Rubinstein sale
1966 *The Helena Rubinstein Collection: African and Oceanic Art, Parts One and Two.* Sale cat., Parke-Bernet Galleries, New York, April 21, 29.

Schweeger-Hefel, Annemarie
1966 "L'art Nioniosi." *Journal de la Société des Africanistes* 36, pp. 251–332.

Seattle
1984 *Praise Poems: The Katherine White Collection.* Exh. cat. Seattle: Seattle Art Museum.

Sieber, Roy, and Roslyn Adele Walker
1987 *African Art in the Cycle of Life.* Exh. cat. Washington, D.C.: National Museum of African Art; Smithsonian Institution Press.

Skougstad, Norman
1978 *Traditional Sculpture from Upper Volta.* Exh. cat. New York: African-American Institute.

Sotheby Parke Bernet
1980 *Catalogue of Primitive Works of Art.* Sale cat. Sotheby Parke Bernet and Co., London, December 2.

Soyinka, Wole

1976　*Myth, Literature, and the African World.* New York: Cambridge University Press.

de Strycker, Louis, and Bernard de Grunne

1996　"The Treasure of Kalumbi and the Buli Style." *World of Tribal Arts* 3 (summer), pp. 48–52.

Vansina, Jan

1955　"Initiation Rituals of the Bushong." *Africa* 25 (1955), pp. 138–53.

1978　*The Children of Woot.* Madison: University of Wisconsin Press.

1984　*Art History in Africa: An Introduction to Method.* London and New York: Longman.

1985　*Oral Tradition as History.* Madison: University of Wisconsin Press.

1990　*Paths in the Rainforests.* Madison: University of Wisconsin Press.

Vogel, Susan M.

1980　"The Buli Master and Other Hands." *Art in America* 68, no. 5 (May), pp. 133–42.

1981　as editor. *For Spirits and Kings: African Art from the Paul and Ruth Tishman Collection.* Exh. cat. New York: The Metropolitan Museum of Art.

1988　as editor. *The Art of Collecting African Art.* Contributions by Robert Nooter and Nancy Ingram Nooter. Exh. cat. New York: Center for African Art.

Washington

1973　*African Art in Washington Collections: An Exhibition at the Museum of African Art 1972.* Exh. cat. Washington, D.C.: Museum of African Art.

Willett, Frank

1967　*Ife in the History of West African Sculpture.* New York: McGraw-Hill.

Wooten, Stephen R.

2000　"Antelope Headdresses and Champion Farmers: Negotiating Meaning and Identity through the Bamana *Ciwara* Complex." *African Arts* 33, no. 2, pp. 19–33, 89–90.

Zahan, Dominique

1950　"Notes sur un Luth Dogon." *Journal de la Société des Africanistes* 20, pp. 193–207.

1951　"Études sur la cosmologie des Dogon et des Bambara du Soudan français, I: La notion d'écliptique chez les Dogon et les Bambara." *Africa* 21, pp. 13–20.

1970　*The Religion, Spirituality, and Thought of Traditional Africa.* Chicago: University of Chicago Press.

1980　*Antilopes du soleil: Arts et rites agraires d'Afrique noire.* Vienna: A. Schendl.

2000　"The Two Worlds of *Ciwara*." Edited, translated, and annotated by Allen F. Roberts. *African Arts* 33, no. 2, pp. 35–45, 90–91.

Zwernemann, Jürgen

1978　"Masken der Bobo-Ule und Nuna im Hamburgischen Museum für Völkerkunde." *Mitteilungen aus dem Museum für Völkerkunde Hamburg* 8, pp. 45–85.

PHOTOGRAPH CREDITS